SUPER REALISM

GREGORY BATTCOCK is editor of several anthologies of criticism in the fine arts, including *The New Art, The New American Cinema, Minimal Art, Idea Art,* and *New Ideas in Art Education.* He teaches art history at The William Paterson College of New Jersey.

SUPER REALISM

A Critical Anthology

edited by GREGORY BATTCOCK

A Dutton Paperback

E. P. DUTTON & CO., INC. · NEW YORK · 1975

Published simultaneously in Canada by Clarke, Irwin and Company Limited,
Toronto and Vancouver.

ISBN 0-525-47377-7

Designed by The Etheredges

LINDA CHASE: "Existential vs. Humanist Realism." A section of the forthcoming
book *Photo Realism* (New York: Eminent Publications, 1975). Printed by permis-
sion of the author.

WILLIAM DYCKES: "The Photo as Subject: The Paintings and Drawings of Chuck
Close." Reprinted from *Arts Magazine*, Vol. 48, No. 5 (February 1974), by per-
mission of the author.

GERRIT HENRY: "The Real Thing." Revised version of an essay originally printed
in *Art International*, Vol. 16/6 (Summer 1972), reprinted by permission of the
author. "The Silk Purse of High-Style Interior Decoration." Reprinted from *Arts
Magazine*, Vol. 48, No. 9 (June 1974), by permission of the author.

IVAN KARP: "Rent Is the Only Reality, or the Hotel Instead of the Hymns."
Reprinted from *Arts Magazine*, Vol. 46, No. 3 (December/January 1972), by
permission of the author.

KIM LEVIN: "The Ersatz Object." Reprinted from *Arts Magazine*, Vol. 48, No. 5
(February 1974), by permission of the author. "Malcolm Morley: Post-Style
Illusionism." Reprinted from *Arts Magazine*, Vol. 47, No. 4 (February 1973), by
permission of the author.

JOSEPH MASHECK: "Verist Sculpture: Hanson and de Andrea." Reprinted from
Art in America, Vol. 60, No. 6 (November/December 1972), by permission of
the author.

J. PATRICE MARANDEL: "The Deductive Image." Reprinted from *Art International*,
Vol. XV/7 (September 1971), by permission of the author.

CINDY NEMSER: "The Closeup Vision." Reprinted from *Arts Magazine*, Vol. 46,
No. 7 (May 1972), by permission of the author.

LINDA NOCHLIN: "Some Women Realists." Reprinted from *Arts Magazine* (February 1974), by permission of the author. "Realism Now." Reprinted from *Art News* (January 1971), by permission of the author.

H. D. RAYMOND: "Beyond Freedom, Dignity, and Ridicule." Reprinted from *Arts Magazine*, Vol. 48, No. 5 (February 1974), by permission of the author.

HAROLD ROSENBERG: "Reality Again." Reprinted from *The New Yorker* (February 5, 1972). Copyright © 1972 by The New Yorker Magazine, Inc.

GENE R. SWENSON: "Paint, Flesh, Vesuvius." Reprinted from *Arts Magazine*, Vol. 41, No. 1 (November 1966), by permission of the author.

HONEY TRUEWOMAN: "Realism in Drag." Reprinted from *Arts Magazine*, Vol. 48, No. 5 (February 1974), by permission of the author.

JUDITH VAN BARON: "The Grand Style." Printed by permission of the author.

ACKNOWLEDGMENTS

For permission to reprint material they printed first, I thank Brian O'Doherty, James Fitzsimmons, Louis Meisel, and Grégoire Müller. For help in preparing this manuscript I thank my editor and Richard Martin.

Robert Stefanotty, Ivan Karp, and Louis Meisel were particularly generous in allowing us full access to their photographic archives, a kindness for which we are very appreciative.

CONTENTS

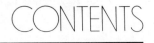

ILLUSTRATIONS

INTRODUCTION

I. THE SUBJECT OF REALISM

"In Europe, as well as in the United States, we are finding new directions in nature, for contemporary nature is mechanical, industrial, and flooded with advertisements . . ."

PIERRE RESTANY

The quotation above is taken from a catalogue for an exhibition of painting and sculpture that was presented at the Sidney Janis Gallery in New York City in December 1962. Called "New Realism," the show included works by such well-known artists as James Rosenquist, George Segal, Robert Indiana, and Tom Wesselmann. Today these artists are generally considered founders of the so-called Pop art movement, yet the fact they were grouped under the heading New Realism many years ago is itself significant.

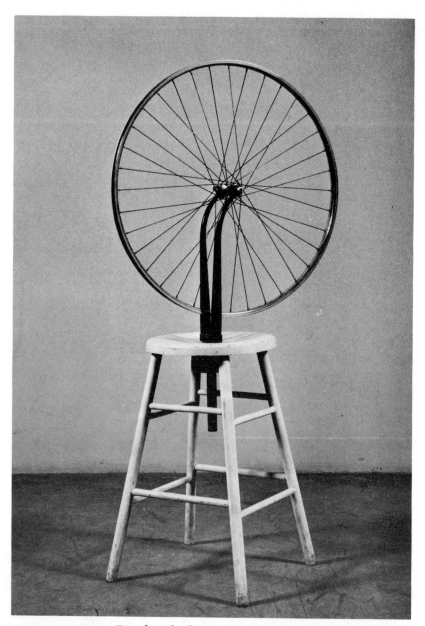

MARCEL DUCHAMP: *Bicycle Wheel.* 1913 (Paris). Original lost; second version: the artist, 1916 (New York). Lost. Replica of 1951 after lost original. Bicycle wheel: Diam. 25½", mounted on painted wooden stool: H. 23¾". Photograph courtesy The Museum of Modern Art, New York. The Sidney and Harriet Janis Collection.

In his introduction to the catalogue for the 1962 "New Realism" show John Ashbery wrote: "New Realism is not new. Even before Duchamp produced his first readymade, Apollinaire had written that the true poetry of our age is to be found in the window of a barber shop." In fact, the history of realism in art is as old as the history of art itself. Throughout the development of art the issue of realism has reappeared countless times. New developments in art frequently were justified in that they contributed to the notion of realism, yet that very notion often differed markedly from one time to another, from one type of art to another. Sometimes the styles were completely contradictory.

In the recent history of art the realism label has appeared over and over. The mid-nineteenth century produced its own school of realism, represented by the art of such figures as Jean Baptiste Corot and Gustave Courbet. Venturi remarked that "Courbet denied beauty in order to stick to reality." Realism, at that time, was identified as a "reaction against romanticism." The art of that period, however, bears little resemblance to today's realism.

The tradition of Western realism allows for a very broad interpretation of realism itself. The modern concern for realism and the contemporary need to define realism has led to new investigations of the entire history of art. One result has been the reemergence, almost the rediscovery, of the great Romantic realist, Michelangelo da Caravaggio, and the rediscovery of the later French master Georges de la Tour.

Hilton Kramer, writing in *The New York Times*, went so far as to claim that Caravaggio ". . . inaugurated the whole realist movement . . ." and that de La Tour is an artist who has given the tradition of realism ". . . its special luster." [1] This view is supported by Lionello Venturi who wrote, in reference to Caravaggio's famous *Youthful Bacchus:* "His realistic conception, which is an insult to the classic god of wine, anticipated the creation of the new realistic form." [2]

[1] *The New York Times,* September 27, 1974.
[2] Lionello Venturi, *Four Steps Toward Modern Art* (New York: Columbia University Press, 1956), p. 34.

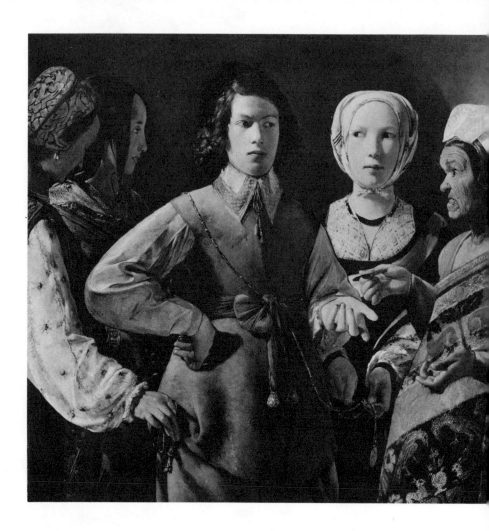

GEORGES DE LA TOUR: *The Fortune Teller.* 1635–1640. Oil on canvas. 40⅛″ x 48⅝″. Photograph courtesy The Metropolitan Museum of Art, New York.

MICHELANGELO DA CARAVAGGIO: *Youthful Bacchus.* 1592–1593. Oil on canvas. Uffizi Gallery, Florence.

Because our ideas of realism in art are constantly changing, the realism of one art-historical period can be far removed from the type of realism advocated by another. Although it is probably safe to say that the kind of realism practiced by many artists today is linked to the realist art created by Caravaggio and de La Tour in the seventeenth century, there are equally important connections to be revealed with recent Minimalist and non-objective art.

For example, today's realism is markedly different in appearance, though not necessarily in philosophy, from the art selected by E. C. Goossen for an exhibition at The Museum of Modern Art in 1968 called "The Art of the Real." The works in the exhibition were primarily representations within the Minimalist style, including Ellsworth Kelly, Carl Andre, and Barnett Newman, and were "realistic" in that they concentrated on the verifiable, physical properties of art objects. The realism had to do with realistic, as opposed to illusionistic *properties,* and as such was mainly an Existentialist realism. Thus the very idea of realism in art had been considerably expanded by the Minimalist style. In clearing away subject matter from the qualities of the work itself, the way had been prepared for yet a new type of realism. It was to be an art that reintroduced illusionist subject matter.

One crucial problem investigated by the Minimalist realists was of major concern to art criticism: Minimal art offered no possibility for interpretation. In fact, such art led to a crisis in criticism in which critical energies were directed away from such traditional roles as those involving interpretation and connoisseurship and toward the relatively arcane philosophical areas that became associated with the "formalist" critical methodologies of the 1960s. Description and identification of the art object itself became the major critical preoccupation. The new Super Realist movement will not automatically result in a return to a criticism of interpretation, although such a step within the field of criticism and aesthetics seems inevitable. Neither criticism nor art remains static.

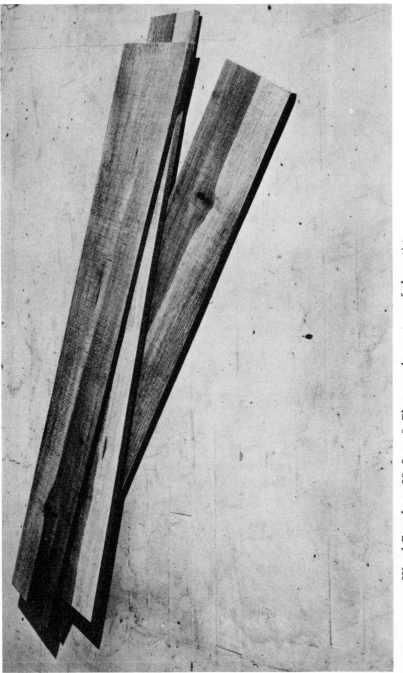

ALAIN JACQUET: *Wood Boards*. 1968. L. 59". Photograph courtesy of the artist.

II. NEW REALISM AND NEWER REALISM

A discussion of the changing face of realism can hardly avoid a peculiar dilemma faced by Surrealism during the first half of this century. It seems clear that the Surrealists, rebelling against standard appearances in art and society, were very concerned about producing their own type of realist art. In fact, we are told that the Surrealists ". . . abhorred as 'unreal . . . art for art's sake' . . ." [3] thus implying that in Surrealist art what was not considered realistic was not particularly desirable.

A preoccupation with realism was not a Surrealist exclusive. The Abstract Expressionist painters and sculptors also claimed an allegiance to realism in art: a leading journal of the period, calling itself *It Is*, emphasized the Abstract Expressionist preoccupation with realism. This preoccupation was demonstrated in the Abstract Expressionists' choice of subject matter, even though the subject matter itself could hardly be termed realistic. Their subject matter, their "realism," was centered on art itself, on aesthetic function, rather than on familiar, everyday objects and themes.

The immediate ancestry of today's conceptual, realist, and process art lies in Abstract Expressionism, wherein serious efforts were made to achieve the improbable and ultimately unattainable goal of subordinating social and iconographic content to the visualization of purely aesthetic functions. Artistic process became the legitimate subject matter for frank and rich aesthetic speculation. Thus, Abstract Expressionism, an authentically revolutionary school at one time, helped make possible the type of realism that is the subject of this book.

The reader will note that of the several important art styles to surface during the past two decades one has yet to be mentioned in this brief survey of realist trends in contemporary art. Superficially at least, Pop art appears to be the one most closely related to Super Realism.

[3] Lucy Lippard, ed., *Surrealists on Art* (Englewood Cliffs, N.J.: Prentice-Hall, 1970), p. 8.

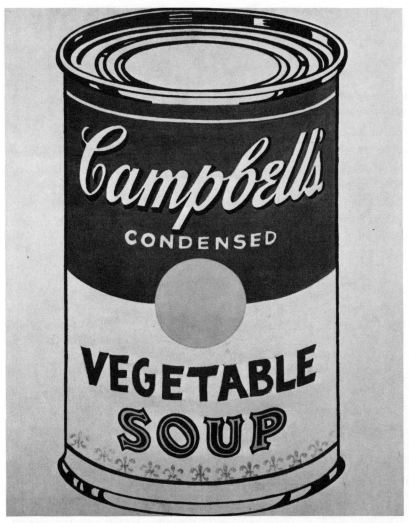

ANDY WARHOL: *Campbell's Soup Can.* 1964. Silkscreen on canvas. 36″ x 24″.
Photograph courtesy Leo Castelli Galleries, New York. Collection of Alberto
Ulrich.

However, it may very well turn out that the realism advanced by the Pop artists is perhaps less related to today's Super Realism than one would suspect. Although both Pop art and Super Realist art emphasize the priority of the image in their subject matter, several major distinctions are apparent. For example, rarely were the Pop art painters and sculptors offering direct representations of everyday phenomena. Andy Warhol's *Campbell's Soup Can* was not, of course, a picture of a soup can; it was, rather, a picture of a label for a soup can. Rosenquist's subjects were frequently representations taken from large-scale outdoor advertising displays. Mel Ramos offered stylish paintings that were mainly references to the art of packaging technology, rather than illustrating the contents of such packages. Wesselmann's nudes were mainly sociological in intent. In short, the Pop art painters seemed determined to present first, recognizable pictures and only secondly, realism as such. The realism found in Pop art was, philosophically at least, consistent with the realism of Abstract Expressionism: the flatness of the image rarely contradicted the flatness of the canvas. The subject matter and the material of art itself, the paint, the canvas, the shape, were the essential ingredients of the art.

III. SUPER REALISM

The first artists to point in the direction away from Pop art and Minimalism and toward Super Realism cannot be easily pinpointed. Alex Hay's representations of blank sheets of lined paper, cash register sheets, and other flat surfaces were one step in that direction. Allan D'Arcangelo's flat traffic symbols were another. John Clem Clarke reproduced Old Masters in his paintings, which were after all flat objects of two dimensions that quite naturally lent themselves to reproduction in a flat medium of two dimensions. Perhaps the most significant decisions that ultimately led to the appearance of the new style were offered by Malcolm Morley.

Morley's paintings of the mid-1960s astonished art lovers because they seemed to represent a type of realism even more vivid than the

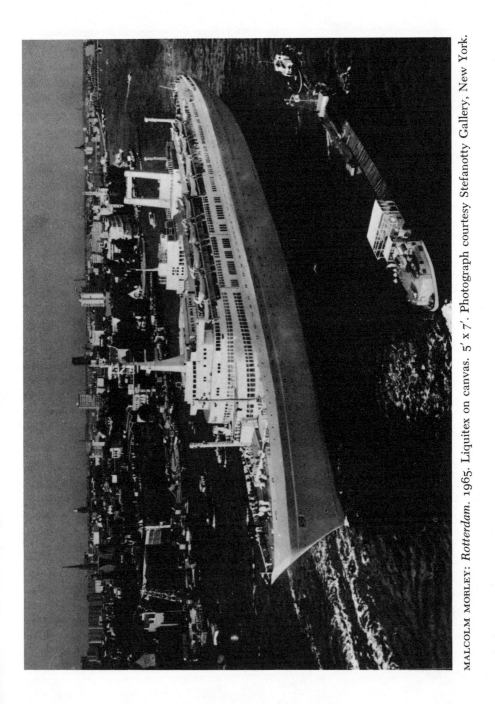

MALCOLM MORLEY: *Rotterdam*. 1965. Liquitex on canvas. 5' x 7'. Photograph courtesy Stefanotty Gallery, New York.

sort made familiar by the Pop art school. They were paintings of ships, of patriotic views, and of solid family values. The paintings seemed, in the main, to be blown-up reproductions of picture postcards, calendar views, and travel brochures. Thus, they were pictures previously identified as flat pictures rather than original plastic inventions.

The philosophical requirement that pictorial subject matter remain consistent with the facts of the pictorial object—a requirement introduced by the Abstract Expressionists and secured by the Pop art and Minimalist schools—served as the major aesthetic idea linking the new realism with the old realism. The new realist type of art discovered by Morley represented an authentically new development within the contemporary pictorial tradition.

It was a change easily as significant and sweeping to art as were the differences between Abstract Expressionism and Pop art and between Pop art and Minimalist art. To claim that the realism of Pop art is similar to realism as found in Super Realist art is to overlook the diametrically opposed aesthetic motivations, indicating we are dealing with a markedly different kind of realism. The only basis for finding compatible characteristics in both Pop art and Super Realism is the irrelevant observation that both realisms claim a photographic-type accuracy of image. In his introduction for the catalogue of the Palm Beach exhibition of realist art [4] Richard Martin points out that "faith in the exactness of the camera's vision underlies both the Pop idiom and New Realism." However, it should be pointed out that developments in art depend not upon faith but upon more verifiable experiences.

Elsewhere, in the same essay, Martin explains his choice of interpretation based upon photography by dismissing the role of the painter: a role that has been consistently diminished by critics since Duchamp and his readymades, since Pollock and his drips, since the Minimalists and their color fields, since the Pop artists and their silk screens. Martin claims "implicit in the relationship of New Realism to the camera is the passive part played by the painter," yet have we

[4] "Imagist Realism," Norton Gallery and School of Art, December 1974.

not learned by now that physical activity vis-à-vis the art object is no verification or confirmation of the aesthetic merits of that object? Only the artist, it would appear nowadays, need exist: which is something more than is required of some artworks, such as those of the Conceptual school.

When Morley introduced paintings of printed pictures, he introduced a new subject for art criticism: something that, throughout the recent history of art, including that of Pop art, had been anathema to intelligent criticism. The new content of art was nothing less than the reintroduction of subject matter itself.

Although mainstream criticism of the 1950s and the 1960s avoided interpretation and the principles of connoisseurship, it subscribed exclusively to a formalist doctrine. The new doctrine was, in fact, the only doctrine that made any sense in dealing with paintings in which the underlying motivation was to contribute objects that were philosophical metaphor: such paintings were pictures of themselves rather than pictures of things. Implied in the new kind of realism is the new kind of subject matter that will ultimately lead to an expansion of the rigid interdictory critical approach that had been so useful.

The opportunities now present for an expanded art criticism will, no doubt, fuel the realist trend toward the invention of a broad iconographical base that will mark a major turning point in the development of Western art, art thought, and art criticism.

The essays in this book deal with a broad range of issues that have engaged the imaginations of Super Realist artists. The work of these artists spans a wide spectrum of styles, techniques, and subject matter. The essays themselves are frequently contradictory and do not claim to offer the art lover and student a final explanation. The brief introductions are intended solely to place the essays within a critical chronology and not to judge the merits or potential of the arguments contained therein.

Realism Now, Sharp-Focus Realism, Photographic Realism, New Realism, Hyper-Realism, the Realist Revival, *il nuovo realismo,* Sepa-

rate Realities, Paintings from the Photo, Radical Realism, Aspects of a New Realism, Figures/Environments, Imagist Realism—these are but some of the labels that have been invented to refer to the new realist style that has emerged since 1970. A special issue of *Arts Magazine* (February 1974) devoted to the subject was called Super Realism because this phrase aptly describes the hyper-realistic quality of so many of the artworks produced. That is the title we have chosen for this book and as a label to describe its subject.

GREGORY BATTCOCK

WHAT IS SUPER REALISM?

Part I

THE REAL THING*

Gerrit Henry

The author is not entirely sympathetic to all aspects of Super Realist art, and he takes several critics of such art to task. He writes "Photo Realism, as well as much hard-edge and color-field painting, Minimalism, and Conceptualism can be seen as the products of latter-day artists taking in deadly earnest the self-consciousness inspired in them by their art-magazine scribes." There are, however, several Super Realists he finds interesting, largely because of ". . . their infidelity and not their adherence to the New Realist mode." These painters include Richard Estes, Audrey Flack, Guy Johnson, Stephen Woodburn, and Noel Mahaffey.

Henry is careful to distinguish between "classical" realists and Super Realists; whereas classical painters through the ages ". . . have idealized reality itself, . . ." the Super Realists ". . . totally

* Revised version of an essay originally printed in *Art International*, Vol. 16/6 (Summer 1972).

devalued reality in order to vastly overvalue . . . the human brain." It is to the "mainstream" Realists, especially painters Philip Pearlstein and Jack Beal, that Henry accords his most detailed analysis.

"Photo Realism is basically not realism at all. More correctly, it is the plastic offshoot of today's conceptual arts," writes the author. Nevertheless he finds a group of "second generation" realists of high potential, and claims that ". . . the relative greatness of these artists will be decided not by the sprawling, record-keeping machine of modern art history but by the artists themselves. . . ." They include Daniel Lang, John Moore, Janet Fish, Yvonne Jacquette, and Joe Brainard.

Gerrit Henry is the former art critic for The New Republic. *He has written art criticism for* Art News, Art International, *and* Art and Artists. *He is associate editor of* Art News.

In an interesting article in *The New York Times*, critic Hilton Kramer divided contemporary American realist painting into three categories, reactionary, radical, and mainstream. Kramer placed academic or neo-traditional realists in the first division, Photographic or New Realists in the second, and in the third, everybody else, Alex Katz and Philip Pearlstein foremost among them. Kramer stated, with perhaps a slight liberal blush, that he favored those artists working the middle ground. But why blush? It may just be today, as it has traditionally been, that those artists who are ideologically the hardest to pin down are aesthetically the most satisfying.

In other words, the mainstream is also the open road. Contrary to popular opinion, the open road is not so safe a place to be as either of the two extreme paths because it follows a course, not of single-minded ideology but of open-minded thought, which just naturally causes all sorts of doubts. Extremists, too, have their doubts, but rather than capitalizing on them as mainstreamers do, they tend to sit on them. The static, breath-holding ominousness of the works of so many Photo Realists is perhaps directly traceable to this latter phenomenon,

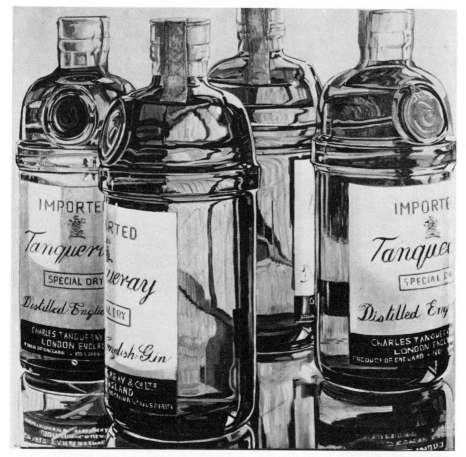

JANET FISH: *Tanqueray Gin*. 1973. Oil on canvas. 40″ x 40″. Photograph courtesy Kornblee Gallery, New York. Collection of Dr. and Mrs. L. V. Kornblee.

and maybe this is why Mr. Kramer, among others, has opted for the relative light and air of mainstream American realism.

Still, it is clear that reactionary and especially radical realists have a public. *Someone* is looking for and "buying," in both senses of the word, New and Photo Realist painting. One such someone is *The Village Voice* art critic John Perreault. In his piece on Philip Pearlstein's show at the Allan Frumkin Gallery, New York, in the winter of 1972, he had this to say:

> While the abstract academies scream that you are not supposed to make representational paintings, particularly nudes, their opposite numbers, predisposed to representational painting—usually for dumb and sentimental reasons—are morally offended by the results of Pearlstein's calculating eye, his calm and practical rendering. To them Pearlstein's paintings are dehumanized or obscene. Is not the human form sacred? What they want is rosy-nippled maidens strewing flowers under golden skies, or sacred mamas reclining voluptuously on silken pillows, or heroic, unreal musclemen fresh from slaying slaves. Cultural pinups. No flab, no bulges.
>
> What [we] get is something entirely different: Hard art, important art, and possibly great art . . .

Where has Perreault seen "heroic, unreal musclemen" or "sacred mamas" in recent realist painting, academic or otherwise? But never mind. What we might more reasonably be concerned with in Perreault's rhetoric is his impassioned call for a "hard" art. One doubts very much if the agonized anti-idealism of a Pearlstein nude fills this particular bill, but this too is beside the point. The point is that the "hard" art, which the critic recommends, is, by some quirk of aesthetic fate, probably the softest and easiest art to achieve. Yes, idealism is always a mistake; no, the full-speed-ahead nihilism of the New Realist school is not the proper response to it. Hard and soft, real and unreal are not the only possibilities open to today's artist, much as we have been told otherwise. The excluded middle of the artistic coin is this: there are contemporary American realists who are painting neither "rosy-nippled maidens" nor "tough and uncompromising" nudes, and

doing it successfully. These artists are not totally "dumb and sentimental" nor are they completely "calm and calculating"—they are, at all times, both. How is it that certain critics and a large part of the public have managed to miss, and miss out on, the work of these painters?

"Figurative painting today can be fully understood only against the background of modernist painting," said J. Patrice Marandel in *Art International*. This statement does not apply to the works of mainstreamers like Jane Freilicher, Philip Pearlstein, Alex Katz, Robert Dash, and Fairfield Porter, but it does apply, eminently, to the Photo Realist canon. Here the negative (in Pearlstein's case) or positive (in the case of the others) *vitality* of an earlier generation of realists, which functioned both with and independently of modernism, is gone, to be replaced by text-book-problem static. It makes sense: the medium is the message, and where the trend in art criticism has been increasingly away from *writing* and toward analytic journalism, so has the trend in the accompanying painting been toward color-plate illustrations of the theories behind this journalism. At this point it's a chicken-or-egg question which creates which.

A film critic once observed that *The Birds* was an unhappy result of Alfred Hitchcock's having believed what countless *auteur* critics had written about him. Similarly, Photo Realism as well as much hard-edge and color-field painting, Minimalism, and Conceptualism can be seen as the products of latter-day artists taking in deadly earnest the self-consciousness inspired in them by their art-magazine scribes. And earnestness can indeed be deadly. To call for a completely "hard," "tough, and uncompromising" art is apparently to call for something other than art, an ideology, in short, the death of art. But death is easier than life. When critics urge us to work for a "tough" art, we should realize that they want art to be "hard" so that it won't be difficult. Maybe now we can venture a guess as to why mainstream realism is largely ignored by the radical art establishment. It isn't that it's too old—rather, it's too perpetually new. It is basically too open-ended to be accommodated by a closed system.

If the art-world medium is, self-evidently, the message, then of necessity we shall have to look elsewhere for our artistic correspondence. Fortunately there is a very diversified group of younger artists presently working in some figurative mode other than the New Realist. Before dealing with these second-generation independents though, some mention should be made of the more independent and interesting painters of the Photo Realist persuasion. Admittedly the style is something of a dead end, with individual variations on it tending to carry the individual out of the category per se. Still, a precisionist spirit and technique are common to all of the artists who follow, even though they have been chosen for their infidelity and not their adherence to the New Realist mode.

If Photo Realism can claim any "greats," one of them is certainly Richard Estes. Whereas Chuck Close's huge photo blowups of substandard human faces are the negative apotheosizing of the genre, Estes' plate-glass city storefronts, eternally and momentarily reflecting, refracting, and composing the urban sights around them, are the positive. An Estes canvas doesn't emphasize urban blight so much as it concentrates on the styles this blight takes, and it is no accident that a certain outmoded but refreshing Art Deco ambience informs even the most contemporary of his glittering street scenes. Rather than dumbly registering the visual ugliness of the city, this painter makes a big compositional thing of it; there is true poetry in the absence of it. This is due largely to the fact that Estes alone among the Super Realists records in his peopleless cityscapes an "atmosphere" that is as much present as the trash and the neon.

The architectural-geometric crunch and clutter of an Estes painting also functions as its principle of selection. Another Photo Realist who formulates the things around him as well as formalizing them is Ben Schonzeit. Schonzeit paints huge, hyperrealistic in-canvas suspensions of everyday and some more infrequent items: eggs, toys, candy, birds, knickknacks, dice, and other important paraphernalia. These elements are all floated in and around one another, on invisible

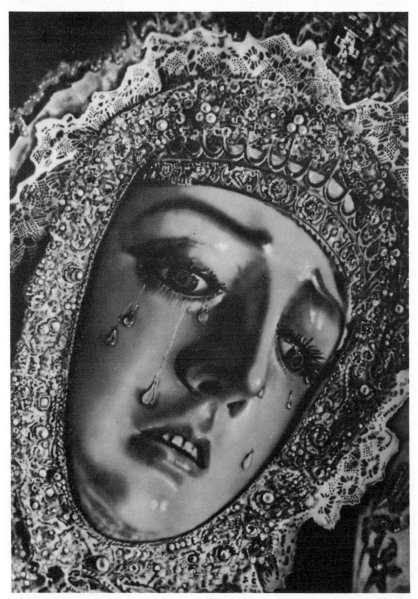

AUDREY FLACK: *Dolores.* 1971. Oil on canvas. 70″ x 50″. Photograph courtesy French & Company, New York.

glass shelves or just up in the air, with further distorted images backing them up prettily or menacingly, as the case may be. If there is an aspect of gimmickry to all this, it is gimmickry of a fine sort. Although Schonzeit's gigantic ends frequently tend to overwhelm their diminutive means, his paintings at least have the virtue of making a hale and genuine grotesquerie of what is too often passed off as mere reality.

One of the few Photo Realists to bypass the American scene, Audrey Flack trains her particular camera eye on the religio-artistic effects of old Europe. Cathedrals and devotional images alike are subjected to her "just the facts, ma'am" sensibility. *Dolores,* an elaborately vested and crowned female figure complete with "real" tears, brings the concept of "innocents abroad" to its tastelessly right apogee.

Guy Johnson is a kind of jester of the Super Realist court. His paintings are bumptious, eerie takeoffs of both early twentieth-century America and Photo Realism itself. In *Gas Station,* with its vintage autos, bowler-hatted men, and goofy, proto-camp signboards, Americana is, rightfully perhaps, made the equivalent of America, and the New Realism is shown to be refreshingly old hat. Whereas Super Realist painters of present-day scenes are commenting largely on the utter impossibility of painting, Johnson's slick but witty double comment holds ingenuously forth on the impossibility of the impossibility of painting. Stringently evocative and lovingly nasty at best, at the very least Johnson's work is like some funny television variety show takeoff of a popular dramatic show on some other network.

Of all the New Realist-type painters under consideration, Stephen Woodburn is the most interesting, perhaps because he is also the one who least qualifies to be included under the heading. Woodburn has come up with a unique, highly quirky style of photographically inspired painting: his works are aqueous, delicately hued, looming foreground, hazily receding background renderings of excruciatingly romantic landscapes—Thomas Hardy by way of the color transparency. In them greenery takes on a mosslike appearance and rocks a cloudlike one, not entirely dependent on paint handling. Woodburn uses photography not as an end in itself, but merely as a means to his

imaginatively unpainterly ends. By overexposing as he does the "pathetic fallacy" of human identification with nature, the artist by no means intends to clear up the confusion. Rather, Woodburn clarifies the fallacies both of *Sturm und Drang* pantheism *and* illusionism by intensifying them to the point of blurred focus.

Noel Mahaffey's paintings are closer to the standard Photo Realism of Chuck Close, Ralph Goings, and the sculptor Duane Hanson, but with a difference. Taking the typical camera-eye remove and precisionist detachment an arresting one step further, Mahaffey gives a sweeping bird's-eye view of things American (a street in Waco, Texas, or the Phoenix Country Club), so that not only the usual absence of artistic or social judgments but also a new possibility for them is made statically manifest. The distance from which this artist paints his scenes is so removed as somehow not to be safe. Although Mahaffey retains most of the recognizable noncharacteristics of the New Realists, his particular vantage point admits of a certain explicit anxiety that indicates trouble in paradise, the paradise in this case being contemporary conceptual art, not the American landscape.

And the above equation between Conceptualism and Photo Realism is not entirely forced. Finally, we can infer from Super Realist painting that its creators are, at heart, idealists. If reality can no longer be forced to yield up an ideal situation as it once was by classical painters, then *unreality* will be forced to do the same. In Photo Realism, reality is made to look so overpoweringly real as to make it pure illusion: through the basically magical means of point-for-point precisionist rendering the actual is portrayed as being so real that it doesn't exist. What does exist off the canvas is the *mind*, which conceived of the idea of the painting of a photograph of reality, in all its intrinsic implausibility. Whereas classical painters through the ages have idealized reality itself, the "classical" New Realists have totally devalued reality in order vastly to overvalue (in other words, completely abstract) the human brain. Photo Realism is basically not realism at all. More correctly, it is the plastic offshoot of today's conceptual arts.

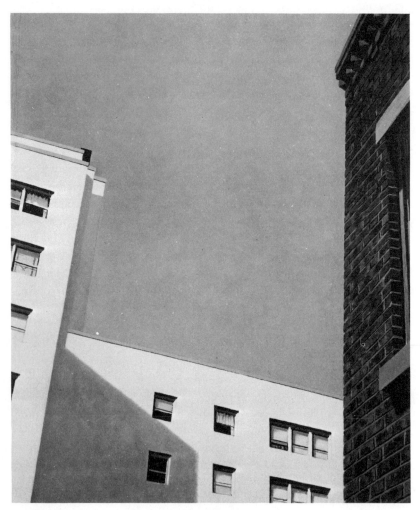

YVONNE JACQUETTE: *New York City Sky I.* 1970. Oil on canvas. 58" x 70".
Photograph courtesy Fischbach Gallery, New York.

What this all boils down to is a rather simplistic equation made on the part of many New Realists between the ideal and the good and the real and the bad. If in John Perreault's case the equation is made between the ideal and the bad, it's the same difference, as they say. If at this late date idealism has proven to be totally bad, then reality, once totally bad, must now be totally good. Apparently the Photo Realists have allowed themselves only these two options, the only two options open to idealists ("A cynic is a romantic at heart"). It's as if they had taken the old Hegelian idea of dialectic through its first two steps and willfully refused to move on to the third. Although this willfulness is interesting and admirable in and of itself, as an *intention*, it doesn't make for very good artworks. True artistic realism involves moving on to the third, synthetic stage of the argument, for without that resolution the two sides of the argument remain purely theoretical, political matters.

Indeed, Photo Realism, Conceptualism, and the other more extreme of today's schools and styles are probably all political manifestations, being representative of the artist's purely political beliefs *about modern art*, if not about the world at large. The camera is the perfect instrument with which to build an art-politics platform; under the banner of absolute accuracy ("The camera doesn't lie") an artist can take one-sided snapshots of reality to his heart's content, and pass them off as the real thing with ease, authority, and the Eastman Kodak Company behind him. But is the camera such a completely reliable observer? It's only a machine, after all. Unless we ascribe some unearthly power to it (as do the Photo Realists, by default) we might possibly take responsibility for its invention on ourselves and make something of it. Even if we do will the camera some magical power, it is *we* who will it. Maybe reality is finally, as folk wisdom would have it, what we make of it. Surely we have all seen snapshots of ourselves and others taken by an amateur shutterbug. Some of them flatter unjustly; some of them unjustly reveal; but some of them, the choicest and, necessarily, the rarest, flatter by revealing.

It is a realist art of this sort that goes to make up the American mainstream to which Hilton Kramer referred, and to which the rest of this piece is devoted. A good way to start might be to compare and contrast two of the more established mainstreamers, Philip Pearlstein and Jack Beal, in the light of what has gone on above. Pearlstein's show came on the heels of Beal's at the Allan Frumkin Gallery in the winter of 1972. Pearlstein's exhibit occasioned more press coverage and general art-world ballyhoo, because whereas Beal's work is easier than Pearlstein's to accept, it is more difficult to grasp. Where Pearlstein's tortuously executed, grimly fleshed-in figures are, to use John Perreault's word, *hard,* Beal's coolly modeled, sensuously bony, young girl sitting in a gaily striped deck chair, her shoulder and back to us as she peruses a kind of coloring-book sketchbook, is, to use my own word, *difficult.* Paintings by both these artists yield up pleasures: Beal's are the pleasures of meditation, color, light and shadow, form, face, and landscape, while Pearlstein's are the pleasures of premeditation, activity, anxiety, and a kind of negative sensuality. Whereas Beal's paintings make the five senses the equivalent of thought, Pearlstein's make thought the sixth sense. A Beal canvas escapes the viewer in its being all there, whereas a Pearlstein tends to disappear in the face of its being too much with him. Pearlstein's *Female Model in Red Robe on Wrought Iron Bench* derives much of its enormous presence from modernist, art-historical associations, while Beal's *Girl Reading* derives its presence from within. Where the Beal provides the viewer with aesthetic satisfaction, the Pearlstein gives deep intellectual satisfaction, of a decidedly perverse nature. Assuming that a rigorous but pleasurable aesthetic satisfaction is one of the ways by which we recognize an artwork, and that we do not entirely get this satisfaction from *Female Model in Red Robe,* might we conclude that in refusing to "compromise" with reality Pearlstein has made a compromise of sorts with art? Could it be, as Beal's painting would indicate, that a slice of artistic cake is more "real" than a slice of life? It isn't by accident that Pearlstein has been dubbed the granddaddy of Photo Realism; his nudes are far more admirable and enjoyable as feats of hard-

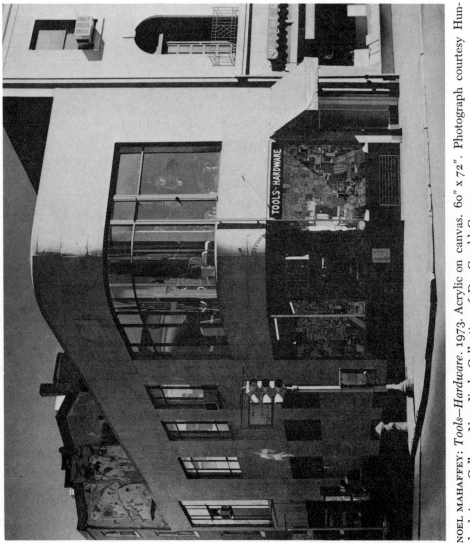

NOEL MAHAFFEY: *Tools—Hardware.* 1973. Acrylic on canvas. 60" x 72". Photograph courtesy Hundred Acres Gallery, New York. Collection of Dr. Gerald Gurman.

headed mentalism than they are as paintings. But are they any more "realistic" in their negative approach than Beal's quiet, colorful studies? Beauty may be in the eye of the beholder, but so is ugliness. Once they have accepted this fact, the contemporary realist and his public will have to start coming to terms with the implications of their valuing one of these qualities over the other.

If none of the six younger painters I will now be dealing with is instantly recognizable as a major artist, they are all instantly recognizable as artists. Each is presently a good painter, and to borrow critic Perreault's words, each is "possibly great." I feel, however, that the relative greatness of these artists will be decided not by the sprawling, record-keeping machine of modern art history but by the artists themselves, which is ultimately to say, "real" art history.

Oklahoma-born painter Daniel Lang is the most formally inclined of the six. His works, colorfully bordered, colored-pencil-like acrylic renderings of midwestern highways and byways seen from a car- or train-type window, are executed in hues that belong more to Op and to Pop than to nature. Lang's style, though, is another matter, but still a complementary one. The artist portrays greenery, mountains, sunsets, and serially receding telephone poles with a hand that hovers decisively between magazine illustration and classical landscape, as if the poetic flatness and banality of the American terrain could be captured only by a quirk. The apparent normality of the midwestern scene becomes what it really is, some arcanely cartoonish something else again. Neat without being unassuming, and as formally careful as they are imaginatively unabashed, Lang's closed-off, open-air vistas and scenic routes are notable for the way in which they use an element of sincerest caricature to set, in at least one manner, the realist record straight.

John Moore's still lifes of mirrors and cone- and egg-shaped objects on tables uneasily draped with cloth bear some superficial resemblance to the magic realism of older and younger practitioners like Alvin Ross and Claudio Bravo, but on closer inspection Moore's objects proved to be bathed not in a physical, magical light, but in

some more truly magical, metaphysical one. The interplay of strictly real and strictly geometric forms makes for a kind of intellectual lyricism the "realistic" point of which is often its very arbitrariness. In recent years the artist has been turning to more straightforward renderings of oddly peopled interiors, open windows, and quietly sunny kitchen chairs and tables, the dynamic reserve and near-mathematical poetry of which prove that it is possible for the young artist of today to get away from formalist abstraction without losing his sense of proportion.

Janet Fish's art seems at first glance a rather compulsive one. She paints arrangements of full, half-full, and empty liquor bottles and honey jars, each of her works initially looking like no more and no less than a kind of serial still life. But Fish's actual intentions are, on the evidence of their realization, anything but Pop or Minimal. The mass-produced elements of her subject matter are carefully selected and composed (labels facing us, labels turned away from us, labels to one side) according not only to their proliferation, but also to their possible uniqueness. That this uniqueness remains, from one honey jar to the next, a relatively moot point does not deter from, and in fact creates, the singularity of the paintings. Each bottle or jar is executed in a kind of matter-of-fact painterly style that renders pointedly abstract reflections in the curving glass at the same time as it reveals them for what they are, painted design. Perhaps not as diversified as some of the other painters presently under discussion, Fish still manages to make a stringent lyricism of the problematic nature of painting reality, with the warm white light and shadows and transparently rich colors of her canvases giving evidence that it is active reflection, and not just premeditation that has gone into her work.

The paintings of Yvonne Jacquette move us closer to the heart of mainstream realism. Here, the sky is seen through a window at a strange diagonal angle, telephone poles and wires crowd up against fleecy clouds and snatches of foliage, and relatively small city buildings are viewed, at a perilously beautiful angle, from the ground up,

with one's hat falling off, as it were. Jacquette's painting has much in common with the realism of an earlier generation of American realists, but is not uninfluenced by vanguard hard-edge and "clean" tendencies. The artist draws on the stylistic advances (more precisely, changes) of her generation without being victimized by them; her canvases are neater, less obviously painterly, and more willingly eccentric than those of the preceding generation while never once losing their claim to mainstream status. This is probably because, painterly or no, Jacquette is as concerned with *perceiving* things as she is with simply seeing them. Her works are not plastic answers to the excruciatingly ingrown problems art history and art-think pose for us, but fresh perceptive airings of some older, more relevant ones. And, to coin a phrase, it works: city buildings seen at certain times of day in certain kinds of light *do* look like these paintings, and would look like them even more if we could just get to them. In short, Jacquette's canvases are not so much factually correct as they are imaginatively accurate, and if this kind of on-the-spot airing of the problems native to representational painting is not the answer to those problems, it is, in at least one sense of the word, the solution to them.

New York artist Joe Brainard is known for his Pop-culture, painted-collage arrangements of the everyday paraphernalia of an American child-adulthood, his *Nancy* (she of comic-strip fame) *Interiors*, and his other wittily high-minded excursions into the commercial field. Recently, Brainard took up a mode that was relatively new to him, portraiture. The artist's portraits were on view in an exhibition at the Fischbach Gallery in New York in April 1972; drawing paper and pencil sketches of friends and fellow artists, they are executed in a style that is reminiscent both of the slickest magazine illustration and the most delicate of Ingres' drawings. If in the past it has been Brainard's gift to make an authentic high art of some of the more incongruous elements of Pop culture, with his portraits he is on his way to making something fine of the craft of popular illustration. Borrowing a slightly sweet, facile manner of drawing from both com-

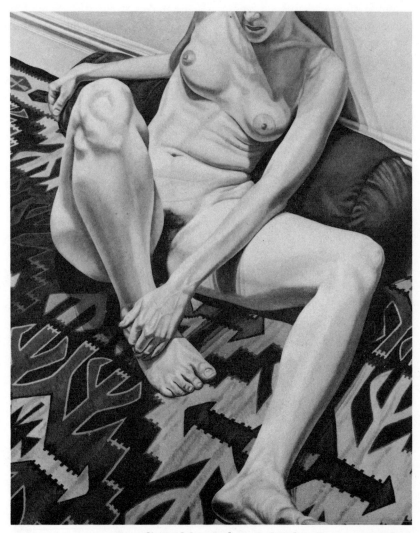

PHILIP PEARLSTEIN: *Female Model on Bolster and Indian Rug.* 1973. Oil on canvas. 60″ x 48″. Photograph courtesy Allan Frumkin Gallery, New York.

mercial and academic sources, the artist makes it completely his own by faithfully adhering to its stylistic principles while putting them at the service of utter reality. The fact that there is nothing "utter" about the changeable reality of the human face so confuses the many aesthetic issues at stake here that it finally clarifies them: the artist borrows a fairly debased style, then puts it to such serious representational and expressive use as to "put it back" again, completely intact, but brand new. The resemblances of Brainard's portraits are uncanny, not so much for their actual resemblances to their sitters as for their sheer *uncanniness*. If one of these drawings looks better or worse than its subject, it is still somehow always *accurate*, for if the viewer doesn't always instinctively recognize the truth of the likeness, he instinctively apprehends the cultural and aesthetic truth of the drawing itself. At the risk of being redundant, it's as if the most genuinely "real" works of realist art depended not on accuracy of depiction, but on accuracy of *style* for their "reality." A Chuck Close canvas may exhibit all the superreflecting requirements of record, but a Brainard drawing exhibits all the superreflective ones of style. Maybe this is why the apparently pretty Brainard portrait, and not the obviously realistic Close painting, seems, on close observation, about to come to life.

RENT IS THE ONLY REALITY, OR THE HOTEL INSTEAD OF THE HYMNS*

Ivan Karp

Ivan Karp is the founder of the O.K. Harris Gallery in New York City, a major showplace for Super Realist art. Karp himself is widely credited with having "discovered" the Super Realist style. He certainly is the first dealer to bring the style to public attention.

In this article Karp uses Udo Kultermann's term Radical Realists *to refer to the realist artists who avoid "self expression" and work in a "national rather than a regional style." He explains the kind of self-expression implicit in the selection of a photograph, or subject, as an ". . . act of conviction undertaken to satisfy the philosophy of no-conviction. . . ."*

The artists discussed here include Richard Artschwager, who is described as projecting an image ". . . in all its dreariness,"

* Reprinted from *Arts Magazine*, Vol. 46, No. 3 (December/January 1972).

and Richard Estes and Ralph Goings, who both make artworks that seem ". . . totally noninterpretative." Of course, the subjects of these works are certainly interpretative. By implication, interpretation is at the option of the viewer. Karp compares Richard Estes with the American realist Edward Hopper ". . . with whom he may eventually be equal."

Besides commenting on the work of Richard McLean, Robert Bechtle, John Salt, and Robert Cottingham, Karp observes that Stephen Posen's paintings represent ". . . an exercise in tactility [that] would have given Bernard Berenson a chill." John Kacere, according to Karp, ". . . has the reactionary gall to work from live models. . . ." The work of Chuck Close is contradictory because, on the one hand, the artist paints "'interesting' people, the antithesis of Radical Realist concerns. . . ." Yet, on the other hand, the work may be taken ". . . as a transmission of photographic information."

In conclusion, Karp claims appreciation of his Radical Realists is open to those who ". . . enjoy the multifarious textures of all artistic expression. . . ." "Art . . . ," he writes, ". . . must be superior to moon travel. The thrill is everlasting and there is no record of it having made anyone exclaim that he felt like a bird."

It is not in the premise that reality
Is a solid. It may be a shade that traverses
A dust, a force that traverses a shade.[1]

In the light of microcircuitry, body transplants, and significant Conceptualism, the idea of notable realist painting in our moment would appear unlikely and possibly ridiculous. But just as a fresh, ripe, homegrown tomato seems suddenly so terribly important, certain

[1] "An Ordinary Evening in New Haven," excerpted from *Collected Poems of Wallace Stevens* (New York: Alfred A. Knopf, 1954). Copyright 1950 by Wallace Stevens. Reprinted from *Collected Poems of Wallace Stevens*, by permission of Alfred A. Knopf, Inc.

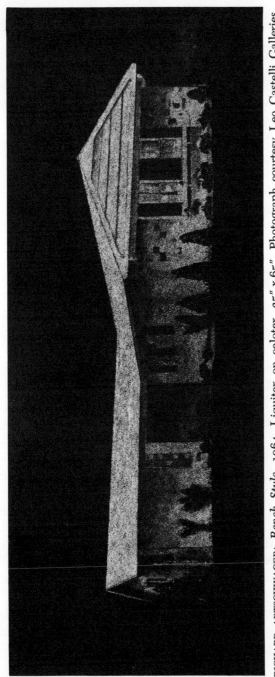

RICHARD ARTSCHWAGER: *Ranch Style*. 1964. Liquitex on celotex. 25″ x 65″. Photograph courtesy Leo Castelli Galleries, New York.

recent paintings of objects and places may reawaken us to the dormant joys of observation.

A particular hierarchy of common objects and familiar places in our landscape compels itself into the native artistic sensibility with powerful insistence. The paintings that issue from this odd relationship to manufactured forms are born both of the natural amazement of the true aesthetic spirit and of a specific need to identify the innocuous and vicious icons of the materialistic glut. Because the object is still sovereign in the West (and will become so in the East), the only way to defeat, comprehend, or savor it is to depict it.

> The objects tingle and the spectator
> Moves with the objects. But the spectator
> Also moves with lesser things, with things
> Exteriorized out of rigid realists.

A surprising number of modern, intelligent painters, fully awake to the various prevailing art movements, have been identified as Radical Realists, as they have been tactfully termed by Udo Kultermann of Missouri. What the Radical Realists have in common is a precisionist painting technique equal, if not superior, to that of any American painter to date. They use photographs as source material in the majority of cases, both for convenience and because the photograph is, in itself, frequently the dominant concern. The image *is* the focus; there is a sense of detachment or noninvolvement with the melancholy or distasteful subject. The avoidance of "self expression" is something they share with the Pop and Minimalist movements, and it represents a further step in the evolution of this uniquely American and profound artistic concept.

Richard Artschwager's paintings derive directly from topical photographs in the shabbiest of printed media and preserve the grainy and textural character of the photo while projecting the image in all its dreariness. The artist began such works over a decade ago, but they were first seen during the ascendancy of the Pop movement when

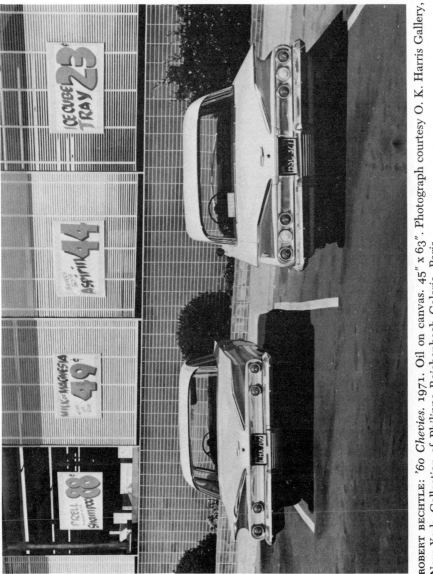

ROBERT BECHTLE: '60 Chevies. 1971. Oil on canvas. 45" x 63". Photograph courtesy O. K. Harris Gallery, New York. Collection of Philippe Reichenbach Galerie, Paris.

ROBERT COTTINGHAM: *Roxy*. 1971. Oil on canvas. 6½″ x 6½″. Photograph courtesy O. K. Harris Gallery, New York. Collection of Saul Steinberg.

they were largely ignored or assigned a borderline place in that ideology. Malcolm Morley connects the development of his systematized realism to the inspiration of the Artschwager works, although Morley emphasizes process over imagery or photostyle. However, his employment of brutal, cliché-laden source material negated, in its mindless efficacy, the concerted objective of system-demonstration. Artschwager has continued the development of his black-and-white translations while Morley has abandoned the precisionist appearance for clearly visible gesturing, contesting the echoes of historic styles in visible proof of his intentions.

The categorical clarity in the works of Richard Estes and Ralph Goings may be taken for what it seems: totally noninterpretative, matter-of-fact transpositions of 35 mm. color slides ". . . untouched by trope or deviation." The photograph intercedes between the subject and the act of describing it and serves to cancel "content" and emotional response. Estes will be related and compared to Hopper with whom he may eventually be equal. Both concern themselves with "secondary" sights: anonymous facades and static atmosphere, a strictly American regalia. Estes' shadowy figures interact among his places and objects and have no "presence" as in Hopper. The *Subway Car* painting commands an existential emptiness and may never win nostalgia. The Radical Realists gainsay nostalgia, but they cannot avoid it. Native places and objects are inundated by the force of American time. The forties and the fifties, the "Dark Ages of Design," may already be fathomed for their dismal stamp and style. The thirties are ancient in this landscape. Nothing manufactured or depicted can hover in our climate, but recedes with violent quickness. We enlarge a decade into a century, perhaps to compensate for a brevity of history or, as the British do with their monarchs, remember dimly, so that the past may be endearing.

Ralph Goings, from Sacramento, paints pickup trucks, franchised hamburger stands, and silly-looking California banks. Some of the trucks are the latest models and they gleam arrogantly in the Sacramento sun. Next season they will be new only in the painting. And in

twenty years, assuming their durability as art, they will be perfect antique pickup trucks and the sentiment will thicken. Hence the process of nostalgia. Goings and Estes prove again that the place or object, no matter how mean, when vividly proclaimed begets a larger meaning. It's a democratic triumph. All things become equal in both their power and vacuity, like a flag without a nation.

Richard McLean and Robert Bechtle work at opposite ends of Radical Realist antiphilosophy. Established in a divided studio space in downtown Oakland, McLean concerns himself with clearly sentimental subjects to achieve a consummate brutalism while Bechtle deals with the cruelest, most unexpressive objects and locations to convey some subtle intimations of emotion. McLean invents his Kodachrome from out of the deadly black-and-white photos in national horse monthlies—magazines dedicated to breeding and showmanship, with illustrations of the specimens, their owners, trainers, stables, and equipage. Horses are not the artist's heritage and he professes not to love them. It's the photos he adores (Wouwermans might weep), it's these he fanatically transmits, and it's hard to see the joy in the undertaking for the average of two months it takes to finish such a work. It must be in the aftermath. No distinctly Californian traits are available in McLean except, perhaps, for the wonder of the sunlight.

Indeed, the Radical Realists work in a national rather than a regional style. Goings' pickups, Estes' facades, and Artschwager's photos indicate places but there is no geographic signature. Bechtle identifies his landscape; houses with Hispanic tendencies and palm trees, it must be California. But the landscape is the background for his autos, usually unglamorous and grave, whose manufacture might best be divined by teen-age boys and autophiles. They are parked on side streets, driveways, and deserted parking lots; the substance of solitude is projected by their bulk and their stance and their aging more than their kineticism.

Bechtle, unlike McLean, does not avoid involvement in his subject. This is apparent. But the anointment of feeling does not despoil the uninterpreted, inviolate existence of the icon.

JOHN KACERE: *D. Froley.* 1972. Oil on canvas. 60½" x 78½". Photograph courtesy O. K. Harris Gallery, New York. Collection of G. Gilles.

This is the crucial separation that the Radical Realists achieve from the "studio" realists whose relation to their subject is the very issue of their art, and from present-day abstract painting, which is still concerned with "inspiration" and poetic effect and which often avoids or negates, as do most of the Conceptualists, in their literary ego-voice, forms outside the intellect, the holy realm of visual experience.

John Salt paints the rotting, rusting hulks of derelict automobiles. The subject is not a discovery or revelation. The artists of Assemblage—Stankiewicz, Follett, Rauschenberg, Chamberlain, Tinguely in his desperate machines—trenchantly describe the qualities of industrial refuse in sculptural forms. The work was mainly expressionistic, which was implicit in the materials employed, while it closely related to the painting of the period. John Salt, working from photographs, can elude the expressionistic aggression of the carcass-cars and deal with them as emblems. The "expressive" element is nominal; an "atmosphere" establishes a tone for each painting and bestows a personality on the wreck portrayed. The selection of subject or photograph is an act of conviction undertaken to satisfy the philosophy of no-conviction; a circumstantial evidence of seeing that does not prove involvement or belief: neutralism as against nihilism.

The procedural delitescence of Goings, McLean, and Estes is accomplished through frontality, while in the works of Robert Cottingham blatant compositional devices are employed for almost theatrical effect. The artist works with the lettering and shapes of advertising signs, the 1950s pomposity style, of which the regulation neon frontispiece of a Holiday Inn is prima facie testimony. The soul of such vulgarity is difficult to husk and needs to be outflanked. The lettering, fragmented and acutely poised, is the strategy. The message comes, apparent, glorious, and drab. But it has no final meaning. There is only the fact of materiality: neon tubes and plastic, daylight, shadow, and therefore the passage of time. ". . . Of dense investiture, with luminous vassals."

RICHARD MC LEAN: *Mr. Fairsocks.* 1973. Oil on canvas. 63″ x 63″. Photograph courtesy O. K. Harris Gallery, New York. Collection of Paul and Camille Hoffman.

In the paintings of Stephen Posen and John Kacere virtuosity is not dissimulated and the realist territory expands and grows ambiguous. Posen constructs sculptural reliefs of variously textured fabrics, finished "process" sculptures in their own right, and then sets about the heroic task of depicting them in two dimensions. There are no shortcuts possible. The patience of the Orient is a requisite along with the Occidental imagination to conceive of such a scheme: monumental still lifes that are never *nature-morte*. The object is made into an emblem representing nothing but itself: an abstract/realist conniption. Simply as an exercise in tactility it would have given Bernard Berenson a chill. Art must be superior to moon travel. The thrill is everlasting and there is no record of it having made anyone exclaim that he felt like a bird.

John Kacere probably discovered that all art is a "return of the repressed" (Mondrian's fantasy was order), and that his fabulous fixation, the semiclothed posterior portion of the human female, need not be buried in abstraction (or Maoist coveralls) to attain a feasible modernism. Kacere has the reactionary gall to work from live models, although his paintings show no "studio" situation or posturing, and the model would find it a strenuous endeavor to prove she was there. The artist's passionate concern is with the fit of filmy fabric against a supple skin, and the focused figure portion is resolved without point of reference, or homage to true scale. Jean Leering describes this spatial dilemma and fragmenting as Relativating Realism and he includes the late Domenico Gnoli, Stephen Posen, and John Kacere in this category. Thus he begins to point up inconsistencies in a unified idiom among the Radical Realists, something that should occur as more incisive analysis of their work begins. American artists do not assemble to agree on aesthetic principles or to write a manifesto. Singular identity is a point of pride. Of the leading so-called Abstract Expressionists only de Kooning, Pollock, and Still were both abstract and expressionistic and none was consistently either. What the Pop artists share more than commercial and common imagery is an attitude

JOHN SALT: *Pontiac with Tree Trunk.* 1973. Oil on canvas. 42″ x 60″. Photograph courtesy O. K. Harris Gallery, New York. Collection of William Jaeger.

of "coolness" and fascinated neutralism in their work, qualities inherited by the Minimalists and, as has been suggested, the Radical Realists. Artists may retain their "fated eccentricity" and experience their age and their environment in similar perspective, and this perspective may constitute what we can call a movement.

Charles Close paints astonishing photo-realistic portraits of "interesting" people. This is the antithesis of Radical Realist concerns and would seem to place the artist among a very small number of effective portrait painters. Yet this work may be taken as a transmission of photographic information in which he would be continuing the Radical Realist adventure. But since an expression of his intentions does not always accord with an artist's production, only time and evidence will help describe the situation.

A number of painters of unequivocal technical ability and admirable patience enliven the spectrum of hyperrealism without clearly participating in the point of view described. Audrey Flack paints European shrines with a rich admixture of devotion, irony, and calm detachment. Ron Kleemann proposes fierce juxtapositions of industrial and vehicular elements. Paul Sarkisian has embarked on a treatise on the American Porch that has resulted in several monumental paintings describing its mystifying agglomerations with obvious affection. A distinctly separate kind of climate may evolve in the paintings of Maxwell Hendler, a California wizard whose life's production may never equal Ryder's but whose near-miniature works looked outstanding at the recent, dismal potpourri of realists at the Whitney Museum of American Art in New York. Don Eddy is remarkably productive in the face of his involvement with the substance and reflective character of automobile surfaces, though the works seem unphilosophically soulless, which is a hazard of virtuosity. Yet in Noel Mahaffey's depictions of hideous cities, the motive of mining vacuity is manifest.

Hence the ripe tomato. Those who enjoy the multifarious textures of all artistic expression with malice toward none may see the simple necessity for a precise imagery at this time and this place, and thrill

in wonderment at how much, and in how many ways, there still is to behold.

Let's see the very thing and nothing else
Let's see it with the hottest fire of sight
Burn everything not part of it to ash.

THE DEDUCTIVE IMAGE*

J Patrice Marandel

"From an informational point of view painted images have too much to compete with . . ." explains J. Patrice Marandel. For this reason "Today's painters' aim has changed; they cannot discover reality any longer. Their subjects are photographs . . ." Thus today's realists are consistent with recent realizations concerning the authority of the flat picture plane. The Super Realist paintings are paintings of images that are already flat. Marandel observes that Super Realist artists do not attempt a trompe-l'oeil manner.

 This article was written in response to a broad survey of realist art, presented at the Whitney Museum of American Art in 1970, that included works by some artists not usually identified with the new school. In confronting the unique properties of today's real-

* Reprinted from *Art International*, Vol. XV/7 (September 1971).

ism, Marandel observes, "If they truly were realists, not only would their works be unnecessary but also essays such as this . . ."

Mainly, the Super Realists are involved in a deductive process. According to Marandel they generally start with a photograph and then ". . . reverse the process and reduce the amount of information first given." He concludes: "What is left out of the picture is then almost as important as what is put in. The result is a deductive image." *Thus instead of adding to what he sees, the Super Realist subtracts.*

Among the painters discussed by Marandel are John Clem Clarke, Ralph Goings, Richard McLean, Chuck Close, and Malcolm Morley. The author notes that some of Morley's color works are framed by a white stripe. "The white border bears to the central image the same relation as the frame to the original painting . . ." Thus Ivan Karp's observation that ". . . Morley emphasizes process over imagery" is recalled.

J. Patrice Marandel is Chief Curator of the Museum of Art at the Rhode Island School of Design in Providence. He was Focillon Fellow at Yale University and has written for several European and American art journals.

During the past four or five years, a fairly coherent group of figurative painters has been shown in various exhibitions across the United States. The most recent, to my knowledge, and also the most catholic was the one organized by James Monte at the Whitney Museum of American Art in 1970. The selection of twenty-two names included artists such as William Bailey, Jack Beal, Harold Bruder, Richard Estes, Arthur Elias, Philip Pearlstein, Richard McLean, Robert Bechtle, John Clem Clarke, and Chuck Close, to name only a few to illustrate the diversity of the choice. Many attempts had been made previously (notably by Sidney Tillim and Gabriel Laderman, who were included in the show) to clarify the situation of recent realist painting. However, their categorizations—no matter how clear—never

led curators to organize a sharply focused show of figurative artists. The situation of these painters in relation to each other as well as to modernist painting in general is certainly one of the most precarious to define. The word *realism* itself, employed frequently in connection with these artists, does not help to simplify the problem. It brings to mind a tradition that not only goes back to Courbet and other nineteenth-century painters but also to Le Nain—namely a tradition of "naturalist" painting, deeply involved in social values. These are lacking in the work of the new generation. A reference to Courbet is legitimate if one remembers what this artist wrote at the beginning of his *Realist Manifesto* (1855): "The title of Realist was thrust upon me just as the title of Romantic was imposed upon the men of 1830. Titles have never given a true idea of things: if it were otherwise, the works would be unnecessary." [1] This remark is also accurate for the younger generation of figurative painters; called "realists" by most critics and writers, they are somehow prisoners of this label. If they truly were realists, not only would their works be unnecessary but also essays such as this, for finally the question amounts to: What is realism?

This group of painters has also occasionally been called the "new academicians." The ambiguity of the term leads to an interesting point. For centuries, academism has designated a certain form of art as taught in official art schools or "academies," where the emphasis was upon drawing, perspective, and the imitation of an idealized nature. Realist movements have always been in conflict with them (even if not a truly realist painter, Caravaggio's choice of common life subjects set him in sharp contrast with the Carracci, originators of the academies; and Courbet's debates with official Salon painters are famous). Artists involved with realist theories had in the past not only a proclivity to represent daily-life subjects but also a tendency to paint in a "coarse" and "rough" manner unusual with academicians. The reality of the subject corresponded in a way to the literality of

[1] Quoted by Linda Nochlin in *Realism and Tradition in Art 1848–1900* (Englewood Cliffs, N.J.: Prentice-Hall, Inc., 1966), p. 33.

JOHN CLEM CLARKE: *Judgment of Paris*. 1970. Oil on canvas. 79″ x 108″. Photograph courtesy O. K. Harris Gallery, New York.

the raw material. For having reintroduced an exact readability of their subjects, the new realists are called new academicians, which is, historically speaking, either a contradiction or an emptying of these appellations of their usual content. This nevertheless stresses the fact that designations such as academicians or realists are totally meaningless without reference to a (contemporary) context. In other words, figurative painting today can be fully understood only against the background of modern painting.

At this point an important difference between what is shown and how it is painted must be underlined. It has been often said that New Realists use "cool" subjects with no literary reference. This is not entirely true. They clearly refuse the evocative associations of other figurative painters, such as the Surrealists, but the use of a subject itself forces their work into categories—figure painting, landscape, still life—which have antecedents. The genre of painting rather than its subject becomes the element that allows references and comparisons.

In his recent paintings, John Clem Clarke places contemporary people in a classical setting, making it obvious that the crucial point is not, say, the story of Lady Godiva or the Judgment of Paris, but their relation to previous representations of the subject. In the same way, a nude by William Bailey recalls quite explicitly Ingres' and Paul Wiesenfeld's Intimist interiors, Bonnard and Vuillard. If the genre gives these paintings their historical dimension, their style relates them to the latest developments of modern painting.

Reviving such genres as portraits, still life, interiors, it is noticeable that no painter uses a trompe-l'oeil manner. Trompe-l'oeil is essentially an old-fashioned way to approach art and the picture plane. The illusion of a third dimension on a flat surface has been the aim of artists since the Hellenistic period. Pliny tells the story of how Zeuxis was able to fool the birds, which came to peck the grapes he had represented. Such an illusionism is today outdated or reserved to marginal areas of the visual arts dealing with experimentation and

new media (holograms). On the contrary, new figurative painters have been influenced by the recent devices of abstract art: enlargement or distortion of the scale, flatness of the surface, straightforward recognition of the painting as a picture, wholeness of the image, all of which forbid the beholder to take what is shown for real.

Although their use of it is anything but the same, most of the new figurative painters employ the photograph as a starting point. That is to say the image they begin with is an *exact* reproduction of their subject. Whereas the traditional (classical) artist had to transfer what he perceived through a mental process to the canvas, mimesis becomes literal in the case of certain figurative painters who blow up the image they want to work with to a screenlike canvas. The process that traditionally led to the final image carried more and more information through its different stages. Take the example of any Baroque ceiling: the painter first started with a sketch—or a series of sketches—showing the general idea of the composition; colors and expression could be added in a painted study or bozzetto; the ceiling finally brought to full light and scale the information gathered in the previous forms of the work. Starting from a photograph, today's painter reverses the process and reduces the amount of information first given. What is left out of the picture is then almost as important as what is put in. The result is a *deductive image.*

Inaccuracies and ambiguities are, as a matter of fact, crucial factors in the perceiving of these works. Ernst Gombrich has noticed that all representational paintings are based on an "etc. principle," which allows the painter to show less because the beholder knows more and can project the end of a pictorial series when he recognizes its beginning. John Salt's crashed-car pictures rely mostly on this principle. In their details, they are unfinished paintings. A few details carefully carried out are enough to give the illusion that the whole painting is equally complete.

John Clem Clarke and Malcolm Morley work from color reproductions of old masters. In both cases, a white stripe differentiates the representation from the picture plane and makes us aware of the

RICHARD MC LEAN: *Miss Paulo's 45*. 1972. Oil on canvas. 60½″ x 60½″. Photograph courtesy O. K. Harris Gallery, New York. Collection of Sidney and Frances Lewis.

reality of the image. The white border bears to the central image the same relation as the frame to the original painting, namely it makes the picture exist as a representation totally separate from its context and designates the center of attention. In the case of Clarke, inadequacies are brought to the canvas through a series of techniques that involve drawing (a blown-up image), stenciling, and spraying. Such an elaborate and unorthodox technique can only bring to the viewer that information and an experience highly differentiated from the one that originated the image. Not only can the different techniques be mentally reconstructed but we are also made conscious of a long series of ambivalences: the ones between the original painting and its model, the color reproduction and the original painting, the new representation and the reproduction. This accumulation of removals does not somehow compensate the original ones but reinforces them as much as it modifies them. The ultimate ambiguity concerns the photograph of such a work, which would provide a new and legitimate state of it, itself opening up more serial possibilities. The "etc. principle" does not occur in Clarke's work as a mental restitution of what is actually missing in the picture (for it has its own very strong existence) but as a way of reference to the original.

In Clarke's paintings, however, variations remain rigorously within certain limits. Images, for instance, are never combined and differences depend mostly on color changes (as clearly stated in the series on Copley's *Gov. and Mrs. Thomas Miffin*). Lowell Nesbitt paints directly on the canvas—that is, without using a projector—in an almost old master technique. His model, a photograph, is squared, each rectangle being reported to the canvas. Changes happen within each one according to "classical" rules of composition. It is interesting, for example, to compare a painting like *New York Ruin with Tire* with the photograph that originated it. Changes occur first in the conception of space. In the painting it has been somehow telescoped and flattened. Illusionistic devices are even lessened by the use of a monotone gray, which also stresses that the painting is above all a representation of a black-and-white photograph, not of a real landscape. The change of spatial

perception depends greatly on other changes that would be unnoticed were the painting not compared to its "subject." Nesbitt's images are probably *less* deductive than those of many of his colleagues. In point of fact it would be more accurate to say that their meaning lies in a friction between a multiplication of elements (not existing in the original) and their pictorial simplification. Heavy, almost expressionist brushstrokes, quite unlike the cool, minute manner of most figurative painters today, emphasize the imaginary quality of the work.

Imagination is totally different in the meticulous renderings of photographs by Richard McLean or Ralph Goings. In both cases the paintings are like those games in which an image seems to be impeccable, but in fact bears recognizable errors. Ralph Goings paints trucks, airplanes, deserted airports. His imagery is one of the coolest of these painters, for no human feeling can be detected. However, everything is in order. Cars are parked next to each other, every object is where it belongs, and one feels rather at ease in front of these quiet undisturbed landscapes painted in candylike hues. The care with which Goings' pictures are executed requires an equally careful attention and reading from the beholder. Very much like Salt, Goings focuses on only a few points of the surface. In *Blue GMC* for instance, the upper part of the representation is evenly painted, but the most painterly care is given to the rendering of the reflections in the window or the shine on the truck's fender. Imagination's role in Goings' pictures is a mental (optical) process that allows the eye to transfer to less "finished" parts of the picture the preciseness of others.

Looking at Richard McLean's pictures of jockeys on horseback, it is almost impossible to hark back to the subject. Unlike others, McLean works from a posed photograph, which is already a formalization of reality. Sharp "Hollywoodian" colors create a further estrangement, and curiously modernist devices such as flattening the surface and paralleling the foreground and the background compositional images are annihilated by the hieratic frontality of the faces. Despite the cool seriality of his work, McLean alone among the new painters introduces the more "psychological" elements. Through the

MALCOLM MORLEY: *New York Foldout.* 1972. Oil/canvas and resin. 357″ x 72″. Photograph courtesy Stefanotty Gallery, New York.

color process, the photograph is artificially made alive. The correctness of the rendering is only apparent; the image bears to reality the same relationship as a movie to "real" life, for, in this case, the more accurate the picture seems, the more imaginative it is.

Reflections in figurative art have a long tradition from fifteenth-century Flemish painting to Ingres' portraits of Madame Moitessier or Madame de Senonnes to Manet's *Bar des Folies-Bergères*. Richard Estes paints store windows that, like Jan Van Eyck mirrors, reflect scenes and objects the viewer couldn't be otherwise aware of. When we actually look into a street store window, we automatically cancel out reflections in order to see what's in the window. Estes forces us to look into the store window in order to see not what is in front of us but what is behind us. The reflecting surface represented is parallel and identical to the paintings and we are made conscious of it, in a work like *Store Front* by the delicate lettering on the left part of the canvas. Estes' paintings are not super-real, as they have been called, but rather supra-real, since he adds more glass and polished reflective surfaces to the slide he's working from. Estes however paints more *surfaces* than things in it and his paintings, in order to "work," are also simplifications. He shows a maximum of objects in the simplest way. Focusing what is to be reflected on the reflecting surface is the most important process on which the illusion will depend. Unlike Ralph Goings' only partly reflecting surfaces, Estes' have an allover distribution. Reflections are everywhere, although distorted reflections of reflections make it unclear from where they originate. Estes' paintings are not unequivocal and their interest does not come from their "reality" but from this uncertainty of what, where, and how things are represented.

Subject matter is the least important aspect of modern figurative painting and if it is impossible to deal on an iconographic basis with these painters, it is however easy to regroup those whose work is concerned with the human figure. Both Chuck Close and Alfred Leslie deal with evenness of information. Chuck Close translates as accurately as possible the information given by a photograph. His images are

JOHN SALT: *Chevy in Green Fields*. 1973. Oil on canvas. 49" x 72". Photograph courtesy O. K. Harris Gallery, New York. Collection of Galerie de Gestlo, Hamburg.

gigantic, painted in black and white, evenly detailed. Working from a photograph, he uses a "frozen" image, somehow more objective because he doesn't allow himself to refer to the model. Close doesn't go beyond the photograph to the original. His realism depends only from the translation of a photograph to paint and canvas. The evenness of his work is objective. It comes from the camera's record and not from a deliberate choice. He said: "[The camera] can't make any hierarchical decisions about a nose being more important than a cheek." The same could be said of Alfred Leslie's also huge portraits. The same attention and an equal amount of information are paid to every detail but since Leslie doesn't use a preexisting image, the equality of the different parts is not an objective, mechanical fact but a rigorous choice. No feeling of depth can be detected in Leslie's pictures and the estrangement sensed in front of them comes from an unorthodox manipulation of perspective. The large scale forces the spectator to discover the painting slowly, area after area. The same process is also true for Close, but there the eye focuses "normally" on the different parts. Leslie forces us, on the contrary, to focus "evenly" on them, each part being painted at eye level.

The reason that painting today cannot be the pursuit of a real image has something to do with the quality of the artist's experience of reality. From an informational point of view painted images have too much to compete with: photographs, movies—not to speak of other ways to measure real phenomena—give a quicker and more straightforward answer to information questions. When painters discovered perspective, they were ahead of their time. Painting was an experiment as valuable as science. Today's painters' aim has changed: They cannot discover reality any longer. Their subjects are photographs, illusions, or, as with Estes, reflections.

THE CLOSEUP VISION*

Cindy Nemser

In this essay Cindy Nemser discusses a major characteristic of much Super Realist art—the closeup, detailed view that frequently is only a small part of a larger whole. Nemser traces the history of "closeup" views in art, beginning with Roman mural painting and into the twentieth century when ". . . the camera brought the closeup vision into ascendancy."

Works by a number of Super Realist artists, including Audrey Flack, Joseph Raffael, Janet Fish, and Lois Dodd, are cited in this article. Nemser's view of realist art involving closeup vision allows for a broad and flexible delimitation of the new style, which tolerates consideration of some artists not usually associated with Super Realist painting.

Cindy Nemser is contributing editor for Arts Magazine *and*

* Reprinted from *Arts Magazine*, Vol. 46, No. 7 (May 1972).

JANET FISH: *Five Calves Foot Jelly*. 1971. Oil on canvas. 30" x 60". Photograph courtesy Kornblee Gallery, New York.

editor of The Feminist Art Journal. *She has written for* Art in America, The Art Journal *and* Arts Magazine *and is working on a book about women artists of the twentieth century.*

Every object rightly seen, unlocks a
new faculty of the soul.
 RALPH WALDO EMERSON.

The urge to get up close, to zero in, to examine details and fragments has manifested itself repeatedly throughout the history of painting. It has also profoundly influenced the recently developed art of photography. Frequently, it has both revealed a need and a reverence for the immediate material world and an awareness of its essentially spirited nature.

Today this closeup of the realistically presented image is the link that connects a large number of stylistically and iconographically diverse artists. Photo realists, such as Chuck Close and Joseph Raffael, straight representationalists, such as Sylvia Sleigh and Donald Nice and painterly realists, such as Janet Fish and Lois Dodd, all share this preoccupation with the up-front point of view. Painters of fruits, vegetables, plants, people, objects, interiors, and exteriors all concentrate on either the isolation of one small fragment of the total milieu, inspecting minutely one or more small items in their entirety, or focus, by extreme enlargement, on one segment of an object or group of objects.

At first glance, one would assume that these artists had derived their closeup vision exclusively from the photographers, particularly Edward Weston, Paul Strand, and Alfred Stieglitz. Indeed, the photographic techniques of these masters certainly influenced the painters under discussion. Yet, as we press backward through art-historical time, we discover that the closeup representational view has roots that stretch back to Roman art.

In the Roman mural decorations from the Villa of Livia at Primaporta, c. 20 B.C., we are presented with a delightful garden

segment, realistically articulated and located within an arm's length of our vision. In a wall painting from Herculaneum, c. A.D. 50, we discover an acutely observed still life of peaches and a glass jar deposited on a simulated niche and brought right up to the beholder's gaze. Portrait busts painted on wooden panels in the Roman style, produced in the Faiyum districts in lower Egypt, present the viewer with a truncated image located immediately on the picture plane.

The object observed close up does not reappear again in Western art until the seventeenth century, but it does turn up in the literal style of the "Fur and Feathers" painting of the Northern Sung period in China. In *Parakeet on a Blossoming Pear Branch*, painted by a follower of the Emperor Hui Tsung, c. 1101–1126, the artist has focused on a single section of living nature, realistically analyzed it, and magnified it to almost larger than life size. Then, by placing it on the picture plane of his silken ground, he has projected this vital slice of nature into the spectator's space.

It is interesting to note that this closeup illusionistic frontal view of various environmental segments has, so far, appeared in cultures where great value is placed upon the material aspects of life. Though both the Romans of the early empire and the Chinese of the Northern Sung court were religious, their spiritual beliefs did not prevent them from reveling in the world of the senses. Leisured, protected, affluent, they could afford to meditate on the purely aesthetic side of the natural and the man-made, eventually discovering the spiritual in both.

It would seem that peaceful abundance is a prerequisite for this type of focused-in vantage point in painting, therefore it is not sur-prising that this fragmented, closeup vision of the actual world should reappear once more in the economically secure, object-oriented culture of the middle-class Dutch and Flemish burghers. By selecting objects such as flowers, fruits, decorative pieces, eating utensils, etc., from the more comprehensive, religious interior scenes of early Flemish painters such as Jan van Eyck and carefully arranging them into closely observed, up-front images, the Dutch artists of the seventeenth century created the still-life category. With the help of the newly discovered

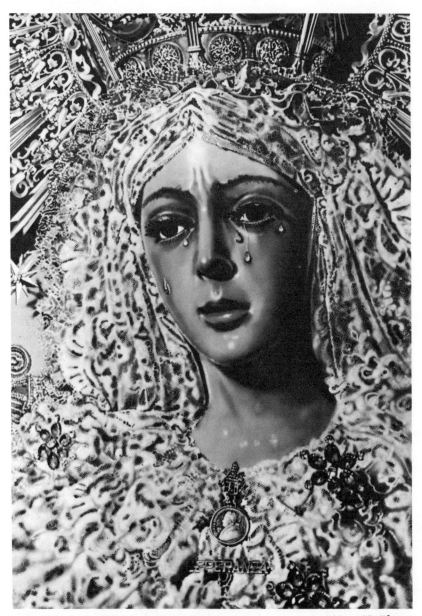

AUDREY FLACK: *Macarena Esperanza*. 1971. Oil on canvas. 66″ x 46″. Photograph courtesy French & Company, New York.

microscope, these Hollanders were able to scrutinize, with great accuracy, the small plants and creatures around them. At the same time, they drew on the older Netherlandish tradition of disguised symbolism that imbued all natural and material objects with a deep spiritual intensity. For example, in such flower paintings as those by Jan Davidszoon de Heem and Willem van Aelst, among many others, there are strong connotations of transcendence; these artists knew that flowers symbolized the brevity of life.

This tendency to discover spiritual symbolism in the isolated aspects of natural and material phenomena is part of our American art inheritance too. In the nineteenth century, Martin J. Heade and John J. Audubon, drawing upon the biological sciences and the transcendental thinking of Emerson and Thoreau, singled out small sections of bird and plant life and painted them parallel to the picture plane for our intimate, detailed inspection. Nature, as seen by these artists, was a revelation of the invisible essence of the divine being. Flowers, with their inevitable cycle of bud, bloom, decay were viewed as paradigms of vitalism; birds, winged messengers of the gods, symbolized freedom. Later on in the century, continuing in this spiritual mode, the closely examined trompe-l'oeil still life arrangements of William Harnett and John Peto fairly jump out into the viewer's space, reiterating the existential "thereness" of the everyday object.

Then, in the twentieth century, the camera brought the closeup vision into ascendancy. The photographer has no choice but to deal with the reality of the world, but he must come to it piecemeal, because the camera is only able to deal with one segment of the environment at a time. Therefore he holds these fragments up for our intimate inspection and, according to John Szarkowski, in *The Photographer's Eye*, "the compelling clarity with which a photograph recorded the trivial suggested that the subject had never before been properly seen, that it was, in fact, perhaps *not* trivial, but filled with undiscovered meaning. If photographs could not be read as stories, they could be

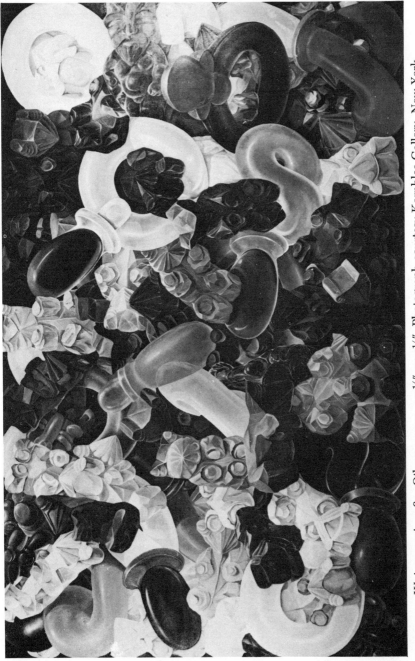

KAY KURT: *Weingummi*. 1969. Oil on canvas. 59⅛" x 94½". Photograph courtesy Kornblee Gallery, New York.

read as symbols."[1] Studying the amazingly articulated portrait, flower, and landscape details of such masters as Stieglitz, Strand, and Weston, it is hard to deny the spiritual essence of their objectness.

Georgia O'Keeffe, responding, as did many other painters, to these photographic revelations, understood the significance of the enlarged closeup point of view, especially in her flower paintings. She made her blossoms big, frontally faced, and right on the surface of her canvas. As Lloyd Goodrich wrote in his catalogue of O'Keeffe's 1970 exhibition: "The flower became a world in itself, a microcosm. Magnification was another kind of abstraction, of separating the object from ordinary reality, and endowing it with a life of its own."[2]

The closeup, realistically constructed images of our contemporary representational artists share an iconography as well as a vantage point with the paintings and photographs of the past. Whatever their subject, these artists focus in on the essential spiritual oneness of all material matter. There is, indeed, a connection between the magnified section of the human physiognomy of Chuck Close, Joseph Raffael, Sylvia Sleigh, and Audrey Flack, the enlarged up-front fragments of interior and exterior views of the house as seen by Sylvia Mangold, Yvonne Jacquette, Cecile Gray Bazelon, and Lois Dodd, and the monumental fruits and flowers of Buffie Johnson and Lowell Nesbitt, among others. These artists seem to have understood the relationship between the human body, the house, and the universe. As Mircea Eliade writes in *The Sacred and the Profane:* "His [man's] dwelling is a microcosm; and so too is his body. The homology house-body-cosmos presents itself very early."[3]

In harmony with this spiritual outlook, Raffael's gigantic blowups of the facial segments of different species of animals and different races of men comes out of his knowledge that all things are part of

[1] John Szarkowski, *The Photographer's Eye* (New York: The Museum of Modern Art, 1966), p. 8.
[2] Lloyd Goodrich and Doris Bry, *Georgia O'Keeffe* (New York: Whitney Museum of American Art, 1970), p. 18.
[3] Mircea Eliade, *The Sacred and the Profane*, trans. Willard R. Trask (New York: Harcourt, Brace & World, Inc., 1957), p. 172.

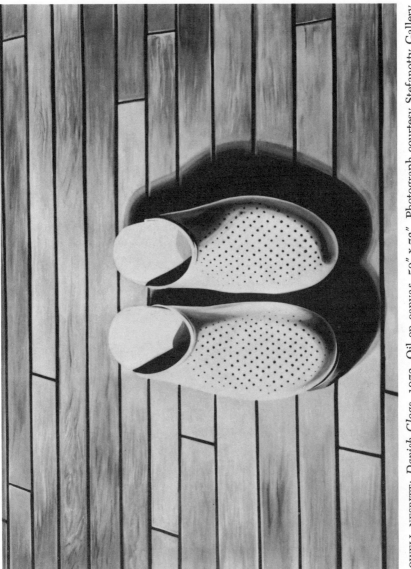

LOWELL NESBITT: *Danish Clogs*. 1973. Oil on canvas. 50″ x 72″. Photograph courtesy Stefanotty Gallery, New York.

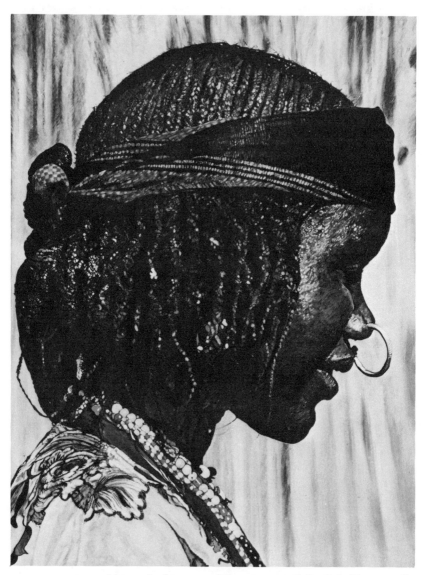

JOSEPH RAFFAEL: *African Lady.* 1971. Oil on canvas. 80″ x 60″. Photograph courtesy Nancy Hoffman Gallery, New York.

each other and all are part of the universe. He says: "I feel that every bit of anything has its own life, its own worth and value. Therefore I treat it all with equal love, equal life-exchange and I know it's all the same, therefore I give it equal attention." [4] Chuck Close's mammoth photographlike portraits, imitating with spray paint the four-color separation techniques of the color print, are transformed through magnification into gigantic topological maps exploring the nature of human matter and revealing man's basic relationship with the other material essences. Close has made contemporary icons out of mortal flesh.

On the other hand, Audrey Flack's large-scaled, photograph-inspired close-up of the head of Louisa Roldan's seventeenth-century wood carving of the *Macarena Esperanza* gives a new spiritual meaning to a sacred object of the past. Her rendition of the divine Virgin, descendant of the great mother goddesses, germinator of all flora and fauna, reminds us afresh of the religious connection between all sorts of matter. The triple-headed portrait of Philip Golub is by Sylvia Sleigh, which is not larger than life, yet is monumental because of the nearness of its location to the viewer's space, also has its origin in spiritual themes. The three views of the boy, each appearing to grow out of the other, can be traced back through Christian culture to the trinity images of ancient Rome.[5]

Moving from the human body to the human dwelling, with its many ornaments and utensils as well as its various sections of interior and exterior space, we observe Sylvia Mangold's huge, painstakingly detailed depictions of a stretch of parquet floor, Susan Crile's sensuously draped carpet segments, and Wayne Thiebaud's lusciously painted, oversized groups of household and workshop objects. The interior and exterior window views of Yvonne Jacquette, Cecile Baze-

[4] Joseph Raffael, unpublished letter to Cindy Nemser, February 22, 1972.
[5] Its specific source is the three-headed sculpture of the *Personification of Prudence* by Antonio Rossellino at the Victoria and Albert Museum in London.

lon, and Lois Dodd, culled out of the context of the larger environment for our intimate contemplation, can be seen as metaphors for the spiritual exits through which human beings pass from their earthly dwellings into the universe. Interestingly enough, these three artists correlate their use of brushstroke with their iconography. The painterly style of Jacquette and Dodd is in harmony with their window vistas and reflections. Jacquette gives us views of sky and clouds, the natural veils of the hidden God, whereas Dodd's window reflects sunlight and tree shadows, elements that are perfectly in tune with her open painterliness. In contrast, Bazelon's window views, revealing concrete architectural edifices, are more fittingly rendered in a flat architectonic manner.

As we travel back and forth from the world of man to the world of nature, the closeup vision continues to emphasize the spiritual unity of all things. Echoes of the disguised symbolism of the Dutch still-life paintings are apparent, though not always consciously intended. Lowell Nesbitt and Ruth Gray, through the techniques of cropping, magnification, and frontality, create intimate portraits of the iris, the sacred flower long associated with the divine mother goddess, the Virgin. Peter Dechar is obsessed with mammoth, sensuously modeled pears, which in Christian iconography are symbolic of Christ's love for mankind.[6] Marianne Greenstone's hydrangeas, Henry Koehler's artichokes, and Rory McEwen's mushrooms are not associated with any specific symbolism; yet each of these painters handles his/her subjects with loving reverence, painstakingly depicting every line and curve so that each magnified, up-front image embodies an essence beyond its immediate reality. Although modern man has lost much of his religious experience of nature, one cannot help but agree with Mircea Eliade who writes: "nature still exhibits a charm, a mystery, a majesty in which it is possible to decipher traces of ancient religious values."[7] Certainly there is a mysterious element in the representations of

[6] George Ferguson, *Signs and Symbols in Christian Art* (New York: Oxford University Press, 1966), pp. 32, 36.
[7] Eliade, *op. cit.*, p. 151.

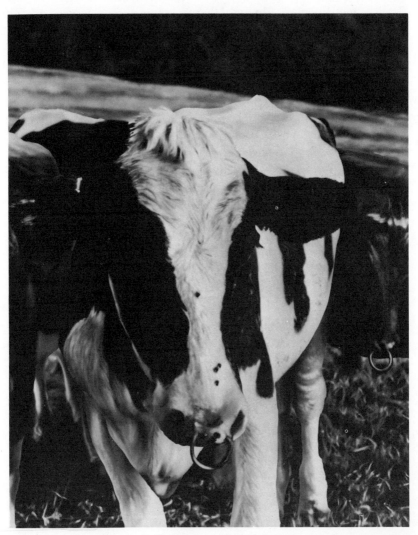

BEN SCHONZEIT: *Dairy Bull* (*without horns*). 1972. Acrylic on canvas. 60" x 42". Photograph courtesy Nancy Hoffman Gallery, New York.

Dechar and Koehler. Through the techniques of enlargement and cropping, their bulging, close-viewed forms seem to metamorphose, to escape into something strange, new, bigger than themselves. Bachelard comments on this phenomenon in the *Poetics of Space.* "When a familiar image grows to the dimensions of the sky, one is suddenly struck by the impression that, correlatively, familiar objects become miniatures of a world." [8]

Living plants as well as cut flowers and plucked fruit, when sectioned and observed as through a magnifying glass, especially retain the vitalist spirit of both the Sung parakeet paintings and the later, Eastern-influenced transcendental depictions of Heade and Audubon. As Benjamin Rowland, in his book *Art in the East and West,* points out,

> still life in the Far East cannot properly be described by the western term *Nature morte* with its implication of a collection of objects dead or inanimate, since such arrangements in Chinese and Japanese painting are, in a sense, as much alive as the most lifelike figure subject with the same suggestion of growth and articulation. [9]

Janet Alling, Rudy Burckhardt, and Anton Van Dalen are among the painters who present us with this same kind of closeup living image of the plant in nature. By taking a detail of the total organism and placing it right on the canvas surface, these artists cause the image to jut out at the viewer, encouraging him to contemplate the essential elements of its particular structure. In Alling's and Burckhardt's smaller paintings the sumptuous, lush, painterly strokes simultaneously add the experience of the materiality of paint to the viewer's experience of nature. On the other hand, in the huge Van Dalen image the linear, heavily shaded patterns provide a different kind of existential sensation.

In contrast, Janet Fish, Don Nice, Ben Schonzeit, and Kay Kurt present us with images of packaged fruits and synthetic foods. These

[8] Gaston Bachelard, *Poetics of Space,* trans. Maria Jolas (Boston: Beacon Press, 1964), p. 169.
[9] Benjamin Rowland, *Art in the East and West* (Boston: Harvard University Press, 1954), p. 134.

contemporary representations are closer to the early Roman and later Dutch concepts of the still life with their artificial arrangements and individual concern for accurate illusionistic portrayal of isolated objects. Yet there is a great vitality to be discovered in their packaged, processed goods. While these artists comment on the commercialism and plasticity of daily life, they also honestly acknowledge its attractiveness by means of selective enlargement of detail and large-scaled frontality. We discover through their closeup vantage point that light hitting the surface of translucent materials, such as glass, cellophane, or gelatin, can spur an artist on to breathtaking depictions comparable to those inspired by the unspoiled products of nature. There is an affinity here with the existential presence endowed by Harnett and Peto in the nineteenth century upon the inert things of everyday experience. These minutely observed objects, despite their exaggerated size and closeup placement, do not threaten or overwhelm us. Rather they give us succor, for they reveal that beneath the artificial, the commercial, the despoiled, there is still the organic, the essential, the eternal.

With their magnified, closeup visions of the exquisite realities of both the natural and the man-made, the representational artists discussed in this essay are reminding us of the beautiful gifts we are so negligently squandering. Drawing on the bounties of our leisured affluent society, they invite us, through contemplation, to experience the oneness of all things and to understand that our material possessions are as essential a part of ourselves as is nature and our fellowmen.

SOME WOMEN REALISTS*

Linda Nochlin

Linda Nochlin describes artists like Sylvia Mangold, Yvonne Jacquette, and Janet Fish as pictorial phenomenologists, and finds their subject matter either metonymic or synecdochic. Although she emphasizes women realist artists in this article, she warns against reading feminine attitudes into their art.

The author is credited with having written the first critical essay pertaining to Super Realist art, in 1968. That essay, "Realism Now," appears elsewhere in this book.

Women artists have turned to realism since the nineteenth century, through force of circumstance if not through inclination. Cut off from access to the high realm of History Painting, with its rigorous demands of anatomy and perspective, its idealized classical or religious subjects,

* Reprinted from *Arts Magazine* (February 1974).

its grand scale, and its man-sized rewards of prestige and money, women turned to more accessible fields of endeavor: to portraits, still life, and genre painting, the depiction of everyday life, realism's chosen arena.

Like the realist novel—another area in which women have been permitted to exercise their talents since the nineteenth century—genre painting, and realist art generally, have been thought to afford a more direct reflection of the woman artist's specifically feminine concerns than abstract or idealized art, because of the accessibility of its language. Yet one must be as wary of reading "feminine" attitudes in, or into, realist works as into abstract paintings. While being a woman—like being an American or being a dwarf or having been born in 1900 rather than in 1940—may be a variable, even an important variable, in the creation of the artwork, little can be predicted on its basis. That a given artist is a woman constitutes a necessary but by no means a sufficient condition of her choice of a given style or subject: it is one element along with others, like her nationality, her age, her training, her temperament, her response to available modes of expression, or her priorities of self-identification.

For the woman realist, like the woman artist in general, the sense of the creative self *as* a woman may play a greater or a lesser role in the formulation of pictorial imagery. In the past few years, with the rise of a powerful and articulate women's movement, this sense of conscious feminine identification has become a more dominant factor in the work of many women artists, who have begun to define themselves more concretely *as* women, and to identify their feelings and interests with those of other women in the realms of art and politics, and in their private realms of imagination as well.

It is, of course, difficult to separate unconscious or half-conscious motives from conscious intentions in the choice of a given realist motif or vantage point. Does a woman choose to depict her living-room floor, the Virgin of the Macarena, or mothers and children, rather than trucks, motorcycles, and pinups out of the conscious feminist principles, or the promptings of the unconscious, or because such material is familiar to

her and easily available, or for a combination of such reasons? To what extent does the depiction of closeup, large-scale views of fruit or flowers, a fairly popular motif among current women realists, depend on some sort of archetypal imprinting of the female psyche, and to what extent on the fact that a major woman artist, Georgia O'Keeffe, made such imagery her trademark? To what degree should realist works be read as iconological symbols—that is, conveyors of unconsciously or semiconsciously held attitudes or ideas and, more specifically, as conveyors of unequivocally feminine world views? These issues all come into play in a consideration of the work of some women realists.

I. SOCIAL REALISM

To a nineteenth-century English genre painter like Emily Osborn, realism (with a small r), if she thought about it at all, meant what it did to most of her contemporaries and has continued to mean to most of the public ever since: subject matter from the contemporary world; a tone that is didactic and moralizing; and a style that is clear, representational, and often richly detailed in its delineation of locale, type, and situation.

Osborn surely must be considered a protofeminist artist: her major works deal with the problems facing the women of her time: *The Governess*, exhibited at the Royal Academy in 1860 and bought by Queen Victoria herself constituted a bitter pictorial indictment of the "practice of treating educated women as if they were menial servants," to borrow the words of a contemporary reviewer; other works, like *For the Last Time, Half the World Knows Not How the Other Half Lives,* or *God's Acre* touch on timely issues of poverty and social oppression, specifically as they affect the lives of women. Her best-known work, *Nameless and Friendless,* is one of the rare nineteenth-century paintings to deal directly with the lot of the woman artist.

It is a painting that was meant to be read and interpreted rather than to be appreciated for its not inconsiderable visual qualities

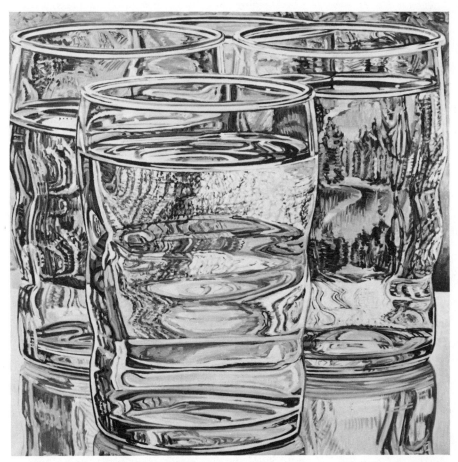

JANET FISH: *Skowhegan Water Glasses.* 1973. Oil on canvas. 40″ x 42″. Photograph courtesy Kornblee Gallery, New York.

alone. Such a work necessarily employed some of the strategies of the novel, the theatre, or the sociological treatise to achieve its ends, and often seems to prophesy the silent film in its emphasis on accurate, significant detail and meaningful gesture. Yet it is wrong to dismiss such examples of Victorian realism as *Nameless and Friendless* as merely "photographic" or "literary" simply because they do not accord with today's established canons of pictorial decorum. They should, on the contrary, be considered a different but equally legitimate and viable mode of visual structure and expression. While it is richly detailed and full of social and psychological information, a work like *Nameless and Friendless* is paradoxically not at all photographic, in the way the work of many present-day realists may be said to be so. Victorian narrative painting, in the complexity of its organization, the explicitness of its social and moral implications, and its dramatically meaningful condensations is at the farthest pole of expression, in its approach to the raw material of experience, from the diffidence and objectivity characteristic of the photographic sensibility. Osborn's work, rather than constituting an apparently random slice through time, like a photographic image, is a carefully constructed palimpsest of significant temporal incidents from which a complex message may be distilled.

Such a didactic and socially meaningful type of realist expression has had its adherents among women artists of the twentieth century. In our own country, during the 1930s, the art programs of the New Deal offered an opportunity to artists of both sexes to create works that commented on the social issues of the day, and that were located on the walls of those public institutions where their messages might reach an appropriate public. In several cases, women artists working on government-sponsored commissions took the opportunity to comment, in large-scale wall paintings, on those social issues that particularly concerned women or in which women constituted the critical motif.

Such was the case in Lucienne Bloch's ambitious mural, now lost, for the Women's House of Detention in New York, of 1936. Bloch

chose a theme relevant to the female audience—the cycle of a woman's life—and placed it in a context familiar to the women prisoners, a city playground in a working-class district. A certain didactic overtone is perceptible in the iconography, in that black and white children mingle and share toys and food while their mothers chat companionably; an unintentionally darker note is struck by the fact that a cityscape of factories, skyscrapers, and gas tanks quite literally closes off the horizon. Bloch was quite straightforward about her attempt to program social significance and utility into her art: first of all, she felt that the prison context itself created "a crying need for bright colors and bold curves to offset [the] drabness and austerity." Second, she wanted to combat the inmates' suspicion of art "as something highbrow . . . severed from the people and placed upon a pedestal for the privilege of museum students, art patrons, and art dealers" by relating her own work to their lives as closely as possible. "Since they were women and for the most part products of poverty and slums, I chose the only subject which would not be foreign to them—children —framed in a New York landscape of the most ordinary kind." Finally, the artist discovered that her actual presence when making the mural had a quite concrete, if not traditionally aesthetic, impact on the women inmates: ". . . They wholeheartedly enjoyed watching me paint. The mural was not a foreign thing to them. In fact, in the inmates' make-believe moments, the children in the mural were adopted and named." [1]

The social idealism and public concern of the New Deal even made its impact on such a private and idiosyncratic realist style as that of Florine Stettheimer. Her *Cathedrals of Wall Street* of 1939, one of a series of cathedrals of New York, is a loving but subversive homage to Eleanor Roosevelt, who occupies center stage, elegant in Eleanor blue, with Mayor LaGuardia dancing attendance and Franklin relegated to inanimate glory as a sort of pantocrator on the flattened

[1] Lucienne Bloch, "Murals for Use," *Art for the Millions: Essays from the 1930's by Artists and Administrators of the WPA Federal Art Project,* ed. Francis V. O'Connor (Greenwich, Conn.: New York Graphic Society, 1973), pp. 76–77.

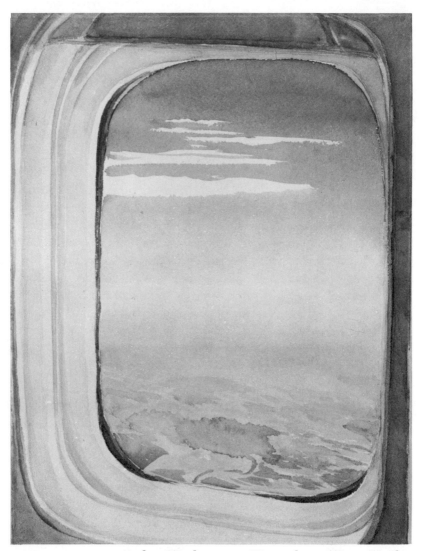

YVONNE JACQUETTE: *Airplane Window.* 1973. Watercolor. 23½″ x 17½″. Photograph courtesy Fischbach Gallery, New York.

white-and-gold facade of the Stock Exchange Building, flanked by a gorgeous golden George Washington. This record of democratic pageantry is couched in a language of such lighthearted decorative prolixity that it deftly undermines, at the same time that it reflects, the more pompous and pretentious large-scale monuments of social significance of the time.

Interestingly enough, many of the women artists who choose to comment on the social issues of the day in their art at the present moment—May Stevens comes to mind, or Faith Ringgold—tend to turn to more abstract or decorative pictorial languages, perhaps feeling that social concern or political protest are more forcefully conveyed by symbolic rather than descriptive means today.

II. EVOCATIVE REALISM

What Cindy Nemser has called "the closeup vision"—"the urge to get up close, to zero in, to examine details and fragments"—has played a major role in the imagery of many contemporary women realists.[2] This kind of realism is at a far remove from the social variety, with its emphasis on the concrete verities of setting and situation.

It was, of course, a woman artist, Georgia O'Keeffe, who first severed the minutely depicted object—shell, flower, skull, pelvis—from its moorings in a justifying space or setting, and freed it to exist, vastly magnified, as a surface manifestation of something other (and somehow deeper, both literally and figuratively) than its physical reality on the canvas. One can think of the work of O'Keeffe and of such contemporary painters of relatively large-scaled, centralized, up-front realistic images of fruit, flowers, or seed-pods as Buffie Johnson, Nancy Ellison, or Ruth Gray as "symbolic" in their realism as long as we are very explicit about the nature of the symbolism involved.

O'Keeffe's *Black Iris* of 1927, like Ruth Gray's iris in *Midnight Flower* of 1972, or Nancy Ellison's cut pear in *Opening* of 1970, or

[2] Cindy Nemser, "The Closeup Vision—Representational Art, Part II," *Arts Magazine*, Vol. 46, No. 7 (May 1972), p. 44. Also printed in this book.

Buffie Johnson's *Pomegranate* of 1972, is a hallucinatingly accurate image of a plant form at the same time that it constitutes a striking natural symbol of the female genitalia or reproductive organs.

The kind of symbolism implicit in these women's imagery, O'Keeffe's iris, for example, is radically different from that of more traditional symbolism, like the so-called hidden symbolism of the fifteenth-century Flemish realists.[3] In the case of the latter, the depicted object—the "vehicle" of the pictorial metaphor, to borrow a term from literary criticism—refers to some abstract quality, shared by itself and the subject, or "tenor" of the metaphor, which it serves to convey. The irises in the vase in the foreground of Hugo van der Goes's *Portinari Altarpiece,* far from being sexual symbols, refer to the future sorrow of the Virgin at the Passion of Christ. The significance may have been suggested by the notion of the sword-shaped leaves of the flower "piercing the Virgin's heart," an implication made even more obvious in the name of the closely related gladiolus, which is derived from the Latin word for sword. But the meaning of the flower is hardly visually self-evident. In the older work, the symbolic relation between the minutely rendered irises and the abstract suffering of the Virgin obviously depends on a shared context of meaning—the iconography of the Nativity: it is something the spectator is supposed to know, not something that strikes him or her the minute he or she sees the flower in its vase.

In O'Keeffe's *Black Iris* or Gray's *Midnight Flower,* on the contrary, the connection "iris–female genitalia" is immediate: it is not so much that one stands for the other, but rather that the two meanings are almost interchangeable. The analogy is based not on a shared abstract quality, but rather upon a morphological similarity between the physical structure of the flower and that of woman's sexual organs—hence on a visual, concrete similarity rather than on an abstract, contextually stipulated relation. In the same way, Johnson's pomegranate suggests woman as a fruitful being—it is morphologically

[3] See Goran Hermeren, *Representation and Meaning in the Visual Arts,* "Lund Studies in Philosophy. I" (Lund, 1969), pp. 77–101, for an excellent discussion of iconographical symbolism, including the hidden variety.

similar to the uterus; the richness of female fecundity: the seeds well up from inside the pomegranate; and her reproductive expandability: the fruit splits under the pressure of its own ripeness—without ever being anything other than a carefully observed and described, if large-scale, pomegranate. (The fruit's mythological significance in the story of Proserpina may or may not play a role in the metaphorical significance of the work, but knowledge of the myth is certainly not essential to our response to its other implications.)

Such morphological metaphors were particularly attractive to the Surrealists, for they tend to be apprehended intuitively rather than to depend on previous information, to make their appeal on the level of fantasy and imagination, perhaps even of unconscious association, rather than to the intellect. As such, they lend themselves admirably to that imagery of metamorphosis on which the Surrealists relied to upset the uneasy boundaries between thing and thing, substance and substance, perception and hallucination or dream. Yet neither O'Keeffe's, Johnson's, nor Ellison's work can be considered "surreal." Their images are simply realist analogues, suggesting and evoking a feminine content—realist images suspended in a suggestive void. If a contemporary artist puts the iris back into a context, O'Keeffe's suggestive aura still plays its role: an interesting, witty new set of implications accrues to the flower in Carolyn Schock's *The Iris* of 1972. Now the irises, desexed and casual, have been put back into a still-life setting of deliberate artifice, like a studio setup; but the feminist implications of O'Keeffe's iris as icon are nicely made into a dilemma by situating the vase between a (masculine?) hammer and a (feminine?) fan. The artist has at once de-sacralized and the same time reactivated the feminist, or feminine, implications of the flower.

III. LITERAL OR THING-IN-ITSELF REALISM

Some women realists today are distinguished precisely because of their choice of unevocative motifs. Artists like Sylvia Mangold, Yvonne Jacquette, Susan Crile, or Janet Fish are really pictorial

phenomenologists. In their awareness of the picture surface, their concern with scale, measurement, space, or interval, their cool, urban tone, their often assertive and sometimes decorative textures, they tend to affirm the artwork as a literal fact which, while it may have its referent in the actual world, nevertheless achieves its true effectiveness in direct visual experience, not evocation. Certainly, their subjects— floors, windows, ceilings, rugs, jars, bottles—count for something, but for what? Perhaps these are better considered motifs rather than subjects, but with none of the arty overtones that have accrued to this term since the nineteenth century. The images of these painters, neither symbolic, metaphoric, nor suggestive, are, in the rhetoric of pure realism either metonymic—one thing next to another thing next to another—or synecdochical—a part of something standing for a larger whole.

Janet Fish, with her battalions of jars, honeypots, glasses, and bottles, traffics in the objecthood of ordinary transparent containers. Their mass-produced curves, their patient, coarse-grained refractions, their elegant or graceless labels are simply there, on the shelf or table, with no heartaches. What, after all, can one Coke bottle remind you of besides another Coke bottle? If, in confronting the human figure, the realist artist or certain photographers, as Susan Sontag has recently suggested, somehow violates an implicit moral sanction by coolly transforming human subjects into visual objects, Janet Fish, the painter of glassware or packaged supermarket fruit, need face no such accusation. If anything, through over life-sized scale and attentive handling, she confers an unprecedented dignity upon the grouped jelly jars or wine bottles that she renders with such deference. The glassy fruit- or liquid-filled volumes confront us with the hypnotic solemnity of the processional mosaics at Ravenna, and with a similar, faceted, surface sparkle.

Sylvia Mangold, in an oeuvre at once austere and profligate, has devoted herself to exhaustive probing of the phenomenology of the floor: one would guess it is the floor of her own apartment. No photograph would care so much, could be as ostentatiously lavish

MARIANN MILLER: *Women on Beach.* 1973. Acrylic on canvas. 50″ x 72″.
Photograph courtesy Stefanotty Gallery, New York.

in its documentation as this dedicated artist; not Walker Evans, not James Agee in his poignant litany to walls and floors and shingles in *Let Us Now Praise Famous Men*, not even Nathalie Sarraute in her thirty-page contemplation of the environs of a doorknob at the beginning of *La Planetarium*, goes farther than Sylvia Mangold in *Floor II*. "Bareness and space (and spacing) are so difficult and seem to me of such greatness that I shall not even try to write seriously or fully of them," [4] says Agee in *Let Us Now Praise Famous Men*— although of course he has been doing just that all along. Mangold might have said much the same thing, but without the final demur. The floor for Mangold is an absolute, its limits not the horizon but the actual boundaries of the canvas itself. In *Floor with Clothes* this surface is interrupted by the gratuitous spatial markers of dropped clothing: the ordinary, stretched to a hypothetical infinity, is measured by carefully delineated, brutally shapeless, exquisitely individuated castoffs.

In 1968, when Mangold created *Floor II*, within the context of dominant hard-edge abstraction, color-field, and Pop, what did it mean to paint a floor with methodical seriousness—straight? What was—and is—the significance of such a choice (*not such a subject*), of such a procedure? Although the painting may look simple, the reasons for its being the way it is or for its being at all are probably not. It is both related to and, at the same time, constitutes a subversion of the abstract art of the time. Of course, the very existence of nonrelational abstraction gave the artist permission to consider something as *nebbish* as a stretch of floor a plausible motif. But if *Floor II* is at once absolutely pure of conventional meaning or "content," like an abstract motif, at the same time it is a representation of an irrevocably concrete *gegeben* out there: it is appropriation, not invention. *Floor's* challenge of abstraction is vividly demonstrated by the identification of the *recession* of the floor with the *surface* of the canvas. Are we looking through or at the picture plane? And from where?

[4] James Agee and Walker Evans, *Let Us Now Praise Famous Men* (Boston: Houghton Mifflin Company, 1960 [orig. pub. 1939 and 1940]), p. 55.

Mangold's mode of approach is a detachment so passionate that, taken as a state of mind, it might well be considered obsession. Her mood may find antecedents in the methodological obsessiveness of certain Surrealists like Max Ernst in his wood-grain *frottages* or René Magritte in that deadpan literalism of texture particularly characteristic of his wood surfaces. But the Surrealists' textural obsessions were always located in a supportive setting of ambiguity or hysteria: they were not simply direct statements of how it is if you look down at the living-room floor for a long time, with or without the help of a photograph. Very sixties, perhaps, is that sense of an intensely personal vantage point that is at the same time very cool and noncommittal. If *Floor II* is antipoetic and antievocative, it is also a reminder that there is such a thing as a deliberately antipoetic poetry, and that the innovative force of the French New Novel, which tried to use prose to erase its own significance, reached its zenith in the sixties. The extraordinarily muted yet rapier-sharp realist imagery of an artist like Vija Celmins offers, perhaps, the best parallel with Robbe-Grillet's attempt to abolish significance in literature: is her *Eraser* of 1970 a sly reference to the French writer's *Les Gommes,* as well as being a self-evident Pink Pearl by Eberhard Faber and nothing more?

Nothing but what is, the thing in itself: that seems to be what Mangold is after. Floors have always been *in* paintings. Jan van Eyck and Ingres seem to have enjoyed them, and the nineteenth-century realist, Gustave Caillebotte, was positively gaga about one in his prophetically literal, high-horizoned *Floor-Scrapers* of 1875, but they have always been a background incident in the work, not, as in Mangold's paintings, the whole subject of it.

But, by implication, Mangold's floor must be part of a larger whole, too: the orthogonals must meet somewhere. The feminine variable, a single strand in the weaving together of possible intentions and motivations, may be worth considering in this larger context, the world beyond the floor. If a woman is hemmed in by the domestic scene, if floors, toys, and laundry are her daily fare, she can still turn adversity into advantage, constructing out of the meanest, most

neglected aspects of experience an imagery horizonless and claustro-
phobic, yes, but concrete, present, unchallengeable in its verisimilitude.
The very mode of approach—part by part, methodical, a little at a
time, like folding the laundry, like knitting, like *cleaning* a floor very,
very carefully, as opposed, say, to the explosive spontaneity, the
allover conquest of a Pollock—has its roots in a social reality. Someone
said of Jean Chardin in the eighteenth century: "Nothing humiliates
his brush"; in the twentieth century we have to go farther to search
out that nothing, and it is *her* brush that is not humiliated; or perhaps
creates a triumph of self-imposed humility.

Yvonne Jacquette did a floor, *The James Bond Car Painting*, in
1967. Here, the domestic vantage point is more explicitly spelled out,
the dimensions of quotidian reality measured out by an overflowing
wastebasket, the bottom of a desk, the foot of a music stand, a toy
train, and the James Bond car itself. The painting was part of a series
concerning space between objects, according to the artist, and this
issue of spaces between things has continued to inspire Jacquette in
an art of greater range but perhaps lesser intensity than that of
Mangold. For Jacquette, space is a function of glimpses—up, out,
down, around—of clouds through windows, of light fixtures on ceilings,
of a fraction of shingled barn against the sky. This is not the move-
ment-suggesting Impressionist glimpse of the fleeting moment, but
the casting of a colder, more fixative eye. Once again, one is tempted
to view these diffident cutoff views as synecdoches standing for a
larger whole: women may be stuck with glimpses for their visual
nourishment, yet the pictorial tensions generated by the interplay
between space and the things that interrupt its freedom are, after all,
what makes art interesting or what makes art art; and this is the
case whether the space in question is the living-room floor and the
interruption the children's toys, or the space is that of the Sistine
Ceiling and the interruption the hand of God.

THEORY AND CRITICISM

Part II

EXISTENTIAL VS. HUMANIST REALISM*

Linda Chase

In her discussion of the existentialist orientation of the Super Realism school, Linda Chase detects a "clash of underlying philosophy" confronting traditional figurative art and the newer type of realism.

It appears that the Super Realist painter is engaged in a reevaluation of the traditions of art and the role of the artist. However, that is always the aim of authentically new art. In the case of the new art under discussion, the reevaluation takes the form of acceptance and objective treatment of subject matter that, more often than not, is noteworthy for its banality.

This "banality" has been noted by the art dealer Ivan Karp who complains that some Super Realist art is not nearly banal enough. Chase does not disagree. She observes: "The fact is, the

* "Existential vs. Humanist Realism" is a section of *Photo Realism* (New York: Eminent Publications, 1975).

modern world offers an incredibly fascinating and diverse array of visual information . . . ," the banality is not of the artist's doing. Rather, "the New Realist is extremely committed to his morality of impersonal observation and unsparing factuality."

Linda Chase has published articles in Art in America, Arts Magazine, *and* Opus. *She is author of the text for* L'Hyperrealisme Americain, *published in France in 1973, and was guest director of the American Section of the 11th Tokyo Biennale in 1974.*

To describe things, as a matter of fact, is deliberately to place oneself outside them, confronting them. It is no longer a matter of appropriating them to oneself, of projecting anything onto them. Posited, from the start, as *not being man* they remain constantly out of reach and are, ultimately, neither comprehended in a natural alliance nor recovered by suffering. To limit oneself to description is obviously to reject all other modes of approaching the object.

ALAIN ROBBE-GRILLET, *For a New Novel* [1]

In the fall of 1971, New York art dealer Ivan Karp, employing Udo Kultermann's term, gave a lecture on *Radical Realism* to a gathering of realist painters at the Alliance for Social Progress on East Broadway. The dominance of first abstract, then Pop, Minimal, and Conceptual art since the 1950s had created difficulties for representational artists, and one might have expected them to welcome this new form of realism that was already pumping lifeblood into their cause and that might even help to open some of the doors modernism had closed in their faces. Instead, slides of Ralph Goings' pickup trucks, Richard McLean's horses, Robert Bechtle's suburban cars, and Richard Estes' chrome and glass buildings were met with cries of "obscene" and "pornography." The audience's outrage was clear and shocking.

"If it looks so much like a photograph, why paint it?" and "What's the difference between that and the photograph?"—these were the foremost questions of the evening, occurring, with slight variations, over and over. Obviously the studio realists objected to the Photo Realists' use of the photograph and to the photographic look of the

[1] All quotations from Robbe-Grillet are taken from Alain Robbe-Grillet, *For a New Novel: Essays on Fiction* (New York: Books for Libraries, Inc., 1965).

TOM BLACKWELL: *Triple Carburetor "GTO."* 1972. Oil on canvas. 78″ x 96″. Courtesy Allan Stone Galleries, Inc., New York.

work. The cool objectivity Karp was lauding was to them a repugnant lack of involvement with the subject, and the smooth, almost inhumanly accurate rendering represented, not a triumph of style, but an accumulation of slick devices. Far more than distaste, however, this invective expressed fear, the fear manifested in all pleas for censorship. The choice of words was apt: nothing that is irrelevant can ever be pornographic. The work of the Photo Realists was perceived as a threat by those traditional realists who sensed that the very premises of their art were being questioned.

It was not an evening for clarifying issues. Tempers ran too hot, and Karp's position as a dealer for almost all of the artists whose work was shown alienated him from his audience. Mistrusting his motives for defending the work, they dismissed his answers out of hand, and he, with what must have seemed to them the smugness of the goose that laid the golden egg, contented himself with clever repartee that tended to increase, rather than to elucidate, the conflict. But it was an exciting evening; an evening during which it became abundantly clear that something important was happening. An art form that could engender that much outrage, indeed, that much feeling of any kind, in another group of artists had to be significant.

As Leo Steinberg points out in his superb essay on the difficulty of confronting innovative art, "Contemporary Art and the Plight of Its Public," artists are always the first and loudest in their denunciations of anything truly new and original in art. When Matisse's *The Joy of Life* scandalized people in 1906, the angriest of all was Paul Signac. A modern painter and member of the avant-garde himself, he nevertheless asserted that Matisse had "gone to the dogs" and, calling the color in the painting disgusting, said it was reminiscent of the "shop fronts of the merchants of paint, varnishes, and household goods." But only a year later Matisse attacked Picasso's new painting *Les Demoiselles d'Avignon,* calling it an outrage and claiming that Picasso had painted it to ridicule the modern movement. And these incidents, as Steinberg asserts, are far from unusual.

"Contemporary art," he concludes, "is constantly inviting us to

applaud the destruction of values which we still cherish, while the positive cause, for the sake of which the sacrifices are made, is rarely made clear." [2] Artists have the greatest investment in the values being destroyed and react accordingly.

In attacking the photographic aspect of the work, the studio realists were instinctively reaching the heart of the matter. Photo Realism is fundamentally different from traditional forms of realism, and the photograph is central to that difference. It is both symptom and cause. The Photo Realist has altered the artist's relationship to the subject matter, and the use of the photograph both registers this change and helps to achieve it.

The Photo Realist replaces the artist's personal interpretative vision with the recording of visual fact; he replaces the subjectivity of the artist's eye with the objectivity of the camera's lens. This subjectivity is the cherished value (to use Steinberg's terminology) that Photo Realism requires its public to sacrifice and it is precisely what the studio realist can least afford to relinquish, because it represents the essence of his art.

In a group discussion that took place in the summer of 1973 between Robert Bechtle, Ralph Goings, Paul Staiger and Richard McLean, Robert Bechtle, using Wayne Thiebaud as an example, stated that the studio realist

> is really interested in the difference between the marks he can make on paper, even though he's trying to be very accurate with it, and the thing itself. The subtle distinctions that occur between what goes on paper and what actually exists there. He's interested in that difference and I think we're not. We try to eliminate that difference as much as possible and resort to the camera to do it.

Ralph Goings went on to point out that the camera is necessarily inimical to such an artist because "it bypasses the very thing which is really the heart of his interest."

[2] Leo Steinberg, "Contemporary Art and the Plight of Its Public," *The New Art: A Critical Anthology*, ed. Gregory Battcock (New York: Dutton Paperbacks, 1966), pp. 7–37.

TOM BLACKWELL: *Bleecker Street Bike*. 1973. Oil on canvas.
75¾″ x 48½″. Photograph courtesy the artist.

The difference between a traditional realist work and a Photo Realist painting may appear to be stylistic, but the clash between them runs much deeper—it is a clash of underlying philosophy. What is at stake, what is always at stake when a new form of art presents itself, is the definition of art.

Until the advent of Photo Realism the art in representational painting lay precisely in the dialectic between the object being portrayed and the human perception of it. Even so-called objective realisms—Constable attempting to capture the "laws of nature" or the Impressionists seeking to capture the effects of light—were dealing with individual perceptions of reality rather than with reality itself.

When he said, in 1858, that the antithesis of realism in art "is not Idealism but Falsism," G. H. Lewis could have been speaking for today's Photo Realists. But, although the nineteenth-century realists spoke of achieving a "styleless style," the paintings of Courbet, Monet, Manet, and Degas are filled with personal stylization and references, conscious and unconscious, to the conventions of classical and romantic painting.

The necessity of translating reality onto a two-dimensional plane involves the artist in choices that can never be completely objective. As Bechtle's comment shows, the Photo Realist uses the photograph to circumvent these choices. Although the nineteenth-century realists gained inspiration and often source material from the new and popular art of photography, they were not ready to relinquish the role of the artist as arbiter of reality.

Art, like religion, has been a process of man re-creating the world in his own image. The underlying assumption of representational painting has been that the value of an image as material for art lies not in itself but in the artist. The central ingredient has not been the subject of a painting but man's relationship to it.

In modern illusionist painting, the value of subject matter has been in the artist's use of it for the exploration of artistic problems. Philip Pearlstein, for example, often erroneously placed with the Photo Realists under the sometimes ambiguously used title of New

Realism, is painting not figures, but figures translated into problems of volume on a flat plane, and their reality, that is, the sense of their humanness, is marginal. The compromising of the illusion is not only an inevitable result of his modernist concerns, it is necessary so that he can allow himself to paint a recognizable image. As a modernist painter, he is only allowing the illusion in order to compromise it. Pearlstein's art represents an exceedingly cold, but nevertheless, extremely personal idiosyncratic vision.

Photo Realism does not deny man's right to interpretation or the importance of personal artistic vision, but it does assert categorically that the artist's interpretation does not equal the object depicted—a Thiebaud piece of pie is not so much pie as it is Thiebaud.

"What a painter inquires into," wrote E. H. Gombrich in *Art and Illusion*, "is not the nature of the physical world, but the nature of our reactions to it." [3] Descriptive art has sought not to reveal things themselves but to reveal their inner truth, their meaning for humanity. Realism has devalued reality.

> We had thought to control it [the world around us] by assigning it a meaning. . . . But this was merely an illusory simplification; and far from becoming clearer and closer because of it, the world has only, little by little, lost all its life. . . .

As Robbe-Grillet so clearly saw, an empty chair may be indicative of an absent person, but to see it as such is to eliminate the possibility of seeing the chair as itself. Metaphor and symbolism have a valid function in art, but the need to appropriate reality to man, to see everything in human terms has resulted in a romantic anthropomorphism that clouds our perception of real things. As long as the objects that surround us are seen solely as repositories of meaning, they can never be perceived as they truly are:

> Objectivity in the ordinary sense of the word—total impersonality of observation—is all too obviously an illusion. But *freedom* of observation

[3] E. H. Gombrich, *Art and Illusion* (Princeton, N.J.: Princeton University Press, 1960), p. 49.

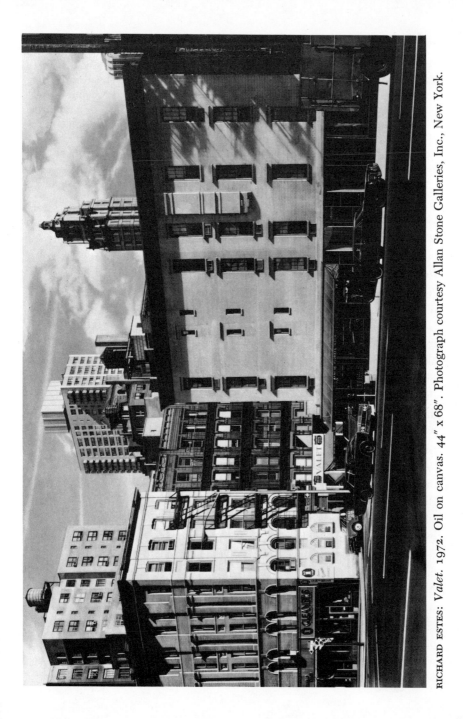

RICHARD ESTES: *Valet.* 1972. Oil on canvas. 44″ x 68″. Photograph courtesy Allan Stone Galleries, Inc., New York.

should be possible, and yet it is not. At every moment, a continuous fringe of culture (psychology, ethics, metaphysics, etc.) is added to things, giving them a less alien aspect, one that is more comprehensible, more reassuring. Sometimes the camouflage is complete: a gesture vanishes from our mind, supplanted by the emotions which supposedly produced it, and we remember a landscape as austere or calm without being able to evoke a single outline, a single determining element. . . .

Instead of this universe of "signification" (psychological, social, functional), we must try, then, to construct a world both more solid and more immediate. Let it be first of all by their *presence* that objects and gestures reveal themselves. . . .

ROBBE-GRILLET

What is at issue is not man's interpretative faculty but the irrefutable existence of reality outside of and distinct from that faculty: "the world *is*, quite simply. That in any case, is the most remarkable thing about it" (Robbe-Grillet).

The positive cause for which the Photo Realist is asking us to relinquish our ideal of personal transmogrification is a renewed and clarified perception of reality. Through his painstaking adherence to photographic detail, the Photo Realist painter is seeking to re-value things, and though it may appear that he is de-valuing the traditions of art and the role of the artist in doing so, it should be clear that he is rather reevaluating these in terms of his particular historical position.

Existentialism defined for us, in the fifties, what had already become a universal experience. Albert Camus called it "the absurd"— the confrontation between the human need and "the unreasonable silence of the world." Search as we might for a meaning for our existence, we could neither posit one convincingly (God, alas, did not create us in his own image) nor conveniently cease to exist. Jean-Paul Sartre summed it up neatly in his phrase "existence before essence." All things, including man, exist prior to and outside of any meaning we might assign to them. And that of course is the key, we *assign* a meaning in order to cope with our own irrational existence and that of our universe. But this assigning of meanings has gotten out of hand while the true meaning, the *presence* of things, has been obscured.

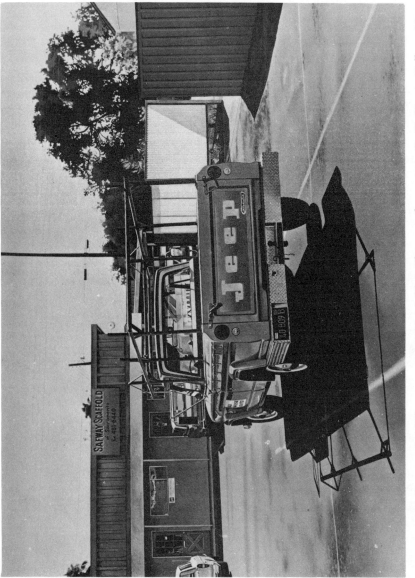

RALPH GOINGS: *Jeep.* 1969. Oil on canvas. 43⅞" x 61⅞₁₆". Photograph courtesy O. K. Harris Gallery, New York. Collection of Galerie des 4 Mouvements, Paris.

The impetus behind Robbe-Grillet's *nouveau roman* and Photo Realist painting is the same. The only way to affirm the concrete reality of the subject matter is to render it with as little distortion and personal overlay as possible: "an explanation can only be *in excess* when confronted with the presence of things."

Robbe-Grillet not only shares a philosophical stance with the Photo Realists, but he has also been influential in its development. Ralph Goings, one of the central figures in the movement, has described his reading of *The Voyeur* as a contributing factor in the transition to his present super-cool Photo Realist style. Goings was particularly struck by the passage in which the protagonist, Mathias, recalls sitting at a table as a child and drawing a seagull that was perched outside the window. Mathias remembers not what he felt, but the grain of the wood, the sheen of the wax, and the precise color of the bird's feathers. It is not surprising that a painter would be struck by this passage since Robbe-Grillet's precise, analytical prose is here used to describe a character in the act of attempting an equally precise and analytical drawing. The message is clear: for the purposes of descriptive art all that is relevant is visual fact.

In Camus' existential classic *The Stranger*, the protagonist, Meursault, is condemned as an "inhuman monster totally without moral sense" because he accepts the facts of his life, both good and bad (his mother's death, a friend's tawdry past, his girl friend's affection) without moralizing, without pretense. Photo Realist painting has also been condemned as "inhuman" for its cold, objective treatment of banal subject matter; for its noncommittal incorporation of polluting engines, hot-dog stands, and other forms of urban blight. Many critics have, in fact, interpreted the painstaking rendering of such subjects as intolerable glorifications. But to do this is to fall into the trap of "significations": to let the supposed meaning of the object obscure its presence.

The Photo Realist is neither glorifying nor censuring, but his objective rendering does often reveal the visual beauty and fascination of the pictorial subject. A Kentucky Fried Chicken stand may be

STEPHEN POSEN: Untitled. 1973. Oil on canvas. 92″ x 74″. Photograph courtesy O. K. Harris Gallery, New York.

immoral as a symptom of our urban sprawl and convenience culture, but, as Ralph Goings' painting clearly shows, it may also be visually engaging precisely because of its synthetic qualities and the variety of textures, light play, and reflections these afford. The fact is, the modern world offers an incredibly fascinating and diverse array of visual information that the Photo Realist does not feel compelled to ignore any longer.

E. H. Gombrich in discussing the history of illusionist painting states:

> It is an interesting and undeniable fact that many great artists of the past were fascinated by problems of visual truth, but none of them can ever have thought that visual truth alone will make a picture into a work of art.[4]

Concerned absolutely with visual truth the Photo Realist does not need to ask what makes a work of art. He knows that the object's presence is its justification, and that this is true for the object in the painting and for the painting as object.

Photo Realism is an art of the seventies not of the fifties, and, although this existential realization represents the central philosophical metier for this generation of artists, they are by no means merely registering a delayed artistic reaction to an already explored philosophical situation.

Camus' Meursault is a compelling image of man as a stranger in his world and a stranger to the world of meanings others have assigned. But the focus has changed. The central concern for the Photo Realist is not the displaced and alienated man, but the world itself—he seeks not to create an image of man but to clarify our image of all that is not man. Robbe-Grillet writes, "the world is neither significant nor absurd," and he takes issue with both Camus and Sartre who, he feels, were still trying to posit an unrealistic relationship between man and the world. Like the Photo Realists', his is an existentialism without existential angst.

[4] *Op. cit.*, p. xi.

But a lack of angst is not a lack of commitment. The Photo Realist is extremely committed to his morality of impersonal observation and unsparing factuality. For most of these painters this commitment involves many weeks and even months of arduous and often boring labor on a single painting. There is a fascinating and frightening madness in painting color separations layer upon layer, in building complete sculptures and then laboriously copying them in paint, in meticulously rendering every flower on a Rose Bowl float, or in a florist's window, or every nut and bolt on an engine. In spite of the artists' desire to paint without a message, the task itself inevitably becomes a statement. Art is, after all, a method of relating to the universe even while exploring its alien otherness.

The act of painting slowly and laboriously what the camera can record quickly and effortlessly becomes a metaphor for the essentially meaningless act of existence. But it is not meaningless after all: The painting is not the photograph. It attains its own presence and offers an intensified and clarified view of at least one bracketed section of the world. The value of human effort is affirmed. The triumph of skill becomes a triumph of spirit as well. The Photo Realist is committed to the realization that all we have left is to see clearly, and he convinces us that this is still quite a lot.

THE ERSATZ OBJECT*

Kim Levin

Appearance, reality, and the role of deception are interacting factors in new illusionistic sculpture. Such works eschew form, replacing it with the simulation of man-made artifacts. As such, art becomes entwined not only in the illusionistic deception of imitating reality but also ". . . in the surface deceptions of materials."

Kim Levin, who contributes a discussion of the work of Malcolm Morley that appears elsewhere in this volume, discovers a synthetic counterfeit of reality within the materials chosen by some realist sculptors, with particular reference to the work of Duane Hanson, John de Andrea, Fumio Yoshimura, and Jud Nelson.

* Reprinted from *Arts Magazine*, Vol. 48, No. 5 (February 1974).

"One thing made of another. One thing used as another. *An arrogant object,*" noted Jasper Johns some time ago. His painted bronze beer cans were perplexing sentinels of literal realism and unreality for almost a decade.

In January 1969 the New Nixon was inaugurated. By July the posthumous Duchamp was revealed. A few weeks later men were walking on the moon. The moon's magic may have been extinguished by that first footstep, but it was beyond our wildest dreams to set foot in Duchamp's magically real landscape, just the other side of an old door.

When his magnificent illusion with sprawling pigskin nude and distant tinfoil waterfall was revealed, totally inaccessible, its role was symbolic. Appearing in the wake of the anti-form, anti-illusion seasons of scatter pieces, earthworks, and conceptual statements, it may have seemed cynically to signal the disappearance of art. By 1969 physical presence had been reduced to raw material or had given way to idea, but what also happened was that form had secretly gone back to nature. And although this may well have meant the disintegration of modern art, art at the same time was reemerging from the ashes in the protective guise of life. Extremes pass into their opposites; evolution is a tricky means of survival. Mimicry of the processes of nature was not as far removed as it looked from imitation of natural forms.

The moon men left the earth artists behind. What earthwork could compete with a footprint on the lunar surface or a human shadow on a celestial boulder? Enacting a Conceptualist's dream, they took golf clubs to the moon but in doing so they destroyed its mystery, relegating it to the status of a future tourist stop—a physical surface, a solid object. Recycling art, making it become a part of nature, was no longer enough. Reality had to follow. Robert Morris' ground-covering of scraps, Robert Smithson's rock samples, or Michael Heizer's distant trenches had been unknowingly paving the way to realism. In 1968 when Alex Hay showed fiber glass replicas of wooden floorboards and giant brown-paper bags, and when Nancy Graves showed life-sized, lifelike camels covered with mangy fur, they appeared retro-

grade, anachronistic reversions to Pop art. Now they seem advanced, venturing prematurely into simulated reality.

Unknown, Duane Hanson and John de Andrea must have already been at work when Marcel Duchamp, posthumous father after the fact, legitimized illusionism: within months their figures appeared, and the tableaux of George Segal and Edward Kienholz suddenly looked insufficiently real. Totally accurate, totally inert, Hanson's and de Andrea's bodies were more real than Mme. Tussaud's, as natural as the animals in a museum of natural history or the stuffed people in *Planet of the Apes*. "I want them to breathe," said de Andrea.[1] The fascination with imitations of life, duplicates of reality, was always lurking in the underbrush, but when the replica is no longer distinguishable from the original—like the robots in *Westworld*—sinister overtones are added: Stalin carried it to extremes—he had several identical rooms in different locations, and he traveled between them in a closed limousine.

Imitation can be repetition, reproduction, or replication, but it can also become pure mimicry. When it does, it is because style is no longer viable: art doesn't suffice. The desire for the absolutely real has unearthed long-buried deceptions and illusions, and has led art to define itself once again as imitation. Mimicking the world of appearances, art conceals and protects itself, forewarned of its own extinction, knowing itself to be a delusion. With artifice it assumes the disguise of artlessness, of nonart, of literal reality.

"The connoisseurs of the future may be more sensitive than we to the imaginative dimensions and overtones of the literal," wrote Clement Greenberg in 1954. He suggested that content could dissolve into form. But formalism is now the past: what he called "old time illusionist art" has collided with the future by becoming, in its newest incarnation, as literal as Minimal form. Turning against its adherents

[1] John de Andrea's and Duane Hanson's remarks are from interviews by Duncan Pollock, Linda Chase, and Ted McBurnett in *Art in America* (November–December 1972). Fumio Yoshimura's and Jud Nelson's quotes are from conversations with the author, November 1973.

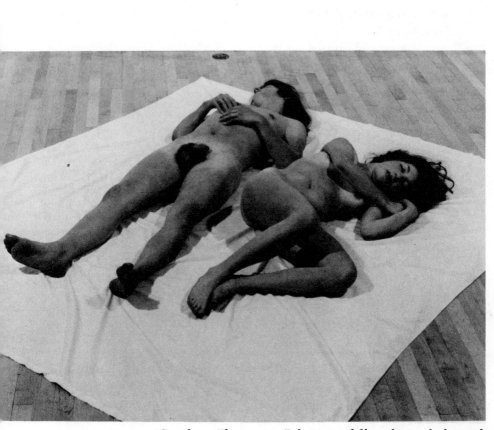

JOHN DE ANDREA: *Couple on Floor*. 1973. Polyester and fiber glass, polychromed. Life-size. Photograph courtesy O. K. Harris Gallery, New York.

with a vengeance, "form" has redissolved into "content." Pygmalion is back in business.

The new illusionist sculpture is minimizing form deliberately. Its forms—its structures—are given, ready-made. Actual size, real space, and accuracy to a model are its necessities. If it isn't cast from molds, it is reproduced by hand, copying exactly the shapes and surfaces of its models in life. In other words, structure has given way to skin.

But appearance is not reality: deception is involved.[2] Shedding form and taking on the ability to simulate actual forms of life and man-made artifacts, art became entwined not only in the illusionistic deception of imitating reality but also in the surface deceptions of materials. Along with the Photo Realist insistence on snapshot stylelessness goes its mimicry of photographic surfaces: it disguises its paintedness with the look of photography. Mimetic sculpture, simulating solid things with counterfeit three-dimensional likenesses, is less limited in its choice of disguises. Polychromed plastics can pretend to be flesh and blood, clay can look like leather, cloth, or cardboard, wood can substitute for metal, or styrofoam for wood. But while Photo Realist painters have been proliferating, sculptors are still scarce. This may be because the idea of a surface stretching over three dimensions is less accessible than flat photographic space.

Staking out the territory of the human body between them, Hanson and de Andrea confront the human surface: the clothed and the nude are equally coverings, skins. What is under the actual clothes of Hanson's bodies is irrelevant as long as the visible terrain is convincing. Leather is also a skin, and Marilyn Levine's leather accessories made of clay, substituting metallic brittleness for soft crushability, like the bronzed baby shoes buried in provincial childhoods, are foolproof to the eye. Her forms are coverings for the body. Rauschenberg's are

[2] The post-Minimal artificiality of bringing nature into the gallery or of sending art into the wilderness should not be overlooked.

coverings for objects: with his clay replicas of cardboard cartons, repeated in editions, he has stepped squarely into the same quicksand of the trompe-l'oeil surface, but they are also extensions of his recent use of corrugated cardboard and his long concern with means of replication. Saul Steinberg, whose past work is full of riddles about nature and art imitating each other, is another trespasser on the grounds of literal realism.[3] Most of the hand-carved and painted wooden replicas of artist's tools on his *Tables* (drawing boards or actual drafting tables) were virtually indistinguishable from real pens, pencils, or brushes, but other objects, obviously wooden, gave away the secret. Fumio Yoshimura, who first made six wooden bicycles in 1970, and Jud Nelson, who showed six styrofoam chairs last fall, make no secret of their material deception, duplicating objects without the benefit of cosmetic coloring; their surfaces, their skins, are bare. They effect a subtle reversal of the trompe-l'oeil confusion: instead of being amazed that it isn't the actual material, we are amazed that it is the unlikely substitute.

A disguise can make something appear to be what it is not, or it can make it appear not to be what it is—it can conceal the identity of a thing, or it can change its appearance. The peace marchers wore army-surplus clothes. Hanson, de Andrea, Levine, Rauschenberg, and sometimes Steinberg conceal the identity of their materials, arrogantly mimicking actuality. The deception becomes visible in the figures only because they don't breathe; in the objects it remains invisible—like Duchamp's heavy sugar cubes made of marble, it is necessary to touch to be sure of the material discrepancies.

Instead of concealing identities, Yoshimura and Nelson change the appearance of their objects by obvious simulation with substitute materials and neutral, uncolored surfaces. Although they deal literally with real objects, their attitudes toward realism are ambivalent: the illusionistic deception is exposed by their materials, which refuse to

[3] Malcolm Morley, the first Photo Realist, also moved into sculptural illusionism with *The Last Painting of Vincent van Gogh* (a mock easel with hand-painted copy of van Gogh's painting, and palette, paint box, and gun). Morley's postcards had led to the possibility of a flat object having a spatial existence.

partake wholly in the illusion. The raw grainy wood of Yoshimura's intricate mechanical or natural objects, whether motorcycle, sewing machine, or tomato plant, and the white and weightless styrofoam of Nelson's chairs emphasize unreality. "We never had realism as an idea in Japan. I'm not intending to make any realism," Yoshimura says, pointing out that in the classic Noh plays, eighty percent of the characters are ghosts. "I'm not really reproducing the thing. I'm producing a ghost." Nelson, building an image as if it is made of air, is also involved with removal from the original. But where Yoshimura is less concerned with accuracy of scale and detail than with improvising a believable approximation, Nelson uses fanatical accuracy in his duplications. His chairs had six different but identical wooden folding chairs as models; each has its own almost imperceptible imperfections, individualities, birthmarks. Of his styrofoam sunglasses he says: "These are mere copies, slavish imitations, everything is replicated to a sixty-fourth of an inch. I'm just pushing the extreme of exactness." But by taking such care, his work implies that each object has a spirit, which he preserves with an Indian-like respect. Claes Oldenburg's ghost objects took liberties, but tactility was insinuated into seeing when he replaced structure with skin. His soft skins, undisguised substitutes for other surfaces, opened the way for other substitutions, modifications, or reversals of hard and soft or heavy and light.

When illusionism became the issue, materials assumed new importance as the carriers of deceptions. And when one material substitutes for another, openly or in secret, structural elements that are no longer functional tend to be retained as decorative vestiges on the surface—hinges that don't bend, wheels that don't turn, stitch marks in stoneware shoes, corrugations in clay boards, pores in plastic skin. Conforming to an alien appearance while keeping their own identity, the materials used by Nelson and Yoshimura openly emphasize pretense. If they seem to stop a step sooner in the process of deception, omitting the polychrome camouflage, their quixotic choices of materials go further to question material existence.

Part of the deception in the work of Nelson and Yoshimura is that

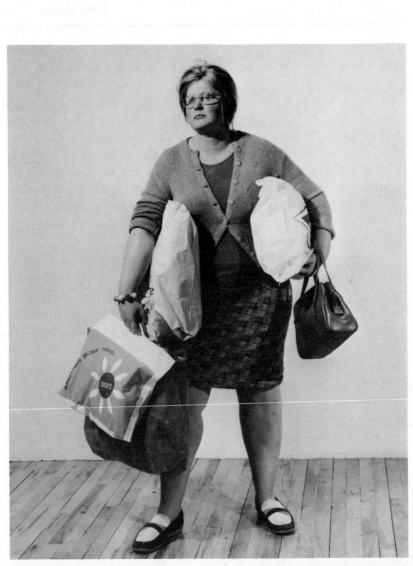

DUANE HANSON: *Shopper.* 1973–1974. Polyester and fiber glass, polychromed. Life-size. Photograph courtesy O. K. Harris Gallery, New York.

it has been crafted so painstakingly by hand. Using substances that cannot be manipulated or molded, they build their work part by part—carving, grinding, and gluing with time-consuming skill—to make it look like a factory-made, mass-produced object stamped out on an assembly line. It is an act of self-defense, countering the blueprint technology of Minimalism. It is Duchamp's Ready-mades—found, instant, effortless choices—in reverse. The irony of the effect is part of the content. But then, even though Hanson and de Andrea use the reproductive shortcuts of casting their structures from life, their skins are painted by hand, with great care. With the moon landing, it was time for other virtuoso displays of accuracy.[4] The robotic technician, the anti-artist, emerged.

Duchamp's *Etant Donnés* bracketed the beginnings of an unexpected illusionism, by coincidence. In retrospect it had been preceded by signposts along the way. Johns's beer cans were the earliest, the most obvious, and the most advanced, in that they were not what they seemed to be. Disguise was not an element in most of the other early impulses toward the real. Considering the entrenched anti-illusion stance of the time, it is not surprising that actual objects, like Rauschenberg's stuffed goat, were favored. Or that the tableau became the form to anticipate simulated reality. Work such as Segal's dining room, Kienholz's more total beanery, or Lucas Samaras' complete bedroom —which, unpeopled and containing only real things, was the most literal—emphasized displaced actuality.[5] When Segal cast figures in plaster, he used the mold itself as the figure—the more likelife cast remained a negative space hidden within. When he used real objects,

[4] The meticulous time-consuming handiwork of Lucas Samaras or Sol LeWitt provides an unlikely precedent.

[5] Vito Acconci's more recent act of transporting the contents of his apartment piece by piece to a gallery can be seen as reducing the tableau to a dismantling process: by way of a Minimal climate, tableaux gave way to the isolated object. The environment became superfluous; the actual site was incorporated. However, instead of vanishing, the tableau has become miniaturized, continuing in the work of Robert Graham and Darryl Abraham, which, although seemingly realistic, could never be mistaken for reality because of its Lilliputian scale.

they remained actual—his plaster molds inhabited real surroundings, sat on real chairs, used real props. As if breaking a Segal open and casting the lifelike shape within, completing a process Segal started, Hanson and de Andrea (who openly acknowledge this relationship) took the next step. It is interesting that Segal himself started making actual casts around 1969: his plaster relief fragments of figures are casts rather than molds, but the fragmentary form forestalls any overwhelming illusionism.

If the figure sculpture of Hanson and de Andrea relates to Segal and to the posthumous Duchamp, and the object sculpture of Yoshimura and Nelson relates to Johns's reversal of the ready-made, there is a curious cross-reference: made in a uniform neutral uncolored substance, the new objects are materially more like Segal's plaster whereas the new figures are cast and painted like the Johns.

Like Segal's figures, those of Hanson and de Andrea express mindlessness and isolation. De Andrea's are nude models posing for pay, tranquil, and vacant, with no private thoughts—bodies for sale. Hanson's are casualties of life, waiting to be thrown away. In his earlier work, accidents or hostilities left the floor strewn with bodies, wreckage, violence. Now he has shifted to more passive wrecks: menial laborers, or the surplus old vegetating in Florida, playing solitaire, staring into space, waiting. They use real props, like Segal's figures; they also wear real clothes. But oddly, the presence of Segal's figures becomes an uncanny absence in Hanson's and in de Andrea's—they are the exact forms of people who aren't there, discarded inanimate bodies, victims of the Body Snatchers. Their totally realistic appearance, their wholly convincing surface, their deceptive illusion of being actual people complete with gooseflesh, mosquito bites, or varicose veins makes the absence all the more apparent. The tension between the formal and the lifelike that existed in the work of Segal has shifted to a tension between lifelike and alive. Like the disembodied three-dimensional images in Dali's or Nauman's hologram portraits, or like Body art with its live performances or photographs, they are impersonations of life. With literal mimicry the famous gap between art and

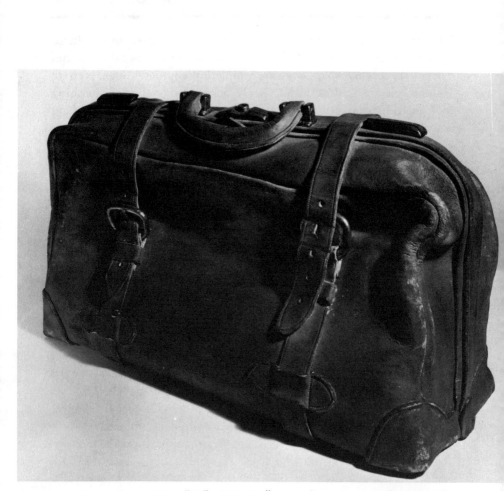

MARILYN LEVINE: *Brown Bag "Sid's Suitcase."* 1972. Stoneware. 23″ x 12″ x 8″. Photograph courtesy O. K. Harris Gallery, New York. Collection of Virginia Museum of Fine Arts, Richmond.

life snaps shut, but it leaves in its wake an unfathomable abyss—a credibility gap between object and image.

But then, could we really tell the difference between the live broadcasts from the moon and those labeled "simulation"? In life, the 1960s, with Lincoln in Disneyland and a wax pope in St. Patrick's, had been full of hints about illusion and reality. The Surrealist tradition of mannequins had been rediscovered during the Pop era, by way of the amusement arcade, and numerous movies involved dummies in scenes of heightened unreality.[6] The cults of dead heroes accumulating through the sixties from Marilyn and Kennedy to Guevara, Hendrix, and Joplin and the controversy over heart transplants indirectly tie in with the morbidity of the new objectlike body and ghostlike object existing as fixed images. Decades ago, Ortega y Gasset wrote with modernist disgust of ". . . the peculiar uneasiness aroused by dummies. The origin of this uneasiness lies in the provoking ambiguity with which wax figures defeat any attempt at adopting a clear and consistent attitude toward them. Treat them as living beings, and they will sniggeringly reveal their waxen secret. Take them for dolls, and they seem to breathe in irritated protest. They will not be reduced to mere objects."

Sculpture, pretending to be of this world, borrowing the existing forms of things in the world, is less an object than a ghostly image, all on the surface. It conceals its own reality by mocking another, arous-

[6] The human replica or mannequin motif has pervaded film, from *House of Wax*, with its illusionistic attempt to make celluloid more real by means of cardboard spectacles, to *Westworld*, where ultrareal robots duplicate actuality in a fantasy retreat. Interest in the mannequin has also appeared in English sculpture, since Jann Haworth's Pop rag-doll figures. Since 1969, Allen Jones's chorus-girl mannequins, contorted to function as furniture, and Malcolm Pointer's painted and clothed plaster casts have appeared. Both, however, remain securely in the tradition of mannequins, not to be confused with real people; their surfaces look reassuringly hard, but this may be a technical shortcoming rather than an intention. Also, both seem less concerned with the subject of reality and illusion than with woman as a fantasy sex object, lewd, degraded, and obscenely used.

ing dread, confusion, and the shock of recognition. Its value lies in deception as much as in resemblance: the degree of its lifelikeness corresponds perversely to the awareness of its deceit. To call it "verist" is misleading. It is the opposite of genuine—a synthetic counterfeit of reality. In fact, simulation could be said to be its subject matter. Plato claimed that art was thrice removed from the truth (removing himself by using the voice of Socrates). "Here is another point: the imitator or maker of the image knows nothing of true existence; he knows appearances only." But the awareness of the new sculpture's duplicity— the realization that it is not what it appears to be—is half the pleasure in this comedy of errors; the object has been found out, exposed as an image. And the spectator, released from an illusion, becomes a participant in a mystery as well as a witness to a comic melodrama of mistaken identity.

Galatea wasn't waiting for Darwin in the Galápagos, but while art tries to come back to life, unrecognizable mutations may occur in the development of forms: reality was never as real as a hybrid hothouse image. As art becomes an endangered species, sculpture resembles natural history. But the real sanctuaries of natural forms are overtaking sculpture. In the Bronx Zoo's new birdhouse, life simulates itself: living birds exist in simulated natural habitats, imitating the displays in a natural history museum and re-creating chunks of actual nature indoors in glassless cases. There is even one jungle tableau— complete with not a tinfoil waterfall but a real one, simulated rain, and watchful birds—that the spectator enters passing through at tree- top level in the midst of total illusion.

"I am not satisfied with the world. Not that I think you can change it, but I just want to express my feelings of dissatisfaction," says Han- son. "I set up my own world, and it is a very peaceful world—at least my sculptures are," says de Andrea, going further. A mouthpiece of 1960s avant-gardism, the Something Else Press, referred in a recent catalogue to "the collapse of the sixties in grand disillusionment." But the "disillusionment" of the late sixties is the illusionism of the seven- ties. With the advent of the New, New Nixon—speaking of himself at

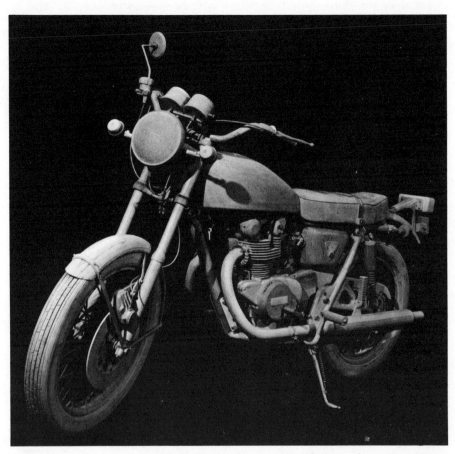

FUMIO YOSHIMURA: *Motorcycle*. 1973. Wood. 40″ x 86″. Photograph courtesy Nancy Hoffman Gallery, New York.

times in the third person singular, as if he were someone else and launching Operation Candor—what could be more apt at this point in time than the appearance in sculpture of a synthetic realism that reveals itself to be total fiction? In art, at least, the believable image has been restored.

REALISM NOW*

Linda Nochlin

The following essay appeared in the catalogue for the first exhibition that sought to recognize the new art style. In it Linda Nochlin observes that, throughout our century realist art has been ". . . relegated to the limbo of philistinism." Pop art, a realistic style of acknowledged importance, is not, according to Nochlin's definition, an authentically realist form, having been ". . . assimilable to the modernist aesthetic position" due to its abstract emphasis on surface and its use of "ready-made imagery."

"Realism Now" is one of the earliest published essays that seeks to identify the new movement, which, ". . . far from being an aberration or a throwback in contemporary art, is a major innovating impulse."

* Reprinted from *Art News* (January 1971). Originally in *Realism Now*, catalogue, Vassar College Art Gallery, Poughkeepsie, New York, 1968.

*Professor Nochlin points out the essential aesthetic and paint-
erly concerns of the realists she writes about; she insists that the
major distinguishing feature in such art is ". . . the assertion of
the visual perception of things in the world as the necessary basis
of the structure of the pictorial field itself." Selected statements
from artists appear to support Nochlin's view that ". . . not since
the Impressionists, has there been a group so concerned with the
problems of vision and their solution in terms of pictorial notation
and construction."*

*The author sticks to a purist critique and is unwilling to ac-
cept the viewpoint that the very existence of referential subject
matter in art automatically means there is literary or symbolic
content in the work. The question is irrelevant, she claims, be-
cause ". . . filmmakers and painters demand that our responses
be restricted to the cinematic or pictorial statements themselves
rather than to the subjects of these statements," a view that is
rejected by some critics, including Scott Burton who writes ". . .
it is the idea of aesthetic means—image before object—that has
changed." [1]*

*Linda Nochlin is Mary Conover Mellon Professor of Art His-
tory at Vassar College. She is the editor of two volumes of read-
ings on nineteenth-century art and author of a book* Realism.[2]

*In recent years Nochlin has been actively engaged in women's
studies and activities, organizing a seminar on Women in Art and
lecturing extensively. She summarizes her views in an essay en-
titled "Why Have There Been No Great Women Artists?"*

Ever since Maurice Denis proclaimed in 1890 that a painting was es-
sentially a flat surface covered with colors assembled in a certain order
before it was a battlehorse, a nude woman, or an anecdote, realism has

[1] *The Realist Revival,* catalogue, The New York Cultural Center, 1972.
[2] *Impressionism and Post-Impressionism, 1874–1904: Sources and Documents*
(Englewood Cliffs, N.J.: Prentice-Hall, Inc., 1966); *Realism and Tradition in Art,
Eighteen Forty-Eight–Nineteen Hundred* (Englewood Cliffs, N.J.: Prentice-Hall,
Inc., 1966); *Realism* (Baltimore, Md.: Penguin Books, Inc., 1972).

fought a losing battle for inclusion within the ranks of avant-garde art. Despite a few minor skirmishes—the Neue Sachlichkeit in Germany, the work of Balthus in France, some American attempts of noteworthy if provincial intensity—realism, in the sense of creating an accurate, detailed, and recognizable simulacrum of visual experience, has been relegated to the limbo of philistinism: the propaganda machines of Soviet party hacks or the sentimental platitudes of *Saturday Evening Post* covers. In the great forward march of modernism, that gradual stripping from visual art of all extravisual meaning, whether literary or symbolic, to paraphrase Barbara Rose, that rejection from painting of all that is nonpictorial, that reduction of art to its literal qualities—in painting, to the flatness and shape of the canvas itself—it would seem that realism is indeed aside from the point, *retardataire*, or, at the very least, sentimentally revisionist. Wistful attempts at "getting the human figure back into painting," such as The Museum of Modern Art's "New Images of Man" exhibition in 1959, supported by a heavy dose of popularized existentialism, only seemed to underline the point: despite a hortatory introduction by theologian Paul Tillich and a commendable effort to equate smeared contours with modern angst or calculated grotesquerie with contemporary alienation, the "new images" turned out for the most part to be not very different from the old expressionism, and modernism marched on its reductive course with Barnett Newman, Ad Reinhardt, Morris Louis, Jules Olitski, and Frank Stella in the vanguard.

To this view of modernism as a teleological progression toward more and more purely optical values in painting, the emergence of Pop as a major force in the early sixties seemed to offer the first undeniable challenge. Yet, after the initial shock of confronting recognizable motifs drawn from contemporary life on the canvas had worn off, Pop scale, coolness of tone and pictorial handling, its emphasis on surface and brilliant color, its flatness of form and emotion, and its use of ready-made imagery rather than direct perception made it assimilable to the modernist aesthetic position. Indeed, many of the qualities of Pop have been correctly, if at times grudgingly, equated with those of cool or hard-edge abstraction.

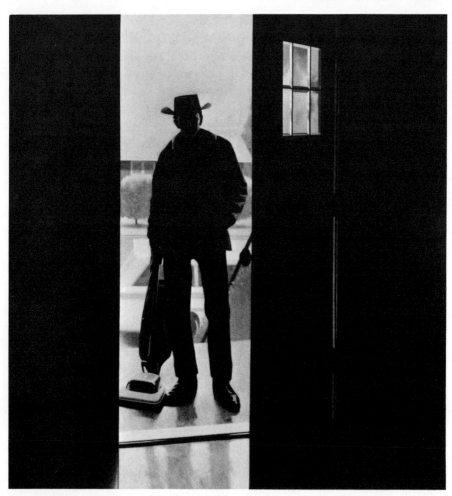

ROBERT BECHTLE: *Hoover Man*. 1966. Oil on canvas. 72″ x 54″. Photograph courtesy
O. K. Harris Gallery, New York.

How, then, do the New Realists fit into the contemporary art scene? Or, one might ask, is it possible for a realist to be new at all in the second half of the twentieth century? The answer to this second question is, as the exhibition reveals, an unqualified yes. If Pop drove the opening wedge into the entrenched view of modernism as a necessary and continuous progression starting with Paul Cézanne and ending with Stella (a progression that requires a bit of internal juggling to maintain its consistency, in order to disassociate the pure abstraction of Kasimir Malevich, who had worked uncomfortably close to the beginning of this unfolding of the reductive spirit, from that of Newman or Reinhardt, who were situated with greater chronological convenience near its end term), then the New Realism has exploded the modernist myth entirely. Despite the patronizing attempts of some critics to consign the New Realism to the peripheries of the contemporary art world—for example, Philip Leider's assertion that the work of Philip Pearlstein, Lennart Anderson, Jack Beal, and Alex Katz is "irrelevant to our fears and hopes for the best modern art" or at most "a respectable minor art," or Hilton Kramer's dismissal of a recent Alex Katz show as "the pictorial equivalent of *vers de société*," it has become increasingly clear during the course of the last two years that the New Realism, far from being an aberration or a throwback in contemporary art, is a major innovating impulse. Its precise quality of novelty, it would seem to me, lies more in its connection with photography, with new directions in that most contemporary of all media, the film, or even with the advanced novel, than in its relation to traditional realist painting.

Yet if one rejects the narrow, abstractionist aesthetic teleology as the proper framework for viewing the New Realism, one must by no means ignore the central role played by recent abstract painting itself in the formulation of the New Realist style. The largeness of scale, the constant awareness of the fieldlike flatness of the pictorial surface, the concern with measurement, space, and interval, the cool, urban tone, with its affirmation of the picture qua picture as a literal fact, the rejection of expressive brushwork, or, if it exists, the tendency toward bracketing its evocative implications through irony or over-

emphasis—all of these elements bring the work of the New Realists closer to the spirit of contemporary abstraction and serve to disassociate it irrevocably from the meretricious mini-platitudes of a self-styled "old" realist like Andrew Wyeth. The ladies of the suburban art-study clubs, who in recent years have dutifully gulped down large doses of Stella and Andy Warhol while secretly yearning for Something Nice they can Recognize, are not getting the answer to their prayers in Pearlstein's nudes or Gabriel Laderman's landscapes.

It is no mere coincidence that many of the New Realists came to their present position after an earlier involvement with abstract art, and their concern with what might be considered purely formal problems remains constant. For Alex Katz, working on the tense borderline between the generalizing conventions of ready-made imagery and the concrete subtleties of immediate perception, the compositional problems presented by expanded scale—overlapping of volumes, cropping, the whole idea of gesture, "how things move to each other across a surface"—are major preoccupations. Philip Pearlstein, a former Abstract Expressionist, resolutely denies any evocative or expressive intention in his nudes or portraits, asserts that he is interested only in the problems of painting, and, like Flaubert in the nineteenth century, who dreamed of writing a novel about nothing at all, conceives of his enterprise as "the perfection of nothingness." Yvonne Jacquette tells us that the *James Bond Car Painting* is "part of a series concerning the space between objects"; Sidney Tillim seems primarily concerned with the interrelation of volumes within a compressed pictorial space; and the expressed aim of Neil Welliver, a former student of Josef Albers, Burgoyne Diller, and Conrad Marca-Relli, is "to make a 'natural' painting as fluid as a de Kooning." What is therefore the distinguishing feature of the New Realism is not some phony superimposition of humanist values onto old formulas, but rather the assertion of the visual perception of things in the world as the necessary basis of the structure of the pictorial field itself; indeed, not since the Impressionists, has there been a group so concerned with the problems of vision and their solution in terms of pictorial

notation and construction. In making this assertion, they are at once reintroducing an element that, from the Renaissance to the twentieth century, had always been considered an irreducible property of the purely pictorial itself—that is, the recording of perceptual data—and at the same time, pointing out the incredibly changed nature of perception itself in the second half of the twentieth century. Whether this perception is direct, or mediated by the mechanical apparatus of the camera, as it is for so many of our artists, is irrelevant to the major issue. The very fact that Pearlstein, who never uses photographs but always works from the live model, was "accused" of relying upon them at a recent panel discussion is a good case in point. Instead of using photographs, Pearlstein has, as far as possible, transformed himself into a camera, and has assimilated many of the characteristics normally associated with photography, such as arbitrary cropping, the close-up, and radical disjunction of scale, to his painting style.

The act of perception is itself total, conditioned both in its mode and in its content by time, place, and concrete situation. While it may be willfully objective—and realists have traditionally tried to divest themselves of personal and cultural impedimenta—it cannot occur in a vacuum: it is this that makes the New Realism so new and so completely of our time. Courbet's nudes could never have looked like Pearlstein's or Beal's or Leslie's. How could they, since they were painted before the invention of the close-up, the flood lamp, or phenomenology? Laderman's West Side Highway landscape could never have been painted by Pissarro, even though both were scrupulously recording visual facts, not merely because the West Side Highway did not exist when and where Pissarro was painting, but because Picturamic Postcard Vues and concepts like *alienation* and *distancing* were unavailable as well. Nor could John Button actually have *seen* his girl on the beach in that particular way if Mark Rothko had never painted or Andy Warhol had not made *My Hustler*. Richard Estes' New York seems light-years away from that of John Sloan or the Ash-Can School. Would the stringently controlled reflections

in *Cocoanut Custard,* based on the objective recording of the camera lens, have come out that way if there had not been a Mondrian or hard-edge abstraction? Or has New York itself become harder-edged in the last fifty or sixty years? For Sloan, as for Manet, reflection immediately implied diffusion and blurring of the image on the canvas. (Think of the shimmering, hazy mirror. mirage in the background of the *Bar at the Folies-Bergère.*) For Estes, who relies on the photograph "as a sketch to be used" rather than as "a goal to be reached," the photographic enlargement of reflections is too fuzzy. "Perhaps the more you show the way things look the less you show how they are or how we think they are," he muses, concerned with conveying the noncoincidence of tactile and visual reality.

Even in what might be considered a relatively neutral realm of subject matter, the still life, the impress of the immediate present makes itself felt. It is not merely the choice of subject that is contemporary—although the James Bond car, the New York drainpipe, the triple-decker hospital bed are particularly of the moment, and the interest of these painters in the theme of garbage or wastepaper may perhaps be related to a similar concentration on refuse, astutely pointed out by Siegfried Kracauer, in the medium of the film—but the choice of vantage point, of cropping, and the deliberate removal of compositional focus. Although the oblique view, the cutoff, and asymmetrical composition were exploited by the Impressionists to convey a sense of the fleeting, the momentary, and the immediate, these devices were rarely used by them for the still life, which would seem by its very nature to resist such temporal definition. Nor is there anything very fleeting or momentary suggested by the firm, unbroken contours and deadpan, descriptive surfaces of the canvases of Jacquette, Tillim, or Nesbitt. Their closeup vantage point, radical cropping, and randomness of distribution are related to the dispassionate intimacy of the television screen and that rejection of a priori order and a posteriori significance associated with Alain Robbe-Grillet and the New Novel as well as with the French New Wave Cinema. Indeed, Robbe-Grillet's call to arms: "Let it be first of all by their

SYLVIA MANGOLD: *All Floor*. 1969. Acrylic on canvas. 33″ x 42″. Photograph courtesy Fischbach Gallery, New York.

presence that objects and gestures establish themselves, and let this presence continue to prevail over whatever explanatory theory may try to enclose them in a system of references. . . . Gestures and objects will be there before being something; and they will still be there afterwards, hard, unalterable, eternally present, mocking their own 'meaning' "–this credo could serve as the leitmotif of the New Realist outlook as a whole. William Bailey's *Eggs* "establishes" itself in this way, as does Don Nice's *Turnip*, which asserts its unique vegetable nonsignificance through sheer scale and scrupulous notation of detail. Jerrold Lanes's observation that Bailey's *Eggs* is reminiscent of *pittura metafisica* "but with no sense of volume or spatial interval" is very much to the point. It is precisely by refusing to impose the artifices of volume or interval upon his eggs that Bailey removes them from the realm of the "metaphysical," i.e., from any context other than that of their sheer visual presence.

The world of the familiar, the ordinary, the experienced, and the commonplace has traditionally been the realm of realism ever since the time of Courbet and Flaubert and down to that of contemporary film, and with it have come the more or less standard accusations of willful ugliness, of lack of coherence or discrimination, of overemphasis on petty or distracting detail, and concomitant coldness or lack of emotion or expressiveness. "*Mme. Bovary*," wrote one critic at the time of the novel's appearance in 1857, "represents obstinacy in description. . . . All the details seem to have been counted one by one, giving the same importance to each. . . . There is no emotion or feeling in it." Courbet was accused of painting objects just as one might encounter them, without any compositional linkage, and of reducing art to the indiscriminate reproduction of the first subject to come along. "He makes his stones as important as his stone breakers," complained one outraged critic of the eponymous painting. And, as is the case with the nineteenth-century realists, one feels with their twentieth-century counterparts that the ordinariness of the artistic statement, or even its ugliness, is precisely the result of trying to get at how things actually are in a specific time and place, rather than

how they might be or should be. It is significant that these painters so often narrow down the boundaries of contemporaneity still further to their own immediate social circle, friends or family, to the space of their own studio or apartment or neighborhood, or, following the lead of the film, turn to the image of synecdoche, the substitution of the part for the whole, and zoom in for a close-up of an even more restricted fragment of these already circumscribed realms until, at the ultimate limit of reductive intimacy, they focus upon such non-significant background areas as underneath the kitchen sink or simply the floorboards of the apartment as a sufficient visual motif for their canvases. As in the case of similar techniques in the cinema, new or enlarged modes of presentation force us to come to terms with previously ignored aspects of the most ordinary experiences of our daily life.

This insistence upon a specific context, texture, and density as essential simply to *being* at a concrete historical moment is central to the impact a nineteenth-century realist work like Courbet's magnificent *Portrait of P.-J. Proudhon* of 1865, where the philosopher, Courbet's close friend and mentor, is represented sitting on the back steps of his house, his smock sleeve clumsily rolled up to reveal the wrinkled sweater beneath, books and papers scattered around him, his two children rendered in their own world of self-absorbed concentration at his feet, the absent Mme. Proudhon indicated by the workbasket and mending on a nearby chair. All these details are related in terms of metonymy (the linking of elements by contiguity), which Roman Jakobson has asserted as the fundamental imagery of realist art, as opposed to the predominance of metaphor in romantic and symbolist works. One is, for example, drawn to examine Proudhon's shoes, not because they are particularly handsome or particularly affecting—certainly, they have none of the pathos or metaphysical implication of van Gogh's various pairs of empty boots—but simply because they are there as a separately rendered but relevant factor in the total situation of Proudhon in his garden. It is precisely the shoes' concrete literalness and, hence, their contiguous relationship to all the other

concrete elements constituting the painting, which is their significance and their *only* significance in Courbet's portrait. It is exactly this sort of accuracy of "meaningless" detail that is essential to realism, for this is what nails its productions down so firmly to a specific time and a specific place and anchors realist works in a concrete rather than an ideal or a poetic reality. One notices the presence of explicitly delineated shoes in several of the New Realists' paintings: in Pearlstein's portrait of his daughters, in Sidney Goodman's *Self-Portrait in Studio,* and in Welliver's *Red Slips,* where they have furnished the title of the canvas itself. The pictorial definition of these shoes is indeed so explicit that one could apply a more precise label to them—Keds, mary janes, Pediforms—just as one could refer to the Scotch tape on the table in Nesbitt's *Joseph Raffael's Studio,* the Hoover in Robert Bechtle's *Hoover Man,* the Kleenex in Jacquette's *James Bond Car Painting,* or the Exercycle in Goodman's *Dialogue;* these brand names are the identifying loci of our time and our world. One is reminded of a dramatic moment in one of Herb Gold's short stories where a character puts Hellman's—specifically Hellman's—mayonnaise on his artichoke, or, once more, of the film, where such brand-name explicitness is an essential quality of the medium.

Not only in the functioning of details, but in the more general area of tone and attitude, the contemporaneity of the New Realists is akin to that of today's avant-garde cinema. Visual directness and emotional distancing are inherent to the aesthetic structure of both. Painters and filmmakers avoid involvement with narrative theme or symbolic content, and resolutely exclude any possibility of interpretation that would involve translating the visual "given" into terms other than its own, or reducing it to a mere transparent surface for an all-important "something more" lurking beneath. In both the New Realism and the avant-garde cinema, the literalness of the imagery makes the art object dense and opaque; anything that would tend to pierce through the presented surface and give rise to narrative meaning or psychological implication is immediately put between parentheses

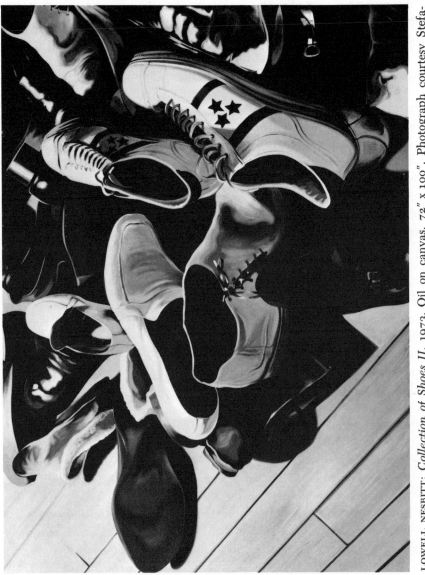

LOWELL NESBITT: *Collection of Shoes II.* 1973. Oil on canvas. 72" x 100". Photograph courtesy Stefanotty Gallery, New York.

and thereby assimilated to the opaque, continuous surface that consti-
tutes the totality of the aesthetic statement. For example, the cloying
or merely ingratiating associations usually evoked by the conjunction
of large dogs and small children is consistently bracketed where it
appears in New Realist canvases: in the work of Alex Katz, the
sentimental theme is severed from conventional response by exaggera-
tion of scale, psychologically unmotivated cutting, and a posterlike
deadening of the surfaces; in that of Neil Welliver, by an ironically
brushy treatment, partly like congealed fifties expressionism, partly
like an overblown picture postcard. In the case of Philip Pearlstein's
young daughters, the artist's deadly, unvenomous account of how it
is with these girls—their solemn, gigantic presences completely
detached from such irrelevant contexts as prettiness or paternal
affection by means of cast shadow and strict contour—makes them
as remote from trivial intimacy as a pair of Buddhas. In Jack Beal's
paintings, the naked female body (another conventional nexus for
subjective response), or its various fragmented parts, are simply one
set of visual elements among others in the total pictorial pattern. As
is so often the case in the visual world of the screen, the human being
is here reduced to an object among objects, a mere subordinate
portion of what film historian Siegfried Kracauer has defined as basic
cinematic reality: those "ever-changing patterns of physical existence
whose flow may include human manifestations but need not climax
in them." Even when the brushwork seems "hot" and impulsive, as
is the case in Paul Georges' *The Return of the Muse* or Jane Freilicher's
Field through a Window, we are kept away from direct contact with
the nude in the first painting by the self-consciously rueful presence
of the artist himself within the canvas, and from a direct approach
to the landscape in the second by the enclosing window frame, just
as in the medium of the film we might be distanced from the subject
by the sudden intrusive appearance of the director, or the introduction
of the physical presence of the camera itself into the screen image.

 The notion, central to the purist critique of representational art,
that the very existence of subject necessarily implies narrative or

symbolic significance, a position already called into question by modernist filmmakers like Warhol or Jean-Luc Godard, is contradicted with equal forcefulness by the New Realist painters. What is the inner meaning of Warhol's eight-hour film of the Empire State Building? What is the deeper significance of a six-foot turnip? Both questions are equally irrelevant since filmmakers and painters demand that our responses be restricted to the cinematic or pictorial statements themselves rather than to the subjects of these statements. Pearlstein and Leslie, for example, are not painting ugly people or deliberately asserting a pessimistic view of human nature in general or feminine appearance in particular. They are simply painting their subjects as they actually see them, probing the appearance of naked human flesh under very strong front illumination from a very close vantage point. The painted images created in this way may war violently with our conventional notions of how a naked woman or a human face should look, and yet this by no means implies that the artists are working under the compulsion of viciousness or grotesquerie; the judgment of ugliness arises from the spectator's response to the pictorial situation, not that of the deliberately dispassionate artist to his subject; for some observers, the mere revelation of new aspects of a familiar situation may be profoundly disquieting, although such a reaction may be quite irrelevant to the intentions of the artist himself. In the final analysis, it seems clear that misinterpretations—and over-reactions—arise from an inveterate tendency to reduce form to a kind of handy, disposable container for content, rather than considering form and content as modalities of a single, indivisible entity. The New Realists would, on the contrary, stand by Godard's proposition: "Style is just the outside of content and content the inside of style, like the outside and the inside of the human body—both go together, they can't be separated," and its corollary, phrased with customary succinctness by William Carlos Williams: "No ideas but in things."

BEYOND FREEDOM, DIGNITY, AND RIDICULE*

H. D. Raymond

Most critics who have written about the Super Realist aesthetic have introduced reservations about the style itself. Among those is H. D. Raymond, who feels that the realists, in omitting ideology and morality from their vision, ignore ". . . the mental constructs through which they are peering." And he goes on to add: "They substitute bleak patience for insight and feel that the reduced materiality they depict is what is." Yet Raymond finds much to admire in the Super Realist aesthetic, including the fact that the artworks ". . . say so many things in their refusal to say anything." He predicts that what may be going on is a ". . . move toward a new collectivity of vision . . . ," and he points out that such artists seem to ". . . show a willingness to share some of the interests and preoccupations of the nonartistic public."

* Reprinted from *Arts Magazine*, Vol. 48, No. 5 (February 1974).

H. D. Raymond has written criticism for Arts Magazine *and* Art and Artists. *He teaches painting in the Faculty of Art at William Paterson College in New Jersey.*

These New—er Newer—Realists depict a fallen world with a fallen technique. They offer a universe of phenomenon from which all traces of the numinous have been drained. Only matter is represented and only the surface characteristics of brittle matter. The spirit or force that has preoccupied painters of the great tradition and given their works its energy has been scrupulously excluded. They are studiously tough-minded and make a point of their objectivity. They reject honest as well as false inspiration because both are associated with jive rhetoric and phony afflatus. Like others of their generation, they are not about to be caught off base in the vulnerability of fervor. They are cool and their methodologies leave little room for the invasions of passion. For the most part they apply paint in a way that pushes value and color contrast throughout the entire work so that there is a synergetic crackle over the whole surface. This is their energy. It is the psychedelic energy of mind flashes rather than the gestural, visceral energy of Tintoretto, Rembrandt, Soutine, or the Abstract Expressionists. No current flows through their depicted objects. Cars and storefronts and consumer products share an airless, harsh light that emphasizes the separateness of things. Colors are metallic, synthetic with thalo blues and greens and acra reds and violets and dioxazine purples replacing the colors that once came from earth and plant.

The palette that was tuned up by color-field painters, stripe painters, hard-edge abstractionists, and ironic Pop artists during the sixties has been adapted for looking at the world *through.* The Newer Realists apply the new colors to sky and building as though applying cosmetics. Along with a taste for makeup hues they inherited an anti-expressionist bias from their older cousins of the sixties. Like the cool painters of the previous generation, they are not dismayed by finding themselves alienated from their own subjectivity but are—

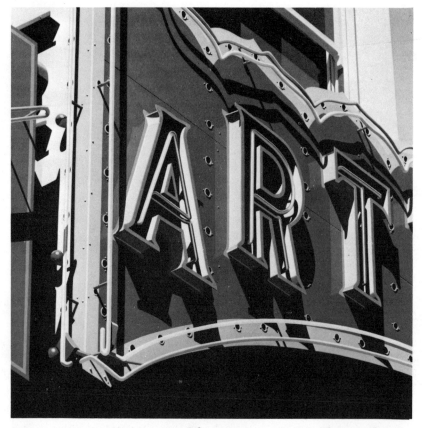

ROBERT COTTINGHAM: *Art*. 1971. Oil on canvas. 77″ x 77″. Photograph courtesy O. K. Harris Gallery, New York. Collection of Ivan and Marilyn Karp.

if they take any time at all to think about such things—glad to be free of the burden. They prefer a styleless style. Like some of the generation who can take their sex without the weight of love, these artists can take their painting without the burden of personal style. A Richard McLean horse could easily live in the same world as a Ralph Goings pickup truck, which might have parked next to a John Salt Volkswagen wreck in front of a Richard Estes cafeteria. There are stylistic differences but they are not due to the artist having asserted them, but rather in spite of the artist having tried to suppress them. Estes' paint is applied with more painterly pleasure than most of the others but this seems more the result of his need to represent the textures of the city in oil paint rather than any deliberate effort on his part. Stephen Woodburn is not directly influenced by camera vision and therefore allows himself to mix neo-Gothic mist into his acrylics and John Clem Clarke makes put-on references to the pastoral tradition, but for the most part a tough positivist logic prevails.

In addition to being a with-it, now attitude, their hard-nosed illusionism protects them from the galling public taunt that they can't paint as realistically as the old masters. What abstract painter—no matter what recognition he has achieved in the miniworld of art—would not be greatly gratified by the more generalized recognition of the less sophisticated mass public. That kind of recognition is authentic only when offered the realistic illusionism of Andrew Wyeth or Norman Rockwell or Salvador Dali. The Newer Realists protect their flanks from public ridicule by their obvious competence in illusionism at the same time as they (with a wink to their sophisticated fellow artists) make use of the tools and esoteric attitudes of the New York scene.

They have two sources of self-esteem. They have broadened the base of the buying public while being taken seriously by the art world. They have their cake and also eat it. They make visual embodiments of societal values. Their world is cool and it is beyond freedom and dignity. They share their public's mistrust of the

instinctive and the spontaneous and the messy. They lust after specificity and certitudes. They offer a reassuring sense of craftsmanship—to themselves as well as to their audience in an age that is increasingly given over to the shoddy. They paint only things. Their culture believes in things and little else. Their products have the look of antiseptic packaging. They look tested and respectable. The heroic emphasis of the Abstract Expressionists on open-ended subjectivity and process rather than product has given way here to an almost total emphasis on the product. Only other artists would tend to be interested in the processes of the Newer Realists. The Abstract Expressionists told us that we, all of us, were composed of mythic psychic strata that were overlaid with individual conscious role-playing strata, and because of this we were all (at least potentially) artists. The Newer Realists tell us that only the professionals are artists. Another triumph of professionalism. They subvert the furnishings and attitudes of the philistine world by practicing their professional high-art techniques (rather than kitsch techniques) on philistine subject matter.

If perception were merely the noting of what seems to present itself to the optic nerves, then these painters could be said to be making a determined raid on the nature of "reality." In omitting ideology, sublimity, and morality from their vision they are sworn to a phenomenologist credo. They stare unblinkingly at what is "really" out there, ignoring the mental constructs through which they are peering. They substitute bleak patience for insight and feel that the reduced materiality they depict is what *is. Nothing* that they stare at is more or less important than anything else that they stare at and so they reject Renaissance focal-point composition, in which important things tended to be larger than less important things as well as in front of other things and more in the center than other things. So the Newer Realists are antihierarchical in their designs. They work each section of a painting as if it were the center of interest. There are consequently an infinite number of centers of interest in each painting. This is in keeping with a relativistic concep-

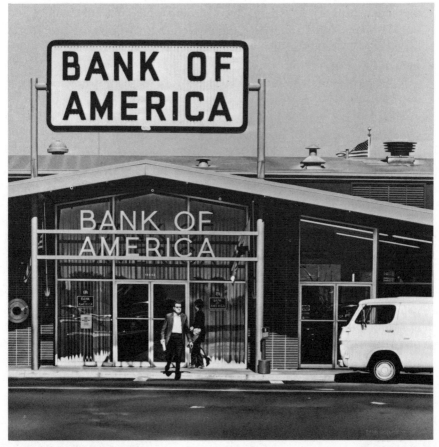

RALPH GOINGS: *Bank of America*. 1971. Oil on canvas. 40″ x 40″. Photograph courtesy O. K. Harris Gallery, New York. Collection of Howard Kraushaar.

tual framework in which there is no place from which any other place can be observed. In post-Renaissance painting (reflecting the Neoplatonic tradition) all things were ordered hierarchically, and the world's hierarchical ordering adumbrated the hierarchical ordering of the cosmos. It was a comfortably anthropocentric cosmos with humanity far up on the ladder.

No such comfort from the Newer Realists. Nothing is unimportant to them, not even humanity. Skies are painted with the same hardness as thermo-pane windows and background cars are painted with the same clarity as foreground cars. In fact figure-ground interactiveness is one of the techniques that has spilled from modernism into New Realism. This nonhierarchy has something to do with the unsettling quality of these works. If nothing is better or worse or more important than anything else, then the ladder stops here—and the ladder isn't vertical. We are presented with visual paradigms of unrelieved horizontality. There is nowhere to climb and the ladder that pointed toward unimaginable levels of transcendency is now on its side. Looking through its psychic interstices, one finds the visible universe divided into segments of equal size. It is probably no accident that most new painters of the realist persuasion prepare their canvases with a grid of equal-size squares. This helps to insure that they view things with imperturbable disinterest. The nonhierarchical ladder is an ordering principle that sees to it that enthusiasm is spread evenhandedly over the entire surface of the work. These works are hedonistic in content; avoiding value judgments about what ought to be painted and puritan in form; dedicated to the work ethic of careful and painstaking craftsmanship. They are paradoxically suspended—like the society they depict—between postponed and immediate gratification. The clarity of their technique is deceptive because these works say so many things in their refusal to say anything. The film *Patton* was seen by admirers of the general as strongly pro-Patton, while peace people saw the same film as violently anti-Patton. In the same way, these paintings can be read as a celebration of minutiae in loving detail or as a lament for lost wholeness, or as an ironic put-down in savage detail,

JOHN SALT: *White Roofed Wreck Pile.* 1971. Oil on canvas. 65″ x 92″. Photograph courtesy O. K. Harris Gallery, New York. Collection of Anita Reiner.

or as a rich amalgam of all these and other meanings. The elusiveness of meaning could be what they are about.

What is suggested though is a general mistrust: mistrust of previously cherished artistic ego trips; mistrust of individuality; mistrust of good taste. The acceptance of a commonality of visual style might be compared to an acceptance of group sex as an antidote to possessiveness and ego-tripping.

What may be going on is a move toward a new collectivity of vision paralleling a general trend toward collectivity. Except for professionalism, most of the trappings of high art have been discarded; transcendency, inspiration, esoteric subject matter, elitist motivation, and personal myth. These artists begin to show a willingness to share some of the interests and preoccupations of the nonartistic public. None of them was born an artist and each served a philosophical apprenticeship to the mass media. Most of their early life—and a good deal of their present life—was and is given over to mass values and prejudices. There is a frank acknowledgement of this fact in their use of publicly approved subject matter and even more importantly in their use of publicly approved illusionistic techniques. Politicians don't ignore the polls. For an artist to ignore public taste would be like a politician ignoring the attitudes of his constituents. The hope of understanding the public mind is not entirely ignoble. The wish to close the gap between the public vision and the artist's vision is a contemporary priority. Artists express their uneasiness with this shared vision by ironic side-glances at their fellow artists, but underlying that irony is the willingness to dispense with this last remnant of elitism. These realists are compiling an inventory of the visible in an era when the visible is rapidly dematerializing under the pressures of the marketplace. To the extent that these and other artists resist the marketplace mentality, at the same time as they increasingly share a nonelitist common denominator of shared interests with the public, will determine whether a new artistic populism is possible. If New Realism identifies with its elitist aspects, it will most likely go the way of other short-lived trendy artistic movements.

REALITY AGAIN*

Harold Rosenberg

"Pictures that copy appearances have been an obsession of American art since the early draftsmen of the exploring expeditions." So writes Harold Rosenberg in the following essay. Rosenberg observes that the main difference between the new generation of artists and its predecessors is that the Super Realists ". . . seem to feel freer of the demands of art. . . ."

Rosenberg compares the 1972 "Sharp-Focus Realism" exhibition at the Sidney Janis Gallery with an earlier exhibition devoted to the realism concept—the 1962 "New Realists" show at the same gallery. The main difference between the new generation of realists and that of a decade ago is that whereas the earlier style arrived ". . . with a bigger bang," the Super Realism is ". . . a rational extension of picture-making in popular styles."

* Reprinted from The New Yorker (February 5, 1972).

Nevertheless important similarities remain, not the least of which is the insistence of both modes to convert art into ". . . variations on existing techniques of visual communication." Sharp-Focus Realism then ". . . represents a renewed relation not between art and reality, or nature, but between art and the artifacts of modern industry, including the mass media."

Harold Rosenberg is author of several books on contemporary art and aesthetics and is art critic for The New Yorker.

The exhibition at the Sidney Janis Gallery in New York entitled "Sharp-Focus Realism" repeats an event staged by the same gallery (though at two other Fifty-seventh Street addresses) a decade ago. The earlier show, called "New Realists," constituted an announcement that what later came to be known as Pop art had reached a level of acceptance at which it could challenge the dominance of Abstract Expressionism. The current Janis replay no doubt anticipates a comparable success in displacing the various forms of abstract art favored in the sixties. The signs of a takeover have been multiplying for some time. Like Janis' Pop roundup, the present exhibition may be more a proclamation that power has been transferred than an appeal for recognition of the new art. Contributors to "Sharp-Focus Realism," such as Malcolm Morley, Richard Estes, Duane Hanson, Lowell Nesbitt, Howard Kanovitz, Robert Graham, and Philip Pearlstein, with their ocean liners, shopwindows, lifelike effigies, and oversize nudes, have been elbowing abstractionists in uptown galleries, SoHo, and the museums for much of the past ten years. Recently, the new representational art has also spread out of town; last year, the Chicago Museum of Contemporary Art and adjacent galleries on Ontario Street suddenly filled up with flesh-colored polyester dummies seated at tables or lying crushed and bleeding alongside shattered motorbikes, amid paintings of panel trucks, entrances to diners, close-ups of torsos, and photographic segments of landscape. With this gradual buildup, the element of surprise in the "sharp-focus" exhibition was bound to be weaker than Janis' unveiling of Pop. Like its predecessor, it aroused the feeling

that history was being made—but that in this instance it was being made rather listlessly. In any case, Pop arrived with a bigger bang. As striptease has already demonstrated, no repetition can equal the impact of the original. Abstract artists whom I met at that opening appeared resigned rather than indignant. Pop had established itself as an art form, and—under the leadership of Warhol, Christo, and other showmen—painting and sculpture had been increasingly amalgamating with the mass media. It was obvious that, whatever its future as a reaction against abstract art, Photo Realism was nothing monstrous but a rational extension of picture-making in popular styles.

Part of the shock of the 1962 exhibition derived from the identification of the Janis Gallery with de Kooning, Pollock, Kline, Guston, and Gottlieb. In the creations of the pioneer Abstract Expressionists, a principle was manifest—the avant-garde principle of transforming the self and society. The "objectivity" of Pop was a deliberate abandonment of this principle, and it had the effect of a betrayal. If Pop succeeded, the epoch of art's rebelliousness and secession from society would have come to an end. Today, the consciousness of drastic oppositions has faded from American art; all modes have been legitimated, and preference for one over another, if any, is determined by taste or some theory of art history. With the presence in the sixties of Oldenburg and Segal as Pop stars of the Janis Gallery, "Sharp-Focus Realism" could hardly amount to a confrontation. Nor has the abstract art of the past decade been of a quality to evoke the passionate allegiance aroused by Abstract Expressionism. After years of being presented with displays of stripes, color areas, factory-made cubes, accompanied by sententious museum-catalogue and art-magazine puffs, the art world might well have reached the frame of mind to welcome a supersize colored postcard of a Rose Bowl parade.

The man in shirtsleeves near the gallery entrance was Sidney Janis—except that he was too heavy and too relaxed, and, besides, he was made of plastic by Duane Hanson. Janis was standing in a corner of the next room, but this time he was a painting by Willard Midgette.

Through the crowd I saw Janis flit into his office, but he looked too tan and a bit more wizened than I remembered, as if he had been modeled by John de Andrea, creator of two nubile nudes of painted polyester and fiberglass in another part of the gallery. That vanishing figure, however, was the real Janis. It is difficult to be sure which of the Janises was the most substantial; nothing can match super-realistic art in subverting one's sense of reality. The interval during which a painting is mistaken for the real thing, or a real thing for a painting, is the triumphant moment of trompe-l'oeil art. The artist appears to be as potent as nature, if not superior to it. Almost immediately, though, the spectator's uncertainty is eliminated by his recognition that the counterfeit is counterfeit. Once the illusion is dissolved, what is left is an object that is interesting not as a work of art but as a successful simulation of something that is not art. The major response to it is curiosity: "How did he do it?" One admires Hanson's *Businessman* neither as a sculpture nor as a concept but as a technical feat that seems a step in advance of the waxworks museum.

Illusionistic art appeals to what the public knows not about art but about things. This ability to brush art aside is the secret of the popularity of illusionism. Ever since the Greeks told of painted grapes' being pecked by real birds, wonder at skill in deceiving the eye has moved more people than has appreciation of aesthetic quality. But for art to depend exclusively upon reproducing appearances has the disadvantage of requiring that the painting or sculpture conform to the common perception of things. De Andrea's *Two Women* miss being mistaken for human nudes because they are too small and have hair that looks like a wig. According to the exhibition catalogue, the figures are "life size," but, as I have noted, illusionistic art tends to generate impressions that are not in accord with the facts. Regardless of whether or not they are as large as average women, on the floor, nude, surrounded by a crowd, they are too small to be credible. And while it is true that girls do wear wigs, hair that looks artificial is inappropriate on simulated girls. If, however, de Andrea's women are not "real," even for a moment, what are they? They are pretty figurines,

but, precisely to the extent that they seem made of flesh, they are a bit grisly in their prettiness, like a beautiful woman known to be suffering from a fatal disease. In their case, the disease is the failure to be alive, even in the spectator's first impression, plus the failure to be art. Among the other puppets in "Sharp-Focus Realism" is Jann Haworth's *Maid,* a doll that can look human only to those who have forgotten the look of human beings, and this forgetting is prevented by a photograph, in the catalogue, of Miss Haworth seated beside her creation. George Segal's white plaster figures are specters that recall to onlookers the people from whom the casts were made; in them, obvious artifice holds reality at arm's length and thus keeps it intact. In Haworth's "sharp-focus" maid, the absence of art eliminates reality, too, and leaves only a costumer's stereotype. Robert Graham's miniature nudes, realistic in their anatomy and skin shades, inhabit glass enclosures that are perhaps intended to suggest terrariums in which a new race of tiny human creatures, protected from pollution, is being bred. Of the sculptures in the show, Hanson's *Businessman* comes closest to fooling the eye, no doubt through the assistance of authentic posture and clothing; de Andrea's *Sitting Black Boy* is, by being naked, unable to rise to this level of deception.

The most successful visual counterfeits, however, are achieved not with free-standing figures but with paintings of objects against a flat background, as in the simulation by Claudio Bravo of a rectangular package tied with cord. With this type of subject, traditional techniques of Harnett, Peto, Raphaelle Peale, and still earlier illusionists are brought into play: lights and shadows produced by intersecting cords and folds and wrinkles in paper make objects appear to stand forward in space. Stephen Posen's *Purple (Split)* is also a painting of a package, though a more complex one than Bravo's; it simulates a pile of cartons of various sizes and shapes covered by a purple sheet that falls in folds about them, and it seems to jut out from the wall. Boxes on a wall are a purely arbitrary motif, and Posen no doubt chose it in order to display his virtuosity in painting drapery and creating three-dimensional forms on a flat surface. Marilyn Levine's suitcase

and boots in stoneware are translations of objects into a different substance without altering their appearance—essentially, this is conceptual art that brings to the eye nothing not present in nature but instructs the spectator that things may not be what they seem.

In Janis' 1962 exhibition, the new Pop art was mingled with half a dozen older modes of representational art. As is evident in the works I have been describing, "Sharp-Focus Realism" shades off similarly into familiar categories of image-making. While Hanson's *Businessman* is naturalism pepped up with new materials, Bravo's lifelike package could have been produced a century ago. Evelyn Taylor's *Untitled* is a Magic Realist canvas in which, as is characteristic of this style, figures and objects stand apart from one another as if they were suspended in an invisible aspic. Paul Staiger's *The Parking Lot at Griffith Planetarium* and Noel Mahaffey's *St. Louis, Missouri*, could have come out of an advertising agency's photographic and design departments without the bother of having been translated onto canvas. Philip Pearlstein's *Nude with Outstretched Arms, Green Sofa* is an academic painting that thumbs its nose at academic composition by cropping the model's head just above the eyes and retaining a stray thumb.

The nucleus of novelty in the exhibition is a group of paintings that share an aggressive glitter precipitated by camera close-ups; it is the duplication of photographs upon canvas that constitutes the new realism. They include Richard Estes' *Diner*, Ralph Goings' *Rose Bowl Parade*, David Parrish's *Motorcycle*, Tom Blackwell's *'34 Ford Tudor Sedan*, John Salt's *Blue Wreck and Truck*, Malcolm Morley's *Amsterdam in Front of Rotterdam*, Don Eddy's *Showroom Window I*, Robert Cottingham's *Shoe Repair*—businesses, motors, entertainment. Each of the paintings is a composition of shining shapes, reflected lights, and clearly defined details skimmed by the camera lens from surfaces of polished aluminum, steel, and glass, painted fenders, electric signs, crowds, and closely packed buildings photographed from above. (Mahaffey's *St. Louis* fits the canon in this respect.) "Sharp-Focus

Realism" represents a renewed relation not between art and reality, or nature, but between art and the artifacts of modern industry, including the mass media. The new paintings and sculptures converge with Pop in that both modes, while seeming to base art on life, actually convert it into variations on existing techniques of visual communication. Pop art fed on the comic strip, grocery labels, news photos, commodities, packaging, billboards. The current "realism" explores such other veins of the media as the photographic travel and publicity poster, the service booklet and the product catalogue, the showroom, the storefront, the picture-weekly glossy—all presided over, one might say, by Hanson's dummy businessman.

Photo-into-art creations are alien to older forms of representation and ought to be exhibited and appreciated apart from them. A painting by Edward Hopper, for instance, embodies the sensibility of a single individual developed over years of looking and drawing, and the same, with all due attention to differences in quality, is true of such contemporaries as Pearlstein, Alice Neel, Lennart Anderson, and Gabriel Laderman. In contrast, a sculpture by Hanson or a canvas by Estes or Goings is welded to the objectivity of the camera, and to the extent that photographs of things have become more real to Americans than the things themselves they achieve superior credence precisely through their obvious artificiality. Estes, to my mind, is the most consistently satisfying of these artists in that he candidly treats painting as a photographic problem of reflecting objects as they appear, while composing in series of brightly colored verticals and horizontals. Pop art introduced a mood of cool neutralism as an antidote to the emotional heat of Abstract Expressionism. This frame of mind has been inherited by Photo Realism, but without the counterawareness of expressionist subjectivity; the new coolness came in from the cold. An outstanding quality of Sharp-Focus Realism is the absence in it of any tension aroused by the art of the past.

Pictures that copy appearances have been an obsession of American art since the early draftsmen of the exploring expeditions. Current conceptions of art as "information" reinforce this obsession.

In copying in paint its photocopies of nature, the present generation of realists seems to feel freer of the demands of art than any of its predecessors. By all evidence, a new stage has been reached in merging painting and sculpture into the mass media. Though William Harnett is a model of the current illusionism, its tutelary spirit is Andy Warhol.

THE ARTISTS

Part III

THE PHOTO AS SUBJECT: THE PAINTINGS AND DRAWINGS OF CHUCK CLOSE *

William Dyckes

William Dyckes warns against coming to conclusions about the work of New Realist artists merely from viewing reproductions, particularly in the case of Chuck Close who ". . . has been one of the most successful in getting at the central problems Photo Realism poses."

The author describes the technique of Close, a leading figure of the New Realist school, in great detail beginning with the artist's early work and concluding with the recent portraits.

Close himself notes: "Had the schools I went to been teaching figure painting, then I'm quite sure that I wouldn't be doing what I am. I knew absolutely nothing (about) figuration."

William Dyckes has written articles for Arts Magazine, Art International, *and* Art and Artists. *He is the author of a book on*

* Reprinted from *Arts Magazine*, Vol. 48, No. 5 (February 1974).

contemporary Spanish art and is making a documentary film on Chuck Close, in collaboration with the artist.

"People keep asking me if I'm still painting heads, and if I say yes they think there's been no change." [1]

About two years ago an art-history seminar at a West Coast university discussed the topic "Chuck Close: What Can He Do Next?" They devoted several days to his work and the corner into which he was supposed to have painted himself, yet none of them had ever actually seen one of his paintings.

Though it is unlikely that many people would fail to be aware of the difficulties involved in dealing with an artist like van Gogh or de Kooning strictly on the basis of what they had seen in books and magazines, the hazards of drawing conclusions from greatly reduced halftone reproductions of photographs of paintings that are intentionally photographic in appearance seems to be less readily perceived. The Photo Realist segment of the New Realist movement has been the victim of many such oversights: of the ironic fact that the very medium that inspired it is also the one called upon to disseminate it; of a superficial resemblance to other methods of painting that draw on the same visible world for their material; of the various pressures applied by those who had reason to encourage or discourage realist movements; and of critical attitudes that have moved reluctantly from outright rejection to tepid recognition of established fact. Of all these artists, none would seem to have been as misunderstood or underestimated as Chuck Close, despite the fact that he has been one of the most successful in getting at the central problems Photo Realism poses.

It is the economy of his style, along with his human subject matter, that has created most of the confusion, leading the viewer easily but unintentionally into iconic pitfalls that distract from the

[1] In conversation. All unidentified quotes are taken from tape-recorded interviews with the artist between January and September 1973. Close read, corrected, and discussed the manuscript of this essay prior to publication. I am also indebted to Don Eddy for suggestions and observations about Close's art and his own.

real point of his work. It is a difficulty that might be overcome if people were to think of Photo Realism in terms of field painting instead of Pop art—as a system of "art marks," as Close has often called them, rather than icons of the banal.

Since the invention of linear perspective, the accurate translation of three-dimensional shapes and settings into two-dimensional ones has been a central and often vexing problem of the realist painter. It was a motivating factor through several major style changes prior to the invention of photography, when the artist was finally relieved of the task of documentation and left to pursue more fully those more entertaining problems of expression that had been piling up since the baroque period. Although a fair number of those who depended on portraiture for a living were pleased to have access to a mechanical means of resolving the spatial-translation problem, the majority clearly viewed the camera as an unworthy rival and began to turn away from stricter forms of representation to stress the abstract, design qualities that only the artist's hand and eye could capture and to make a more conscious point of the uniqueness of his materials.[2] The idea of borrowing not only the technical skills of photography but of imitating its physical characteristics as well was literally unthinkable at the time—and continues to be so for a large part of the public even today.

By the latter half of the sixties, art was ripe for a photographic style—not because of a renewed interest in realism, but because the camera and the photograph had achieved such absolute currency in everyday life. There was no longer any question of competition after a hundred-odd years of the most radical experimentation in both arts. Moreover, the imagery of the media had become an integral part of the landscape, recorded, interpreted, and even directly employed by a generation of Pop artists. At the same time, artists moving into areas

[2] "Impressionistic composition is unthinkable without the application of focus. The lens of the camera taught the painter . . . that all subjects cannot be seen with equal clearness . . . it was the broadcast appearance of the photographic images in the eighteen-sixties that taught the Impressionists to see and represent life in focal planes and divisions." Sadakichi Hartmann, *The Whistler Book* (Boston, 1910), pp. 163–164, quoted in Van Deren Coke, *The Painter and the Photograph*. (Albuquerque, N.M.: University of New Mexico Press, 1971).

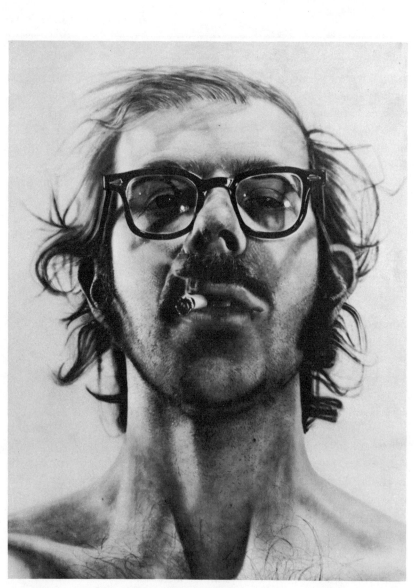

CHUCK CLOSE: *Self Portrait.* 1968. Acrylic on canvas. 108″ x 84″. Collection of Walker Art Center, Minneapolis, Minnesota.

involving performance or monumental constructions at a distance from the public turned to the camera to document, interpret, enhance, and diffuse their work. Photo Realism was undoubtedly a foregone conclusion, even if no one happened to be aware of it at the time.[3]

Selecting a subject matter presented the future Photo Realists with more problems than they expected. The traditional weight of this element in representational art proved a distraction to viewer and artist alike, and even though the artists appear to have tried to minimize the confusion by limiting themselves to single subjects in order to emphasize their essential concern with questions of technique, their audience has generally taken it to mean exactly the opposite and come to distinguish them by the much simpler means of stating what they usually depicted.

The absence of the human figure was a hallmark of the early Photo Realist movement, a fact that should have made it clear very early that this particular approach to realism was not like those that have perennially appeared since the invention of Cubism. Of all the artists who began working with photo-based images in the mid-sixties, only Close elected to focus on the human figure, but he, too, has side-stepped the many problems raised by the existence of a long European tradition of figure painting. By stressing the photographic quality of his image he has managed to treat his subject more as an object than a being. Even so, Close's decision to paint the face went against the conventions being prescribed by those who viewed the New Realist impulse in terms of Pop art and who carped against all but the most banal subject matter, which they held to be an essential element of a specifically American form of realist painting.

Close was moved by the need for a more demanding model against which to measure his work. The human face provides as many problems of shape, texture, surface detail, reflection, and so forth as

[3] For a more extensive commentary on the Pop generation's interest in and approach to photography, see Richard Hamilton's collected statements and observations in the Guggenheim Museum catalogue of his work, published September 1973.

the materials of city landscapes. And if faces are not among the least emotional things one can portray, the struggle to keep them impersonal adds to the interest of making them. Using his friends as subjects requires him to be exact. Painting less specific, nonhuman surfaces would allow too many imprecisions to get by simply because they would be too difficult for him (and the viewer) to detect.

In order to make the photograph's information about the surface of the face both available and unavoidable, Close employs a gigantic scale. In approaching these works one is first aware only of the head itself, but upon moving in—drawn by the promise of a vast amount of unusual additional information—one is forced to relinquish this image and deal only with the real content of the painting: how the details of a face as recorded by a camera have been translated by the artist into colors and shapes made of paint. Moving in toward the picture the illusion of space through focus gives way to an awareness of the flatness of the painted surface and the brilliance of certain highlights fades into the dullness of the paper and paint, just as the image of the face itself becomes a kind of abstract landscape.[4]

This treatment of scale is more important and complex than one might expect, for the whole concept has changed drastically in recent times, from that of a relatively minor element dictated by the subject matter of factors exterior to the work itself (would it decorate an entire wall or a small chamber? was its purpose to exalt or simply to record?) into a major one. Since the day that Jackson Pollock broke the wristlock on painting and extended the working gesture to include the entire arm and torso—to his own ability to throw the paint across the canvas—scale has been carried to colossal proportions that are limited only by the physical and economic means available to the

[4] Several years ago Close experimented with scale in another medium. Using a live model and a very precise system of panning, he made a portrait with a movie camera, slowly crossing the picture area with a macrocloseup lens that provided a high degree of detail on the screen. The system was much more effective in enforcing a concentration on details, but it proved virtually impossible to identify the correct head from photos after only one showing. *Slow Pan/Bob*, 16mm., black and white, ten minutes long, 1970. Available from the Bykert Gallery, New York.

artist (e.g., Claes Oldenburg's proposals for gigantic monuments based on common objects, and Michael Heizer's drawings made with a motorcycle). Scale was a far more essential element of Pop than it had been of Abstract Expressionism, encouraged by billboards, the generally prodigious proportions of the land- and cityscapes it celebrated, and the anything-goes attitude of the artists. Though it was arrived at for very different reasons, Close's huge scale immediately encouraged seeing his work in the same terms as James Rosenquist's, and the consequent assumption that what he was doing was merely a technically more refined version.[5] In fact, his scale has proved quite unique. John Roy (the subject of the painting *John*) has pointed out in discussing these works with Close that when the paintings of the Abstract Expressionists became larger, their brushwork also became larger, so that scale—part to whole—actually remained the same. Close was the first painter to work on such an enormous scale without making correspondingly large marks.

In spite of his attempts to reduce emotional content, the works unavoidably retain (or acquire) a certain level. The sheer size of the heads leads to descriptions that favor the word *monumental* and suggest a kind of exaltation of humanity or a godlike superiority. The effect is further encouraged by the single concession to the logic of the image that Close allows to infiltrate his pictures—shooting the photographs from slightly below, in keeping with the visual relationship that the viewer will have with the work when first confronting it.

[5] See for example Hilton Kramer's attack on Close as recently as two years ago (*The New York Times*, December 26, 1971). What seems to have happened is that there is an inevitable confusion of motivations caused by the overlapping of our rather brief contemporary "periods." To understand why Close sees the way he does one must remember that he is really a product of the fifties, "when you were sort of programmed to turn on to oil slicks on mud puddles and cracks in the sidewalk and all that"; trying to link him too directly to the inventions of Pop is extremely misleading when he thinks more like an Abstract Expressionist. Don Eddy is another good example of the varied sources of the Photo Realist movement. He started to paint when isolated from contemporary movements and was gradually moved toward this style because of his background as a professional photographer and simply because his knowledge of art history was largely based on reproductions.

The anonymous, head-on mug shots are kept as cool as possible, lighted and posed not to flatter the subject but to supply interesting painting problems. Any suggestion of expression on the part of the model is avoided—a smile would provide a whole new set of lines and shapes and textures to examine, but the overall look of the image would be too strong. As it is, the way the subjects focus their eyes on the single point of the camera's lens—and therefore *both* of the viewer's eyes at once—creates a unique and very disturbing sensation (which is impossible to achieve other than photographically). "I reject humanist issues in my work," Close insists, but he admits that "that doesn't mean that there aren't, ultimately, other levels of content. It's just that I can't afford to think about them."

Close's gargantuan amplification and literal interpretation of photographic information force upon us the realization that we have never carefully examined the world around us, or the various ways in which it is presented to us. The fact that so many persist in seeing these paintings as highly factual representations of people rather than as *photographic* representations of people is proof of the total assimilation of photographic syntax as visual fact. It is an easy enough matter to bypass the sensation of distortion in a family snapshot or a newsphoto, but it requires a lifetime of training to screen so much out of a nine-foot-high painting.

Unlike so many other forms of realism, which tend to celebrate the visible world and the remarkable abilities of the painter's eye, Photo Realism is essentially critical. It raises questions about the way we see and reminds us of the many physical and psychological factors that alter, compensate, or diminish the things we look at. These artists do not present photographs as a more truthful way of seeing, but as a means of understanding more about what we do see. Photo Realism is not only unconcerned with realism, it is actively involved with artificiality. Those artists who use the camera as something more than a translation device—and they are the only ones who may accurately be called Photo Realists—are aware of its shortcomings and gladly make use of them to expand the vocabulary of art.

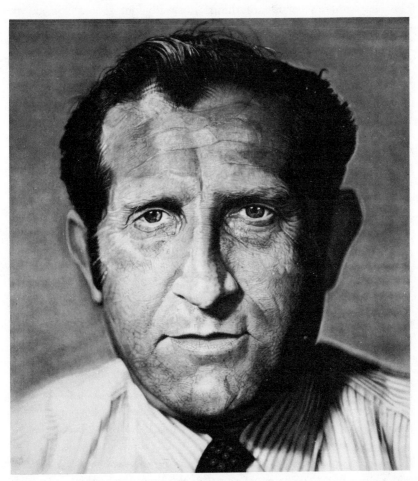

CHUCK CLOSE: *Nat.* 1971. Three-color process, acrylic on canvas. 100″ x 90″.
Photograph courtesy Bykert Gallery, New York.

The camera's version of things is simply not so realistic as we tend to believe. It does not record things in the same way that we see them. Its lenses have never been able to duplicate the range of field of the eye without extreme distortion; its treatment of perspective is substantially different.

The focal length (for the 8″ by 10″ camera he uses to take the original photograph) that most closely resembles that of the eye is the 160 mm. lens, but Close uses a 190 mm. lens to make his working model. The reason for this is his wish to exaggerate the focus of the picture by restricting the depth of field to only an inch or so at the plane of the eyes. The longer lens can do this more readily, but it also compresses. (The general effect of longer focal-length lenses on perspective can be seen in the familiar "stacked-up" look often encountered in arty photos or movies, where distant automobiles seem to be on top of one another instead of one after the other.) The distortion is fairly mild with a 190 mm. lens, yet it alters the subject's appearance enough to give a narrower look to the head. This is partially camouflaged in Close's work by the extremely tight focus, which makes the nose and ears seem farther apart, but it may well contribute—along with the "push" of the focus—to the strange sensation that we get from these portraits, despite his best efforts to defuse them.

Depth of field is closely linked with scale in these works; the former is very dependent on the latter. An extremely limited depth of field is only confusing in a normal-size photograph, because an out-of-focus tip of a nose makes no sense to us when it is only a fraction of an inch away from a sharply focused eye. But taken up to a scale where the two are several feet apart, the differences become understandable and a very vivid sensation of physical depth is established, in which the eyes are level with the picture plane, the nose seems to hover out in front, and the ears and shoulders are set well back. The result is so striking that one wonders how it happens that painters have for so long ignored or rejected focus as a means of suggesting depth.[6]

[6] Close is not, of course, the only one to be experimenting with focus and perspective today, although a surprisingly small number of artists are. Ben Schonzeit has

Close's painted focus clashes with our own, imposing a different kind of viewing. We are accustomed not only to supplying our own focus but also to adjusting it at a point slightly in front of the picture we are taking in, so that we can absorb the entire image at once.[7] This is a relatively sophisticated way of seeing, one that came about with the invention of perspective drawing and the idea of a painting as a unified work, and it has been powerfully reinforced by the larger size and constantly changing images of the motion-picture screen. Close manipulates the focus and perspective in an attempt to "orchestrate" our response, establishing preferential viewing distances and leading the eye, but he does not try to follow the cinematic convention of using focus to designate important areas. On the contrary, he fully intends to call attention to the beauty of the reflection of an earring or a strand of hair when it is blurred—things that we would never normally notice in a photograph or a film and are utterly incapable of seeing with our eyes alone. The pleasure that he gets in discovering these details as he paints is one of the principal risks he runs: the unconscious desire to "crank it up a little" and make the area *too* interesting.

Ironically, Close became a Photo Realist not because he was interested in the photographic image but simply because he wished to

done some of the most spectacular things in this area, but his contributions were obscured for a long time by the distracting conglomeration of colors and *effects* he was putting into each painting. In 1973 he began to concentrate on simpler and more easily recognized subjects, relying too heavily, perhaps, on sheer size. Don Eddy is a particularly interesting case because he has gone for just the opposite effect, using the camera to achieve a highly restricted sense of dimension. In his more recent works, where he has moved away from surface reflections to deal with transparencies, Eddy has manipulated extreme depth of field to overcome the natural selectiveness of the eye in viewing a shopwindow and sandwiches—many planes of various depths on the same level. He, too, is essentially a field painter and is concerned with the interactions of shapes and colors rather than with the representation of specific objects in space.

[7] "Film Literacy in Africa," *Canadian Communications*, Vol. I, No. 4 (Summer 1961), pp. 7–14. Quoted by Marshall McLuhan in *Gutenberg Galaxy: The Making of Typographic Man* (New York: New American Library, 1969), pp. 36–39. African audiences, the article further states, normally scan the image in more or less the same way that Close wants us to do in his paintings.

impose more discipline on his work. Like every artist who has been to art school, he discovered that his first need was to escape his education. He had acquired a great facility for producing paintings under the rules of abstraction that held sway in the more advanced schools of the late fifties and early sixties (in his case, the University of Washington in Seattle and the graduate school at Yale). "Had the schools I went to been teaching figure painting," he observes, "then I'm quite sure that I wouldn't be doing what I am. I didn't think of this consciously at the time, but if I'd had to look around and find something about which I knew absolutely nothing, it was figuration." His West Coast background may also have been influential, for figuration had continued to be an issue there long after it had been rejected in the East; but the painterly style that prevailed was too much like the form of Abstract Expressionism he had learned in school to offer any real change. He did not wish to interpret forms any longer but to start over again in very controlled circumstances. So he elected the most precise model and syntax he could find—that of the camera.[8]

His first attempt at a photographically realistic kind of painting was a nude of Cinemascope proportions, which he began in 1966. The first version was never completed because it soon became obvious that the problems involved were far greater than he had anticipated. On the second try he discarded brushes altogether and cut back from a full palette to black paint alone, using the white of the canvas as a photograph uses paper. Still not entirely sure of how to go about it, he tacked a twenty-six-foot-long canvas to the wall and began to experiment.

I started at one end of the painting and by the time I got to the other I had used it as a testing ground for a lot of different systems of

[8] The term *syntax* as employed here is borrowed from William M. Ivins, Jr.'s, seminal study of the evolution of prints, where it is applied to "a convention of drawing" developed in any period to fit the needs of the craftsmen who cut and printed wood blocks or engravings. It seems a particularly apt term in describing Close's work because of his decision to adapt a mechanical reproduction system. *Prints and Visual Communications* (Cambridge: Massachusetts Institute of Technology Press, 1969).

getting stuff on. I used sponges, rags, spray guns, razor blades, even erasers. I stuck a pencil eraser in an electric drill and started to use that to take off the paint I didn't want. When I began, the only thing I knew for sure was that I didn't want to use white paint.

The painting ended up as an erratic anthology of techniques, too inconsistent and obviously too confused to be shown, but an extremely efficient learning device. Among other things, it led him to adopt the airbrush for its precision and absence of brushwork and impressed upon him the need to concentrate on the problems of syntax—which, in a sense, is what his painting has been about ever since.

Before attempting any further works, he made a number of large pencil drawings in which he sought a relationship between the way a drawing is made and the way a painting might be, using only the white surface of the paper and the black graphite. Then, settling upon the portrait as his subject, he began the first series of works—eight large black-and-white heads that occupied him from November 1967 through April 1970.

By the end of this series Close had refined his technique to a degree that appeared insuperable and, not having any more problems to resolve, he began to look around for new ones. "I didn't get bored with the image," he cautions,

> but with the process, with not having anything new to think about in the studio. I wanted a *real* change, one that would affect the way I thought, the tools I used, and all that, and that's when I decided to get color back into my paintings. I'd originally gotten it out because I'd always been too dependent on it, too dependent on certain "learned" color relationships. But this time I tried to find ways where I didn't need a palette and where the color literally mixed on the canvas.

The initial problems required about a year to work out, this time with colored pencils and watercolor paints. He turned to another photographic process, the dye transfer, to break the image down into the three component colors—the red, blue, and yellow bases—and their intermediate combinations. Setting these up alongside of the painting,

he proceeded to duplicate each step in order (an extraordinarily difficult feat of matching, simple as it may sound). He began at the top in order to avoid accidents and worked his way down, area by area, staying within boundaries defined by wrinkles, scars, shadows, or edges, and completed the full set of colors before moving on, a system that helped him to maintain constant values throughout the work. He applied exactly the same system to the background, reproducing it with all three colors even though it happens to be a fairly uniform and anonymous gray.

The acrylic color series, begun in January 1971, was completed in only four works, largely because of difficulties posed by the material.

> The opacity of the pigment was such that I was never able to have the system work completely to my satisfaction. Although it was possible to make paintings I liked, the system still seemed too bogged down in things that were qualities of the pigment. It was too coarse and not transparent enough, so I decided to make a change in my way of thinking about it. First I changed the scale, because that would change the way my hand moved and also the surface. And then I changed the paint and the base to watercolor and paper.

So far he has painted only two of these, between the summers of 1972 and 1973, both on a scale slightly larger than half of what he had used before. He hopes to try at least one more, this time working in an even larger scale than the acrylics.

Color is another parameter of Close's art that, if not as important as focus and scale, nevertheless offers major opportunities for the development of a new syntax. Photographs, and especially printed reproductions, have a very weak claim to verisimilitude, no matter what the advertisements say. Magazine color in particular is hopelessly artificial, being subjected first to an impossible division into three basic tints and then reconstructed largely by guesswork in a printshop where great numbers of copies are run off on a press that is constantly changing amounts and strengths of ink. The covers of *Newsweek*, to give just one example, often run to wild extremes that will strike everyone

CHUCK CLOSE: *Self Portrait.* 1973. Ink applied with airbrush, and penciled grid. 70" x 57". Photograph courtesy Bykert Gallery, New York.

as downright garish in another ten years. True, they are dictated in part by the needs of the advertiser on the back cover and the desire to attract the eye on the newsstand, but they are not atypical. Compare the reproductions in your favorite thirty-five-dollar art book with the original sometime and you may find reality slightly disappointing. Not even those conservative Swiss printers with their seven-color processes seem to be able to resist tarting things up a little.

What Close sees and brings out in the color of his paintings is much the same thing that the Pop artists saw, but it is far more subtly stated. Their obsession with vulgarity as a national characteristic led them to the more blatant manifestations that occur in advertising. Close's coloring, like the rest of his painting, is not supercolossal but simply larger than life.

"When I was doing the black-and-white paintings," he recalls, "I got along perfectly well with a black-and-white TV. But when I started the ones in color I had to go out and buy a color set. It's funny, but I didn't really *see* color for many years. But when I started to work with it again I kept bumping into colors I really liked." He is fascinated, for example, with the way that television deals with a tone as traditionally pedestrian as gray, making it "the most incredible color in the world because it is actually red, green, and blue. It has a kind of subliminal, full-saturate quality to it. Maybe it'll be a bluish gray or a reddish gray, but it's the *richest* goddam gray I've ever seen."

Close's most recent experiments constitute his most radical departure, a series of "drawings" done with an airbrush. Unlike the others, these make no use of the instrument's capacity for blending but only for controlling density. He has broken his image down into tiny dots of gray set in grids that range from as few as eleven squares across to more than two hundred in experiments that test the degree of detail necessary to convey the essential information about the face and the original photograph. They are a product of his desire to maintain a maximun neutrality toward every part of the image and another step toward the ideal of economy.

Looking at the eye is one thing and looking at the cheek, another, but I have always tried to have the same attitude toward both of them. But because of the nature of things I had to function differently. The act of making an eyelash with one long stroke is not the same as making a cheek. So as much as I was interested in sameness, there was still a need to function differently, depending on what I was doing. But by breaking it down this way I can make the act of painting exactly the same all the way through.

Close calls these works drawings because the issues involved seem to him to be drawing issues. They, too, are about artificiality, but in a more obvious way than the paintings. No attempt has been made to erase or otherwise conceal the grid, which automatically establishes the picture plane. And even though the fuzzy focus of the individual dots promotes a strong sensation of depth behind it, the grid constantly brings the viewer back to an awareness of the fact that this is a flat surface.

The whole complex image is built on a suprisingly simple base, a structure of four dots set in a square that shifts the artist's reference point from the surrounding dots—which could easily lead to confusions —and relates the question of values more directly to the photograph he is using as a model. Needless to say, Close is reusing the same black-and-whites that served him for the paintings. New images are hardly necessary when he is dealing with them in entirely different ways. The next step is color, of course, and he has already begun to make smaller studies toward this end. Among his other immediate plans is a three-color lithograph, a project that will take at least six months and requires a special press that will take eight-by-six-foot paper.[9]

It is an interesting coincidence (perhaps less of one than he himself realizes) that these works also correspond to a form of photo syntax in spite of their practical origin. It is, of course, that of television

[9] He previously experimented with the long-abandoned technique of the mezzotint in the spring of 1972. A short account of this print was published in *Arts* (December–January 1973), p. 73.

and wirephotos (but not that of halftone reproductions, which re-create shadings by the *size* of the dot), and again it is a form of syntax that has thus far been ignored, a whole new area to explore. The more he takes away, the more he finds to deal with.

Chuck Close: What can't he do next?

ROBERT BECHTLE: *1971 Buick.* 1972. Oil on canvas. 48″ x 68″. Photograph courtesy Louis K. Meisel Gallery, New York. Collection of Ed Cauduro.

CHARLES BELL: *Gumball Machine #1*. 1971. Oil on canvas. 54″ x 72″. Photograph courtesy Louis K. Meisel Gallery, New York. Private collection.

ARNE BESSER: *Betty*. 1973. Oil on canvas. 72″ x 52″. Photograph courtesy Louis K. Meisel Gallery, New York. Collection of Stuart M. Speiser.

TOM BLACKWELL: *Enfanta.* 1973. Acrylic on canvas. 48″x 72″. Photograph courtesy Louis K. Meisel Gallery, New York. Collection of Mr. and Mrs. Morton Neumann.

ROBERT COTTINGHAM: *Newberry.* 1974. Oil on canvas. 78″x 78″. Photograph courtesy O. K. Harris Gallery, New York.

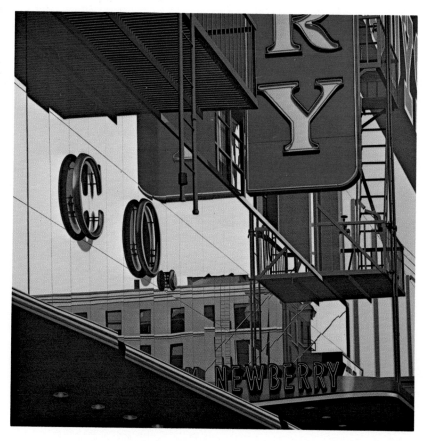

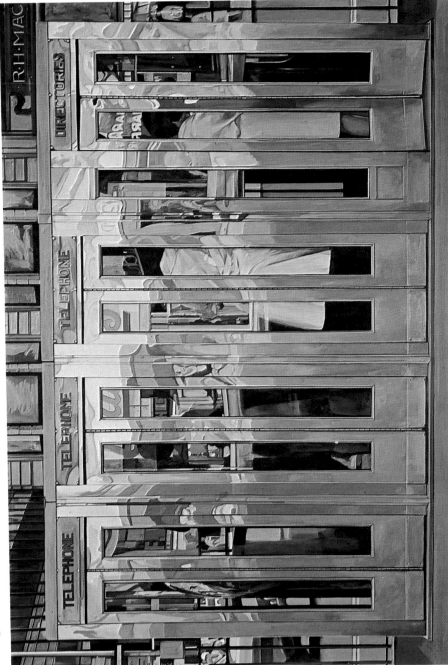

RICHARD ESTES: *Booths*. 1967. Oil on canvas. 48″ x 69″. Photograph courtesy Louis K. Meisel Gallery, New York. Collection of Haigh Cundey.

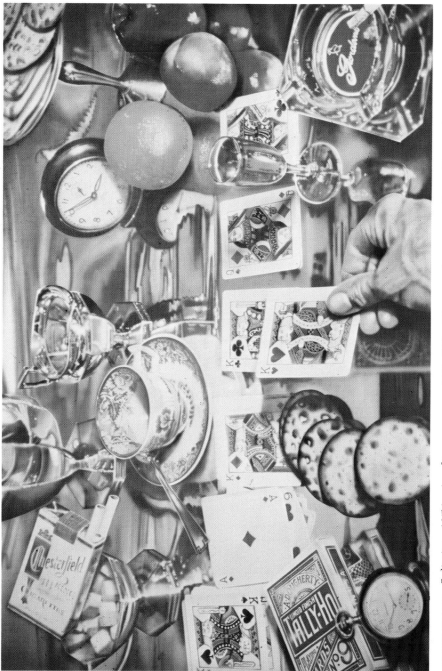

AUDREY FLACK: *Solitaire.* 1974. Acrylic on canvas. 60″ x 88″. Photograph courtesy Louis K. Meisel Gallery, New York. Collection of Mr. and Mrs. Barrie Damson.

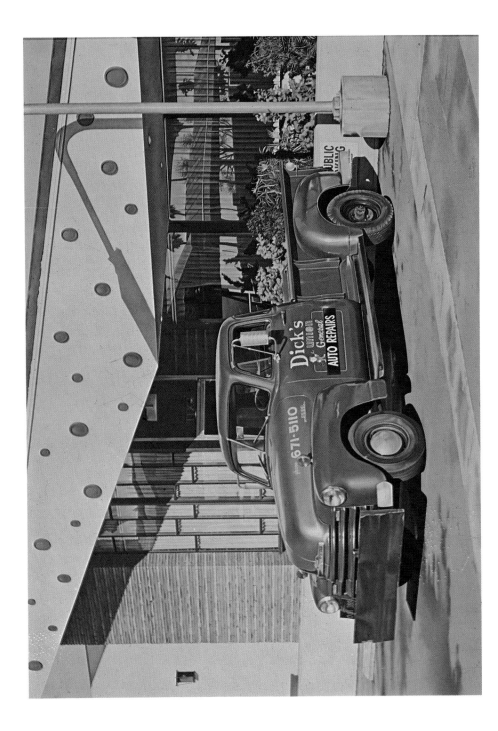

RALPH GOINGS: *Dick's Union General.* 1971. Oil on canvas. 40″ x 50″. Photograph courtesy O. K. Harris Gallery, New York. Collection of Sidney and Frances Lewis.

YVONNE JACQUETTE: *Twelfth at Second St.* 1973. Oil on canvas. 84″ x 70″. Photograph courtesy Fischbach Gallery, New York. Private collection.

RON KLEEMANN: *Mongoose*. 1972. Acrylic on canvas. 36″ x 48″. Photograph courtesy Louis K. Meisel Gallery, New York. Collection of Daniel Filipacchi.

SYLVIA MANGOLD: *Floor, Floor Mirror, Wall*. 1973. Acrylic on canvas. 84″ x 65″. Photograph courtesy Fischbach Gallery, New York.

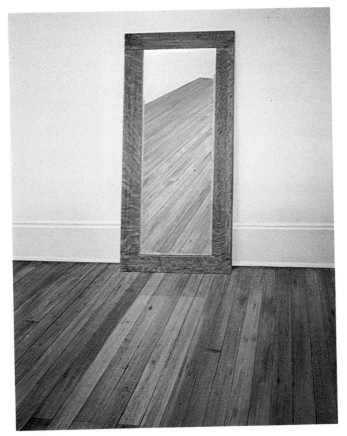

MARIANN MILLER: Untitled. 1974. Oil on canvas. 60″ x 90″. Photograph courtesy Stefanotty Gallery, New York.

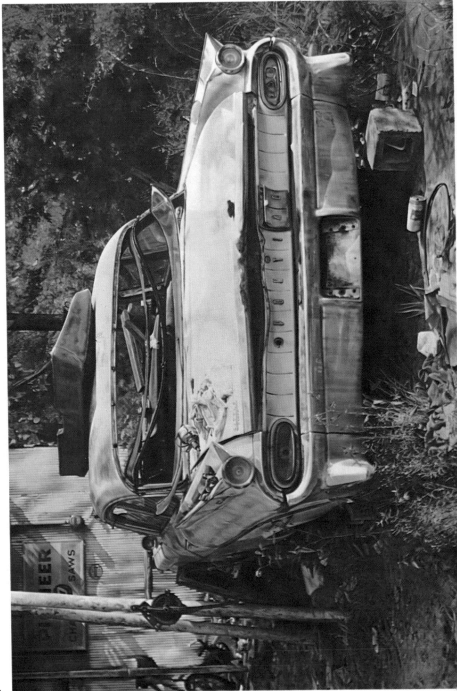

JOHN SALT: *Pioneer Pontiac*. 1972–1973. Oil on canvas. 49″ x 72″. Photograph courtesy O. K. Harris Gallery, New York.

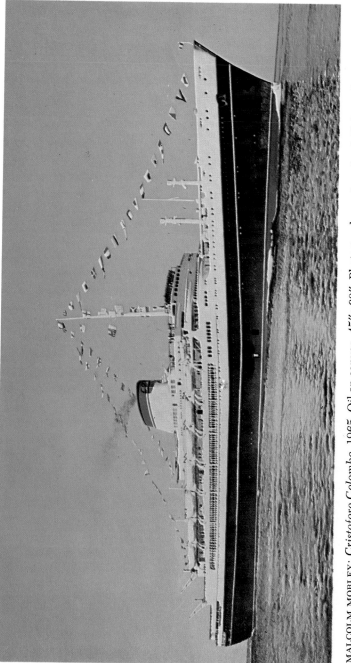

MALCOLM MORLEY: *Cristoforo Colombo.* 1965. Oil on canvas. 45″ x 60″. Photograph courtesy Louis K. Meisel Gallery, New York. Collection of Mr. and Mrs. Paul Hoffman.

MALCOLM MORLEY: *S.S. France*. 1974. Oil on canvas. 72″ x 64″. Photograph courtesy Stefanotty Gallery, New York.

JERRY OTT: *Study from Manson/Tate Murder*. 1973. Acrylic on canvas. 55″ x 68″. Photograph courtesy Louis K. Meisel Gallery, New York. Collection of W. Moos.

THE SILK PURSE OF HIGH-STYLE INTERIOR DECORATION*

Gerrit Henry

Douglas Bond's paintings differ from the work of other Super Realist artists in that their subject matter is ". . . not McDonald's stands, bad skin, or other symbols of cultural blight, but rather symbols of cultural, and, possibly, spiritual affluence . . ." So writes Gerrit Henry, who goes on to observe that the ". . . times are none too ripe for representational painting of any sort . . ." Yet he finds Bond's paintings "handsomely appointed, lovely to look at, and unique."

Gerrit Henry, an editor of Art News *magazine, criticizes Super Realism in detail earlier in this book.*

Since its inception a decade or so ago, Photographic Realism has for the most part been an art—or anti-art—of the banal, the ludicrous, the

* Reprinted from *Arts Magazine*, Vol. 48, No. 9 (June 1974).

blighted, and, often enough, the downright ugly. Witness Chuck Close's grueling super-scaled close-ups of the ravages of the human face; Ralph Goings' I-couldn't-care-less renderings of McDonald's and Carvel stands; Noel Mahaffey's sere, ominous aerial views of Phoenix, Arizona, country clubs; and, last but certainly not least, sculptor Duane Hanson's real-as-life incarnations of gross Miamians or blood-spewing, down-for-the-count prize fighters. Nothing especially appealing or engaging here; "beauty" was not a clause in the Photo Realist manifesto, nor was expression, or even social concern. The triumph of Photo Realism was, baldly and unequivocally the triumph of the technomechanical, and if artists of the persuasion had any slogan at all, it was, apparently, "I am a camera."

Refreshingly enough, the slogan behind young California painter Douglas Bond's Photo Realist canvases at the O.K. Harris Gallery in New York in November (1973) would seem to be "I am a camera with good taste," a proclamation to which a viewer accustomed to a more strictly know-nothing sort of picture-taking can only say hurrah. Bond's warmer, more romantic approach to photographic painting is by no means without precedent: witness Audrey Flack's ecstatic, tearful madonnas; Richard Estes' cruelly handsome, steel-and-glass city street-scapes; and sculptor John de Andrea's breathless, bouncing nude youths. All of these artists have been steadily working a more "romantic" Super Realist vein than the "classical" realists discussed above. Now the thirty-six-year-old Bond has come on the scene to put yet another delicious kink in what is surely the deadliest, "straightest" style of painting to appear in recent years.

The kink is, as mentioned, "good taste." As subject matter, Bond chooses to paint not McDonald's stands, bad skin, or other symbols of cultural blight, but rather, symbols of cultural, and, possibly, spiritual affluence: home furnishings, especially those much sought-after, Art Deco–inspired "antiques" of the 1930s and 1940s. Bond is a painter of interiors, quite visibly in the tradition of Hendrick Terbrugghen and Gerard Ter Borch, except that his compositions are peopleless. "Things," decorative and otherwise, are the characters in Bond's anec-

DOUGLAS BOND: *Bath Room*. 1972–1973. Acrylic on canvas. 76″ x 64″. Photograph courtesy O. K. Harris Gallery, New York. Collection of Susan Forrestal.

dotes of fashion, and they are allowed to speak for themselves. Rattan furniture, geometric-inlay floors, and monogrammed towels abound, as do semicircular Deco makeup tables, bamboo refreshment carts, glass-topped children's desks with flower decals on their sides, and, in one painting, cowboy boots and gun. If each of the decorative elements in these works tells a story, it is the story of itself, of its possible monetary or sentimental value, and, preeminently, of its place in the history of decorative fashions, whether that place be authentically deserved or nostalgically assumed.

Mindless nostalgia is, of course, one of the dangers an artist risks in doing this sort of thing. Bond neatly solves the problem by making each of his high-fashion interiors highly anonymous, blending fifties Postwar with thirties International and sixties Minimal with forties Casual, until the final effect of his paintings is that of their having been culled from the pages of some Modern Millennium edition of *Better Homes and Gardens*. One thing can be said for certain: the artist's two favorite rooms are the kitchen and the bathroom, a predilection for one or the other of which he shares with such many and diverse talents as Roy Lichtenstein, Jan Vermeer, the creators of *Father Knows Best*, graffitists, Jean Baptiste Chardin, George Segal, and the Alfred Hitchcock of *Psycho*. And with good reason: the kitchen and, more recently, the bathroom, have been and still are the two supreme domains of bourgeois man. In Bond's work, both locales take on an impossible dignity and luster, as evocative and poetic as they are antiseptic, and as invitingly habitable as they are roped off with velvet.

For all his affiliations with *haute bourgeois* art of the past and present though, Bond is still primarily a Photographic Realist. His technique is a la mode, glossy, precisionist, and unpainterly; his subject matter is not landscape and people, but places and things. The same thing is true of the work of the aforementioned Estes and Flack, leading us to conclude that the difference between the "classical" and "romantic" Photo Realists lies not in differing technique, content, or even treatment, but in differing *attitudes* toward the surroundings in which they live. The classical Photo Realist's apparent attitude is that

DOUGLAS BOND: *Bath Room.* 1973. Acrylic on canvas. 45″ x 66″. Photograph courtesy O. K. Harris Gallery, New York. Collection of William Jaeger.

the contemporary American reality—say, a Carvel stand—is, at bottom, too hideous to commit to canvas, yet commit it he must since he is a realist painter, and this is what he sees. The subject, not deserving of art, results in a completely destylized painting that is *not* art. If it isn't art, then it must of ontological necessity be something else, like, for instance, a *moral judgment*. This because the artist is not saying "I can't make art," but rather, "the cultural circumstances won't allow me to make art." The blame for the classical Photo Realist's work of non-art is implicitly laid at the feet of society: "there," the photo-painting of the Carvel stand seems to be saying, "is what you've done to me."

The attitude of the romantic Photo Realist, on the other hand, favors art over morality. He or she conceives of the contemporary American reality as a situation that must, by the very laws of nature, have its good and bad features, and it is this amoral, aesthetic sensibility that allows the artist to show a sense of style—if not actually employ one on canvas—in his discriminating choice of subject matters. Knowing that the sow's ear of the Carvel stand defies genuine artistic representation, Douglas Bond chooses the silk purse of high-style interior decoration as his subject, thus producing technically photographic paintings the content of which is purely artistic. Finally, Bond's appropriation of fashion magazine decors and Technicolor (rather than Kodacolor) hues may not be as amoral or frivolous as it seems: who's to say that an Art Deco tea set is any less "real" than an open pore or rolls of sunburned fat? To quote Maurice Merleau-Ponty: "It is imposible with man to superimpose a first layer of behavior that one calls 'natural,' and a fabricated cultural and spiritual world. All is fabricated and all is natural with man, so to speak . . ."

All things considered, of course, the times are none too ripe for representational painting of any sort, natural or fabricated, cold or warm, precisionist or painterly. Throughout this century the ongoing desecration of the landscape has been accompanied by the ongoing primacy of abstract art, so that the contemporary American painter who wants for whatever reason to paint realistically is faced with a double, and possibly a triple, dare. With no native realist tradition to

draw from, no recent representational masters to learn from, and nothing much to look at, the young realist painter is more or less fated to wind up working in a total vacuum. The less hermetically sealed, though, the better. Douglas Bond's vacuums are handsomely appointed, lovely to look at, and unique. Working in an area of painting the ethos of which is all too often materialism for materialism's sake, he displays the distinction of being a true spiritualist of the material.

MALCOLM MORLEY: POST-STYLE ILLUSIONISM*

Kim Levin

Malcolm Morley is generally considered the first artist to work in the Super Realist style. In this article Kim Levin traces his development from an abstract Minimalist painter to a realist painter whose paintings are ". . . about art as much as they are about the world."

Levin notes the relationship between Super Realist art and its Abstract Expressionist heritage. She observes that "The formal repetitions of the past decade contained the seeds of the current fascination with imitation . . ." Morley's early realist paintings— mainly pictures of boats—were, in fact, pictures of pictures or picture postcards of boats. Thus they were pictures of flat objects, not unlike Jasper Johns's "flags" or "targets" and Andy Warhol's

* Reprinted from *Arts Magazine*, Vol. 47, No. 4 (February 1973).

soup can labels. However, the scale has changed, and as Levin observes: "A photograph can be reproduced in any size, and scale becomes elastic."

Earlier in this volume in an article entitled "Existential vs. Humanist Realism," Linda Chase explains the importance of the photograph to Super Realist art. She points out that "The necessity of translating reality onto a two-dimensional plane involves the artist in choices that can never be completely objective."

Thus respect for the factual, the existential "flatness" of the painting is honored. Levin observes: "The subterfuge of painting landscape as an object would seem to carry with it the idea of place as a souvenir." And Levin concludes that: "Seeing only surfaces, he invalidates the distinction between figurative and abstract."

Recent paintings by Morley contain some dramatic changes, almost defacements, that, according to Levin, represent an evolving concept of realism rooted in the phenomenological philosophy of Maurice Merleau-Ponty. Morley's recent The Last Painting of Vincent Van Gogh *represents ". . . the self-inflicted death of inspiration, the end of the myth of the romantic artist."*

Kim Levin has contributed articles to Art News *and* Arts Magazine. *She is New York correspondent for* Opus *and has written a monograph on the art of Lucas Samaras.*

According to the ancient but recently relevant story, Zeuxis may have painted grapes so lifelike that birds pecked at them, but the curtain that Parrhasius painted across his picture deceived even Zeuxis: to the eternal embarrassment of art history he asked to have the curtain lifted. Vermeer pulled back the curtain and exposed, behind a transparent picture plane, a box space that could contain even the artist, but he left the viewer a voyeur on the other side.

"All two-dimensional surfaces are pornographic. You are controlled because you can't penetrate them," says Malcolm Morley, who

began his recent painting of Raphael's *School of Athens* as a public performance; [1] costumed as Pythagoras, with phony artistic gestures and with Scriabin being played in the background, he painted one row of the gridded canvas and a strip of the Raphael appeared.

Duchamp's *Etant Donnés*, instead of shutting the door once and for all on art, opened peepholes to long-forgotten puzzles. If the beautiful old man in carpet slippers fathered the art of the sixties, he also bequeathed a private joke to haunt the seventies: the old ghost of illusionism. To be or not to be is no longer the question. The question is: are we witnessing a rebirth of the idea of art as imitation? As Morley's favorite philosopher, Maurice Merleau-Ponty, predicted, "The inquiries we believed closed have been reopened." [2]

The story of real birds pecking painted grapes had long been obsolete: art as a counterfeit of life went out with Meissonier. However, the question of imitation began creeping back before the sixties, unrecognized of course. Robert Rauschenberg erased a Willem de Kooning and the "industrial" revolution began; the handcrafted gesture gave way under pressure. It started as a rude test of the uniqueness of the personal brushstrokes of Abstract Expressionism; Rauschenberg's pair of identical paintings, Jasper Johns's flat flags subjected it to the idea of repeatability. In the ensuing confrontation, the look of mechanical precision and mass production took over: repetition is the one element that unites the art of the sixties.

The Abstract Expressionist doctrine of art as a way of life, by shutting the material things of the world out of the studio, created the gap that led to a confusion between art and life. Art moved, literally, physically, into the domain of life—onto its own flat surface or into real space. It became another object in the world. *Illusionism* was a bad word in the sixties, but it was practiced by the very people who

[1] Invited to give a lecture at the State University of New York in Potsdam early in 1972, he did the performance instead.

[2] "Eye and Mind," *The Primacy of Perception*, ed. James M. Edie, trans. Carleton Dallery (Evanston, Ill.: Northwestern University Press, 1964).

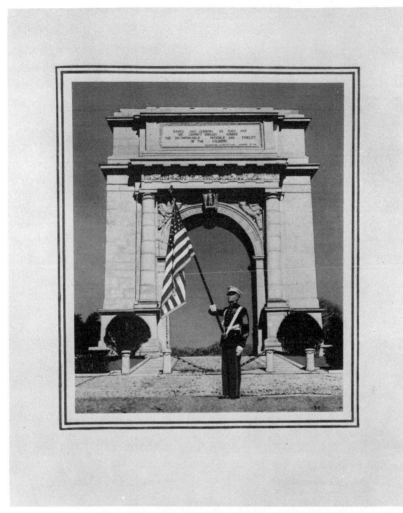

MALCOLM MORLEY: *U.S. Marine at Valley Forge*. 1968. Liquitex on canvas. 60" x 50". Photograph courtesy Stefanotty Gallery, New York.

hurled it as an epithet.[3] No one at the time would have said they wanted art to become more "lifelike," but the desire for the absolutely real led not only to making things literal but also to making things realistic—to, in fact, a new illusionism. The formal repetitions of the past decade contained the seeds of the current fascination with imitation, not only the act of duplicating and repeating but also inquiries into the imitation, the reproduction, and the replica. Roy Lichtenstein's diagram of Madame Cézanne was a beginning. Malcolm Morley's paintings during the second half of the decade showed the way to the present.

As a child in London during World War II, Morley used to make balsa-wood models of ships, exact and precise, according to detailed plans. The *H.M.S. Nelson,* almost completed, was left on a window shelf overnight, sanded and ready to be painted. But in the middle of the night a flying bomb destroyed the model ship and the house, and Morley, unharmed, became a refugee. He never made another model ship, and he says this blocked memory surfaced, only recently, under analysis.

In the early sixties, his studio was an eighth-floor walk-up in lower Manhattan with a panoramic view of the harbor, and his paintings were abstract. They had horizontal bands of different kinds of markings that questioned the validity of handwriting. They seemed to offer a variety of ways of painting the same thing, as if to expose a basic unreality, a fraudulence about painting. They also had something to do with landscape, testing nature against art by offering alternative means of representation, somehow trying to test how the making of art corresponded to the look of the world, probing for the inconsistencies, for the edge between one and the other. The horizontal bands were horizons. And spontaneity was predictable.

"I was still yearning for that original image that had been lost forever. All art had possessed every image. What I wanted was to find an iconography that was untarnished by art." Morley, working as a

[3] For example, the way a Dan Flavin cornerpiece wipes out the corner, or the way the high finish inside a Donald Judd cube denies its cubic shape.

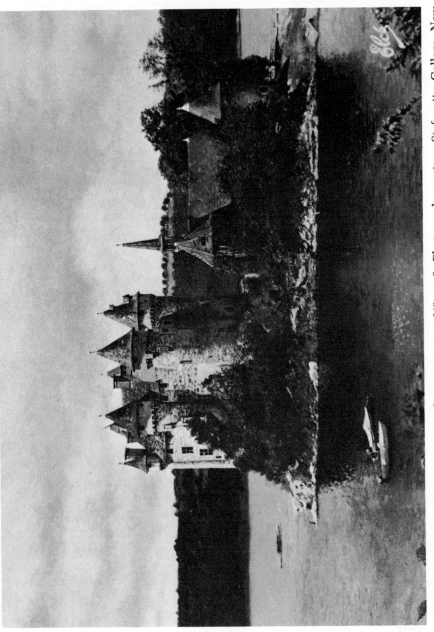

MALCOLM MORLEY: *Chateau.* 1969. Acrylic on canvas. 22½" x 37". Photograph courtesy Stefanotty Gallery, New York. Collection of Lewis Pollock.

waiter at Longchamps Restaurant, exchanged a few words with a customer who had just come back from London: it was Barnett Newman. "I said, you're the reason why I'm here. Then old Barney Newman really became my teacher. . . ."

The last of Morley's abstract paintings had four strips of a photograph hanging from its bottom edge: a reproduction of a ship, cut into separate bands. Richard Artschwager, who was using a grid for his paintings at the time, saw it and told Morley to forget the painting but keep the ship. "I'd been wanting to make an entry into objects. Actually I went down with a canvas to paint a ship from life. Then I got a postcard of a ship. The postcard was the object." In retrospect, he says that every time he drives up the West Side Highway the superstructures of the ships, with their bands of railings, portholes, and lifeboats, look like his abstract paintings. "I feel that Barney Newman emptied space and I'm filling it up again."

The first ship painting, done meticulously on a grid in 1965, in stunningly realistic sharp focus, full-color Liquitex, without a trace of handwriting, was the *Leonardo da Vinci*. His new illusionism was literal and basically honest. Unexpectedly, it shared underlying premises as well as its grid structure with Minimal art. It gave itself up as false before it began: the most faithful reproduction of nature— the Kodacolor replica—was the most deceptive, as art. The game was up. No one would ever mistake a Morley for a plein-air painting: it had all the delusions of a color print.

With his wide, white-painted borders Morley sealed in the illusion, bracketed it, always bringing the eye back to the surface, never letting it get lost in the illusion of space. With the white border [4] used as a delaying action, space was proclaimed as fakery and was neutralized:

[4] The painted borders with which Seurat framed his pictures were a preparation for the optical sensations by which dots of color could assemble into a picture; Morley reversed the process, with admiration for Kasimir Malevich's *White on White*. An unfinished nineteenth-century painting of a harvest scene by Eastman Johnson is an unintentional ancestor, with a broad border of unpainted canvas onto which one figure strays.

the blank white edge is a no-man's-land canceling out the insistent space. It is also part of the illusion; the fact is that it is there in the original. So art was a grandiose copy of a cheap imitation of nature— on a flat surface. "It was like making art that couldn't be reproduced, because it goes back to the source it came from." The invisible painting, it reverts to being a photographic reproduction. The reality, twice removed, was a surface realism that had to do with the snapshot, the reproduction, the two-dimensional image of reality. The third dimension exists as a conscious deceit on a flat surface; it is never mistaken for the real space. The reality is the surface, smooth, transparent, invisible. "I accept the subject matter as a by-product of surface," he said in 1967.[5]

Therefore, in order to be painted, the world had to be disguised as something literally flat. The shallow space and real scale of the early American trompe-l'oeil paintings of postcards, stamps, and souvenirs held on the surface by letter racks could be dispensed with if the vacation postcard, the posed snapshot, the travel poster became the whole painting. A photograph can be reproduced in any size, and scale becomes elastic. Haberle, when photography was still a novelty, had to turn the world into a package to enlarge it—a landscape painting seen through wrappings torn in the mail. Morley makes it a blown-up replica of a reproduction, complete with hand-painted copyright or trademark. The source is banal and public, with its own built-in falsifications.

The subterfuge of painting landscape as an object would seem to carry with it the idea of place as a souvenir. New York is a postcard, stamped, addressed, and mailed. Rotterdam can be city, ship, or travel poster; the city and the ship are equal echoing forms, taking up adjacent wedges of the surface. Such echoes recur throughout Morley's paintings: conical turrets of a castle repeat as triangular sails of boats, a chateau on an island substitutes for a ship, a coronation equals a beach scene, because of a similarity of shapes or colors. If a place equals a thing, the location of forms in space equals the location

[5] In a statement for *Sao Paolo 9*, catalogue, 1967.

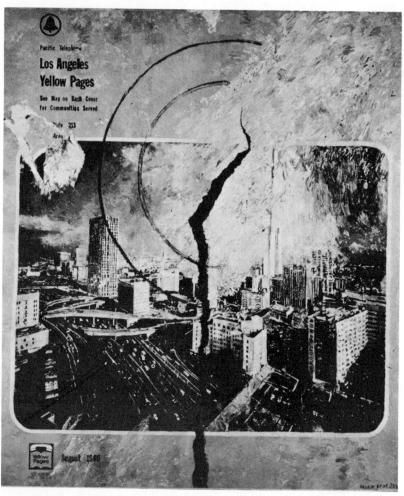

MALCOLM MORLEY: *Los Angeles Yellow Pages.* 1971. Acrylic in wax. 90″ x 108″. Photograph courtesy Stefanotty Gallery, New York.

of paint on a surface. Like an uncomprehending tourist in the material world, Morley confuses the categories, deliberately. Seeing only surfaces, he invalidates the distinction between figurative and abstract. When the likeness is preordained and the means become imitation, abstract considerations can take over; his organization is formal, abstract—and accidental. But then, the accidental has supposedly been an accepted tool of art since Surrealism. If Surrealism set the illusion of dreams against reality, Morley "chooses the simulated experience of reality, the counterfeit, and subverts it from within with an abstract eye; his attitude is closer to the Dada than to the realist tradition." [6] His double-edged illusionism relates to Dali's desire to make hand-painted photographs or to Duchamp's defaced Mona Lisa.

To paint a ship named *Leonardo da Vinci* (or one called *The United States*) implies a demythifying process by which an identity is usurped and defused, and a withdrawal of meaning takes place in the guise of homage. To paint a postcard of that ship suggests a ready-made version of Jasper Johns's notation: "Take an object. Do something to it. Do something else to it." Pop art may have been cynical in the way it made use of debased commercial images. Morley's work rather suggests detachment, combined with ironic longing for the impossible: the idealized vacation propaganda of vacant contentment, the scenic wonder, or the smiling family are the superficial symbols of experience, of escape, of how things never were. It is the opposite of nostalgia. The flat surface of painting is "pornographic" because it leads you on to unfulfillable desires: no matter how exactly it reproduces the world, you cannot enter its space, possess its images, or eat its grapes.

By the time Duchamp's posthumous work publicly posed the question of illusionism in 1969, Morley had all but finished perfecting his answer. Was it coincidence that while the "verist" sculptors produced the offspring of Duchamp's bride, a whole school of Photo Realist Technicolor painters sprouted up, each with a specialty, sleek

[6] K[im] L[evin], "Reviews and Previews," *Art News* (April 1969).

and deadpan—the new salon painting with shiny, transparent surfaces and sometimes even white borders; and repetition, the formal device of the sixties, became the life-style. Comments Morley, "The Cubist painters are much better than Picasso—it's always harder making the prototype."

Now, while the anonymous salon art of the seventies, domesticated and docile, strays not too far away, Morley, working in an old building on Long Island Sound, with clerestory windows and a portico of flat wooden slats that simulate classical columns, rejects the invisible painting and sinks the ship.

The red X in the South African racetrack picture had less to do with political protest than with crossing out a conception of realism. It was truly the most illusionistic painting he had made. The X was not part of the gridded design: it was added, affixed instantaneously; painted on plastic, reversed and pressed against the surface, it was printed over the painting like a monotype. Coincidentally, it paralleled in its shape the crisscross letter-rack device of trompe-l'oeil, but it was simply a fatal flaw across the transparent surface, expressionlessly demanding visibility. Following that, the surface began to get rough, the paint became more and more visible.

With the *Los Angeles Yellow Pages,* the imperfection becomes integral. The gesture of crossing out the finished perfection of the racetrack painting is replaced by the preliminary tearing of the original telephone book cover and including the rip in the grid, relegating the ripped surfaces back to the surface plane, and referring to the central rip held together by safety pins in Duchamp's last painting, *Tu'M.*[7] The phone book cover is not only ripped; as if used as a paint rag, it carries residues of paint that have been wiped onto it. It also bears the scar of a palette knife stuck to it; a bit of its surface is torn away where the tool was removed, deforming the edge between border and illustration and buckling the illusion further.

The *New York City* postcard in the 1972 Whitney Annual was

[7] The telephone book cover also shows the penciled red outline of a protractor, a reference to Johns's device circles.

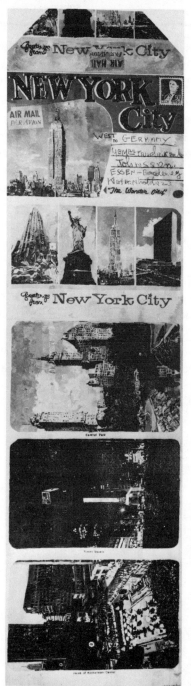

MALCOLM MORLEY: *New York City.*
1971. Acrylic in wax. 62″ x 212″.
Photograph courtesy Stefanotty Gallery, New York.

the first New York had seen of the new visible surface, with "an induced carelessness as if I were doing something other than painting, polishing shoes for instance . . ." Up close, the paint detached itself from the things represented to feel its way over the surface, to insist on its paintedness, on its own substance, in much the way it had done in Cézanne's mountains or Johns's flags. The resemblance of the paint quality was inescapable, which is appropriate because Johns's images, as flat and unyielding as the picture plane, had become Morley's flat images that yielded an illusion of space. His recent *Regatta*, a painting of a cashed scenic check bearing his signature, recalls, besides his own ships, Johns's white flag and Duchamp's *Tzanck Cheque*.[8] It was actually Johns's Buckminster Fuller map of the world that influenced Morley in his breaking down of the surface: the map of the world led to a postcard of New York.

It is a deluxe postcard with a series of New York landmarks strung across it, the tourist's proof of having been to Mecca. Morley made the postcard's flap as a separate shaped canvas, "the beginning of my moving away from Euclidean painting." The stamp, with a subtle resemblance to Madame Cézanne, and the air mail stickers were also separate surfaces that were stuck on. The border, always an aspect of the actual object, had become in the *Los Angeles Yellow Pages* an area for greater incident. In the postcard it is even more integral, edging neatly around each view, intruding across the wide canvas to divide it into rectangles, like an all but forgotten memory of his early banded abstractions or an overlay answering to the invisible grid underneath.

With the second postcard, the unfinished *New York City Foldout* now in his studio, the painting comes off the wall and occupies real space, standing on the floor like an enormous folding screen, thirty feet long and painted on both sides. The two-dimensional surface gives way to a series of angled planes that warp and curve like paper. Like

[8] Duchamp's check, dated December 3, 1919, is for the sum of $115. Morley's, dated August 3, 1971, by chance is for an almost similar sum, $116.94.

the original postcard, which is meant to be held in the hand and turned over, the views of New York are upside down and sideways, right side up, reversible; right and left are interchangeable. Close up, the images dissolve into a mass of thick, rough paint, solid Windsor Newton oils knifed on straight from the tube. Bits of matter that look like paint scrapings from a palette—little, messy, made things including a crumpled and unrecognizable page out of a pornographic magazine— are wounds on the paint surface, which is itself a prickly impasto of tactile peaks of paint. The increased roughness is an intensified contact with the solid surface; refusing to be invisible, it fights back as the choppy rough paint insists on its density. Says Morley, ". . . it is only a close-up of the earlier work. I used to do it under a magnifying glass and I felt like a pygmy." Now he wants to approximate the feeling of the magnification. It may be a relaxed reaction to the earlier exactness, a Burroughs-like shorthand, but it is also raw vision, bare opticality scratching at the eyeballs. "Each bit represents this patch of sensation."

The prosaic replica gains phenomenological overtones in the change of scale and category. Its implications correspond to Maurice Merleau-Ponty's radical reduction: "By the reduction Merleau-Ponty does not understand a withdrawal from the world towards a pure consciousness. If he withdraws, if he 'distends the intentional ties that bind us to the world,' it is 'precisely in order to see the world.' " [9] From a distance the thick substance of the paint reverts to an approximation of the postcard images, the surface returns to transparency. The Empire State Building and the Statue of Liberty reassemble themselves in the intervening space and the painting seems an exact replica of the postcard. "Morley represents, that is *shows again*, the world as paint." [10]

Morley's paintings have been considered artless in their literal and reductive mimicry of the world, but they are about art as much as

[9] Pierre Thevenaz, *What Is Phenomenology?* (Chicago: Quadrangle Books, Inc., 1962), p. 83.
[10] In a statement for *Documenta 5, 1972,* catalogue.

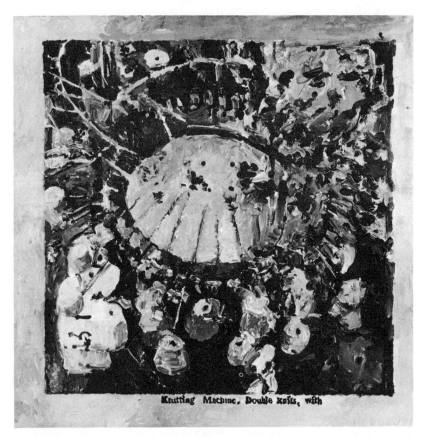

MALCOLM MORLEY: *Knitting Machine*. 1971. Oil on canvas. 24″ x 24″.
Photograph courtesy Stefanotty Gallery, New York. Collection of Edmund
Pillsbury.

they are about the world. From the flatness of an oversized print exposing the deception of Vermeer's space, Morley has moved to a painterly paraphrase of Raphael's *School of Athens* and to a heavily impastoed copy of van Gogh's last painting, both of which besides being imitations have another intent. "For me painting is a way of making the past clear."

In an ambitious, futile effort to encompass the wisdom of antiquity, Raphael made the structure of man's thought visible as a series of steps on which Euclid and Copernicus could stand next to each other. Raphael, in a masterpiece that has gone out of style, was painting history. Morley repaints the Raphael as histrionics—as a piece of theatre—and the artist as a mime replaying history [11] leads to the theatrical tableau of his *The Last Painting of Vincent van Gogh* (1973), a portrait of the absent artist. Placed on a historically correct mock easel, Morley's copy of van Gogh's *Cornfield with Crows* is displayed; on the ground beside it, an open paint box contains the traditional painter's palette and, instead of a brush, a gun—a period replica, the gun he might have shot himself with. A historical tableau depicting van Gogh's suicide, sentimental, melodramatic? A visual equivalent for a human condition, or a way of underlining his departure from the obscenity of the painter's limitations? [12]

When illusion threatened to become reality, Duchamp shut the door. His secret tableau allowed only a glimpse of the raped Muse. Morley's construction openly announces a footnote—the self-inflicted

[11] By mistake he started in the wrong square, and, on close examination, it is apparent that one strip of the painting, cutting across a row of heads, is shifted slightly sideways; Morley accepts this accidental shift with pleasure, as "evidence of my lobotomizing philosophy." He also likes the fact that Raphael's figure sitting on the cube was an exact copy from Michelangelo.

[12] In *The Last Painting of Vincent van Gogh*, construction becomes reconstruction. It is appropriate that it contains multiple references to recent history—to Rauschenberg's Combines, Rivers' last Civil War veteran, Dine's palettes, Segal's portrait of Sidney Janis with a Mondrian—as well as to the image of the painter at his easel in the Vermeer, and to Morley's own recent rough paint. If Morley's earlier work suggested the mood of Michelangelo Antonioni, his most recent work suggests parallels with the films of Ken Russell.

death of inspiration, the end of the myth of the romantic artist. As illusionist space was relegated to the surface and as figuration resulted from a grid, thick paint is detached from expressionist torment and reduced to another substance, devoid of irony or nostalgia, and painting is history. Style is going out of art.

VERIST SCULPTURE:
HANSON AND DE ANDREA *

Joseph Masheck

In his discussion of the astonishingly realistic sculptures of John de Andrea and Duane Hanson, the two major sculptors working in the Super Realist style, Joseph Masheck points out that "If they prove susceptible to aesthetic analysis and judgment, so do works of nature." Thus the basis for a new, generally anti-formalist type of criticism, in which the subject is the main focus for critical analysis, rather than the exclusively aesthetic factors of the art object, is acknowledged.

Although Masheck distinguishes between the artworks he discusses and nature itself, and assumes the improbability of complete and total realization of nature as art, he contributes toward the new shift in critical perspective. Thus, a concern with

* Reprinted from *Art in America*, Vol. 60, No. 6 (November/December 1972).

the political and social aspects of the events described in the
works becomes an appropriate subject for critical speculation.

In a similar vein, Masheck allows himself the critical luxury
of considering qualities of ordinary physical beauty as artistic
criteria (in his discussion of de Andrea's nude figures), and he
reminds the reader that ". . . intrinsic bodily beauty has a long
history. It is one of Western sculpture's most venerable criteria of
value and appreciation." Masheck discovers in the history of art
criticism his critical precedent—in the writings of Johann Joachim
Winckelmann. When Masheck warns, "Like it or not, realist art
can say more things than abstract art can," he reverses an aesthetic
tradition rooted in the philosophy of Hegel, who noted: "Neither
is objective naturalness the rule, nor is the pure imitation of
external appearances the aim of art." [1]

Joseph Masheck was an oarsman on the lightweight crew at
Columbia College, where he received his A.B. degree in 1963. He
teaches art history at Barnard College, is a contributing editor of
Artforum *magazine, and has written essays for* Art News, Studio
International, *and* The Burlington Magazine.

With an ostensibly styleless and baldly descriptive art upon us, we
seem uncertain how to apply the term *realism.* This has always
presented some difficulty simply because all realist art, no matter how
"real," is still art and, hence, somehow different from the reality of life.
Bernard Berenson's definition of art as life with a higher coefficient of
reality has never been adequately explored, although it is one of the
most fecund of his clever dicta.

When realism was mentioned in connection with Pop art, nobody
was terribly confused because style—a vivid evidence of mimetic
transformation—was of the essence. Pop art faked out the avant-garde;
Neorealism assaults it. The response of some critics to the emergence

[1] Lionello Venturi, *History of Art Criticism,* trans. Charles Marriott (New York:
Dutton Paperbacks, 1964), p. 200.

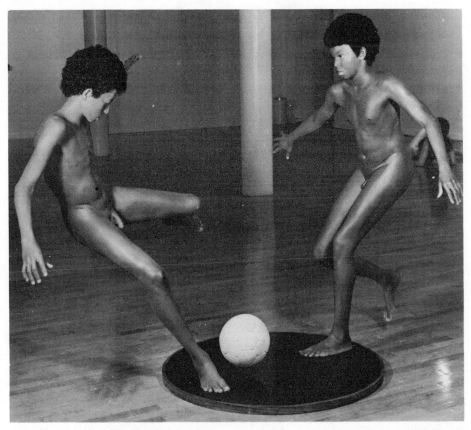

JOHN DE ANDREA: *Boys Playing Soccer*. 1971. Polyester and fiber glass, polychromed. Life-size. Photograph courtesy O. K. Harris Gallery, New York. Collection of Everson Museum of Art of Syracuse and Onondaga County, Syracuse, New York.

of Pop was a funny spectacle. The emperor turned out to have been well dressed after all. Neo- or New Realism [2] touches on Pop concerns but has a blunter, more brutal thrust. Ironically, it involves an iconoclasm that demands the institution, rather than the abolition, of recognizable, life-referring forms. Confidently anti-intellectual, even populist, it sees abstract art and the criticism that services it as a sort of honky folly. Abstraction had been attacked many times before, but never as comprehensively.

To the extent that New or Radical Realist sculpture is deliberately designed to frustrate criticism, it shares some ground with Minimalism. In fact, its preoccupation with the human body (even as against its *form*) sometimes has the quality of a rigorous restriction to an uncontaminated, unformalized Ur-form. But hyper-realist sculptures couldn't care less whether we find them bad art or not even art at all. They are oblivious to us because any consideration we give them has to be critical, and, in turn, any consideration sophisticated enough to amount to criticism must at least account for, if not proclaim, abstract values. This is why we can experience difficulty and even annoyance with such works, despite their easy descriptive literalism. In a sense they deliberately forfeit a claim to serious attention. Yet, by managing to be far more grossly radical than anything in the avant-garde, they require it.

For all their patent obviousness such sculptures have a very

[2] Harold Rosenberg, discussing the terms *New Realities* and *New Realism* in connection with the emergence of Pop, spoke of "the name 'Realist' (being 'New' usually goes without saying)." See "The Game of Illusion: Pop and Gag," in *The Anxious Object: Art Today and Its Audience* (New York and Toronto: Horizon Press, 1969), p. 57. Actually, the fad of naming cultural developments "new" is a recapitulation of an 1890s theme, perhaps with overtones of a jaded exhaustion of the very novelty that is its theme. Holbrook Jackson, *The Eighteen Nineties* (London, 1913), notes Grant Allen's "The New Hedonism"; H. D. Traill's "The New Fiction," the New Paganism, the New Voluptuousness; Wilde's "The New Remorse," the New Spirit, the New Humour, the New Realism, the New Drama, the New Unionism, the New Party, the New Woman; periodicals named *The New Age* and *The New Review;* a New Park Lane, the New Century Theatre, the New English Art Club; John Davidson's *New Ballads* and George Gissing's *The New Grub Street.*

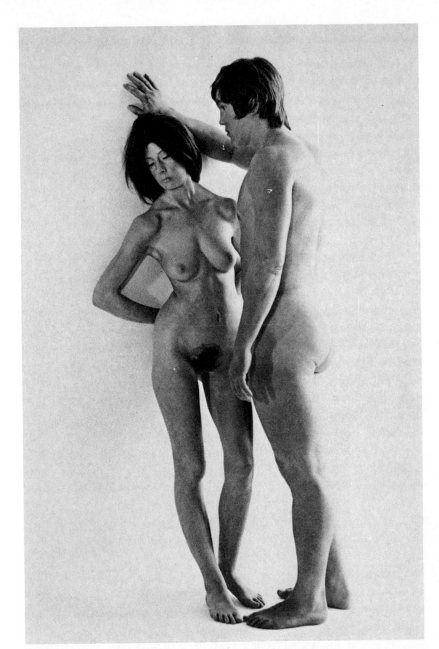

JOHN DE ANDREA: *Man Leaning and Woman.* 1971. Polyester and fiber glass, polychromed. Life-size. Photograph courtesy O. K. Harris Gallery, New York. Collection of Galerie Claude Bernard, Paris.

uncertain identity. If they prove susceptible to aesthetic analysis and judgment, so do works of nature. To the extent that we deal with true mimetic transformations—as we may in John de Andrea's handling of the nude—we seem to be dealing with artistic materials. But to the extent that we overlook mimesis (i.e., are "fooled"), we actually project our responses onto an illusion of nature and not even an illusion of art. No one glances at these figures and imagines he is looking at statues. Our glance brushes by them and we pretend, even if involuntarily, that they are people.

To modern eyes the hyperillusionism is a distraction, even though many are entertained by the distraction. We are used to assuming that it is impossible to re-actualize a natural motif completely and that the zone between this practical limit and the real object in nature comprises aesthetic territory. Yet there have been periods in which sculpture was intended to be as fully and confusingly "actual" as this. To recall polychromy and the use of glass eyeballs and real metal props is to see even ancient sculpture in a less polarized light. In the sixteenth century Northern artists made decorative castings from actual natural features. The Baroque supplies countless examples of contrived illusionism in sculpture.

These works may also seem to be art objects because they sustain the same type of analytic consideration as do unqualified works of art. Yet here is another hitch. Often photographs of them seem easier to handle as art objects than do the pieces themselves. Photographs appear to stabilize those features that render the object graspable and distinct; this is particularly true of lighting. In real space, despite their alarming resemblance to human beings, the most vivid trait of these figures is an embalmed fixity, whereas in photographs they look not only more like art objects but also more likely to be alive. Since the works themselves are "stills," still photographs of them help to drain away their real (not illusionary) lifelessness. Responsibility for un-reality is discharged into the illustration.

In a real room the feeling that these figures are altogether in-

animate is actually the source of their disappointment as well as of their fascination; we feel the full impact of the fact that, unlike real men, women, and works of art, these objects lack *souls*. The soul, as the Scholastics describe it, is the animating principle in a thing, and its evidence is motion. The stillness of these figures is not a stillness of repose. It is the mortuary stillness of bodies trapped in lifeless moments, akin to those plaster figures made by filling cavities left by corpses at Pompeii. Max Beerbohm, writing on Madame Tussaud's waxworks, concluded: "Even when the familiar features of some man or woman have been moulded correctly, how little one cares, how futile it all seems! The figures are *animated* with no spark of life's semblance. Made in Man's image, they are as Man to God." [3] By comparison with these works, George Segal's plaster figures have a soulful animation: seemingly alive with thought, Segal's are aesthetically helped by the roughness of their forms and "reproduction"—white coloration, which, even when it does suggest "art," does not evoke already "actual" sculpture.

So in a sense these works are not sculptures at all, but antimatter counterparts to sculptures. They reverse Suzanne Langer's distinction: "it is expression of biological feeling, not suggestion of biological function, that constitutes 'life' in sculpture." [4] These would-be sculptures seem to supply all that is functionally required for a human presence.[5]

[3] Max Beerbohm, "Madame Tussaud's," in *More* (New York, 1922), p. 43, italics mine.
[4] Suzanne K. Langer, *Feeling and Form: A Theory of Art Developed from Philosophy in a New Key* (New York: Charles Scribner's Sons, 1953), p. 89.
[5] Compare the extreme mechanistic position on the human body taken by Descartes: "The human body may be considered as a machine, so built and composed of bones, nerves, muscles, veins, blood, and skin that even if there were no mind in it, it would not cease to move in all the ways that it does at present when it is not moved under the direction of the will, nor consequently with the aid of the mind, but only by the condition of its organs." René Descartes, "Of the Essence of Corporeal Things and of the Real Distinction between the Mind and Body of Man," *Meditations Concerning First Philosophy* (pt. vi), in his *Philosophical Essays*, ed. and trans. Laurence J. Lafleur (Indianapolis, New York, Kansas City: Bobbs-Merrill Company, Inc., 1964), p. 138.

What is missing is the apparently visually irrelevant feature of internal activity. Surprisingly, the *look* of life turns out to be the real superfluity, as against the *feel* of life.

Although there were illusionistic features in ancient and Baroque sculpture, only after the impact of neoclassicism did a branch of sculpture fully capitulate to vulgar naturalism. It was around 1776 that Christopher Curtius, Madame Tussaud's uncle and a Swiss doctor who had already used wax casting for anatomical studies, decided to found the famous waxworks. In about the same year Luigi Vanvitelli supplied the illusionistic Diana and Actaeon groups for the great cascade in the castle garden at Caserta. Two years later, in 1778, François Girardon's seventeenth-century Apollo group in the Versailles garden was installed in Hubert Robert's illusionistic setting for it. All these projects (c. 1776–1778) are evidence of a new taste for figure sculptures so real that they might be sleepwalking in the world.

Was this a response to the frigid, hermetic, antitactile orthodoxy of the neoclassicists or a perverse eddy within the ranks? In reaction against Johann Joachim Winckelmann's "quiet" and Gotthold Ephraim Lessing's worries about narrative content, these late eighteenth-century sculptors produced human figures that almost seem as if they could be entertained or seduced. Isaac Newton considered the art of sculpture to be a matter of "stone dolls,"[6] and it may be that what Curtius, Vanvitelli, and Robert were all after was merely a better kind of doll.

Charles Baudelaire's dissatisfaction with figure sculpture was of a more general order. In his essay "Why Sculpture Is Tiresome" (Salon of 1846), he argued that the main weakness of sculpture is its extreme spatial obviousness and its unrefined immediacy. If Baudelaire was so ready to level his guns at the realistic sculpture of 1846, what would he say about the illusionistic people-surrogates of Hanson and de

[6] Newton used the words "stone doll" in referring to the Earl of Pembroke's passion for antiquities. See Joseph Spence, *Observations, Anecdotes, and Characters of Books and Men Collected from Conversation*, ed. James M. Osborn, Vol. I (New York: Oxford University Press, 1966), pp. 350–351, No. 876; also, David Brewster, *Memoirs of Newton*, Vol. II (London, 1855), p. 411.

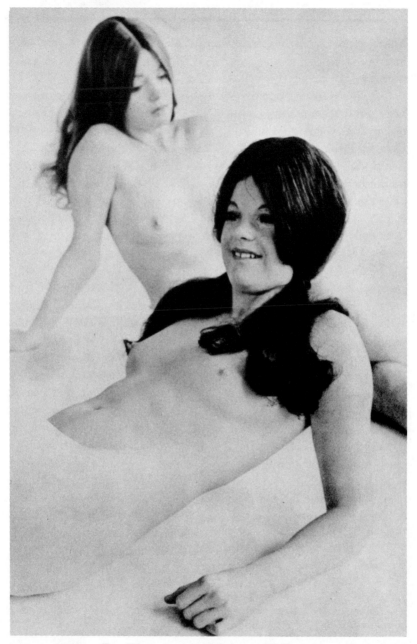

JOHN DE ANDREA: *Two Women*. 1972. Polyester and fiber glass, polychromed. Life-size. Photograph courtesy O. K. Harris Gallery, New York.

Andrea, who cast polyester versions of human beings, both singly and in groups?

Duane Hanson's people are clothed. The nature of their dress, in fact, grants them a truly realist quality of exemplarity: the figures are convincingly individual and also representative of some type—boxers, tourists, hardhats, women of the lower and middle classes. Hanson's group sculptures are easier to approach than most of the single figures, no doubt because they demarcate a kind of theatre of activity that, although it flows into our space, is tensely and anxiously distinct from it. In *Vietnam Scene, Race Riot,* and *Football Players* (all 1969), there is an odd number of figures in each group—which is an interesting hangover from picturesque aesthetics.[7] Partly for this reason they have the pictorial qualities of tableaux.

In *Vietnam Scene* there are five shirtless soldiers, four of them dead. The title suggests both a narrative site and a theatrical phase of action, perhaps even a "theatre" of war. Bodies lie in scattered disarray with a kind of exhausted urgency. *Race Riot* has seven figures, three pairs engaged in hand-to-hand combat and one man about to break into one of the pairs. Curiously, the politics of the event are not so clear as one might suspect. True, a white cop is kicking and beating a fallen black, but another black is coming up behind the cop with a raised sickle in one hand and a swinging, spiked star on a chain in the other. It is frightening to see, but nothing articulates the fright. The piece reminds me of a bronze monument to the bull chase at Berrioplano, in Navarre. In that work, men in their street clothes run in front of the charging bulls, and one fallen man is attended by another in a posed pair that is similar to the cop and the kicked black in *Race Riot.* Now in the bull monument there is a victim, but nobody is guilty. Unless we could show that this memorialization of the bull run had,

[7] In the eighteenth century Lord Kames, aesthetician and agriculturist, advised gentlemen to keep an odd number of cows so that when they grazed they would more likely compose themselves in nice arrangements. Tableau designers have always sensed this.

DUANE HANSON: *Riot* (detail). 1968. Fiber glass, oil, polyester. Life-size. Photograph courtesy O. K. Harris Gallery, New York.

for instance, some covertly fascist rationale, we should have to say that *Race Riot* is the less morally clear work, even though it looks so didactic.

In Hanson's *Football Players* the player in the middle is attacked by two opponents. One tackles him from behind and the other, a black, crudely grips his face mask and forces his head back. The arrangement is dynamic and tense, and nicely organized about the threatened leg on which the victim rests his weight. The agitation is rhythmic and sequential and compares, in earlier American sculpture, with George Grey Barnard's *The Struggle of the Two Natures of Man* (1893). But there is somehow a false sense of time, as if we were seeing an instant replay that, in three dimensions, produced an inappropriately slow, dancelike effect.

The dirty uniforms and the grunting, heaving thrusts do have a kind of Pindaric decorum and strength. The unflinching gutsiness of *Football Players* is far from ironic; it is suggestive of the especially American realism of George Santayana's essay "Philosophy on the Bleachers" (1894),[8] which emphasizes the moral qualities of athletic brutality. It is perhaps significant that the black player is shown breaking a rule: he is decidedly not sublimating. In any case, the sophistication with which the violence is handled here is far greater than that of President Nixon explaining the bombardment of North Vietnam in football imagery.

The single figures include monstrosifications of American types. Works like *Tourists* (1970), *Supermarket Lady* (1970), and *Woman Eating* (1971) really grow out of Fourteenth Street realism, except

[8] In *George Santayana's America: Essays on Literature and Culture* (Urbana, Ill.: University of Illinois Press, 1967), pp. 121–130. Santayana cleverly shatters the cliché that treats athletics as training for warfare by introducing a notion of sublimation: "The relation of athletics to war is intimate, but it is not one of means to end, but more intrinsic, like that of the drama to life. It was not the utility of athletics to war that supported the Greek games; on the contrary, the games arose from the comparative freedom from war, and the consequent liberation of martial energy from the stimulus of necessity, and the expression of it in beautiful and spectacular forms" (p. 123).

DUANE HANSON: *Vietnam Scene.* 1969. Polyester, resin. Life-size. Photograph courtesy O. K. Harris Gallery, New York. Collection of Wilhelm Lehmbruck Museum, Duisberg, Germany.

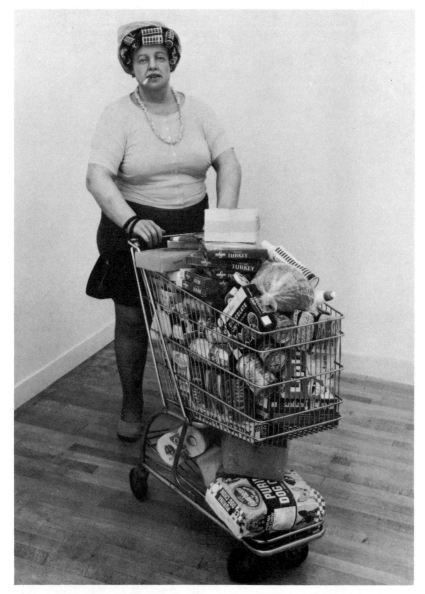

DUANE HANSON: *Supermarket Lady.* 1970. Polyester and fiber glass, poly-
chromed. Life-size. Photograph courtesy O. K. Harris Gallery, New York.
Collection of Dr. Peter Ludwig.

that their ludicrous bite is Pop-derived. Even the monstrosifications, however, could be related to hyperhefty figures in pictures by Reginald Marsh. *Tourists* is so totally vulgar in subject and so baldly executed that it will pass on, like some infection, a quality of its subject to its owner. *Supermarket Lady*, bulging out of her sweater and skirt as cornucopiously as her rolling basket overflows, is a female wise guy, with curlers and dangling cigarette. The meaning here seems pretty carefully controlled: she deserves the life that she's so sure she enjoys. But the lady in *Woman Eating* is treated very badly. We are asked to respond solely on the grounds of her offensiveness to taste, when it is clear that she is simply unpleasantly poor. To find her funny or even offensive is to exercise actual uncharity, even if on an artificial object. This problem, which is central to Hanson's work, relates to one explored by Roger Fry in "An Essay on Aesthetics" (1909), in which he discussed the special nature of verisimilitude and empathy in film:

> With regard to the visions of the cinematograph, one notices that whatever emotions are aroused by them, though they are likely to be weaker than those of ordinary life, are presented more clearly to the consciousness. If the scene presented be one of an accident, our pity and horror, though weak, since we know that no one is really hurt, are felt quite purely, since they cannot, as they would in life, pass at once into actions of assistance.[9]

This insight seriously qualifies our initial presumption of a spatial "theatre" of action surrounding Hanson's figures. Their shocking nonhumanity (despite their uncanny visual naturalism) prevents these figures from generating any of the irony of live actors in a theatre. More than in the Theatre of Cruelty, "our pity and horror . . . are felt quite purely."

This same unexpected moral subtlety informs *Hardhat* (1970), perhaps Hanson's best piece because it lasts while many of the others fade like jokes, cartoons, or one-shot anecdotes. The man here immortalized might feel moved to beat up young socialist types or make

[9] In *Vision and Design* (New York: Meridian Books, 1957), p. 19.

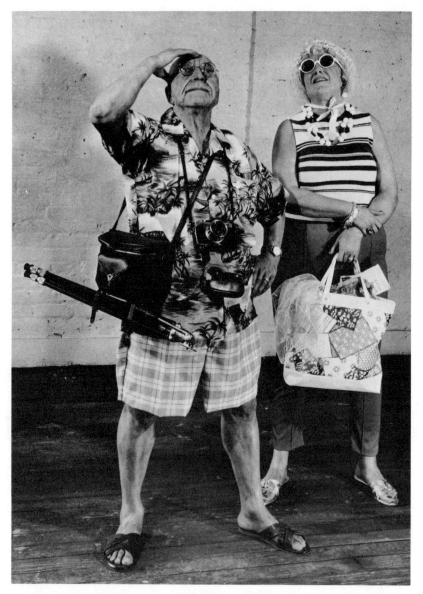

DUANE HANSON: *Tourists*. 1970. Polyester and fiber glass. Man 5'2"; Woman 5'4". Photograph courtesy O. K. Harris Gallery, New York. Collection of Saul Steinberg.

pussy calls at passing girls to prove he's OK. But when we see him here, frozen in time, sympathy rushes in. Instead of "waving," the flags on his hat testify to a tender, if small, idealism, just as the can of beer from which he drinks suggests a certain incivility but also reveals a modicum of good taste—Pabst. His pose is actually rather winningly gracious, and the expression on his face is reflective and nearly transcendental. Even his clothing has a Courbet-like honesty and manly drape. Finally, there is an overall dignity to the figure, a Bogartian moral maturity that overlies the apt resemblance of the man's pose to that of the great Hellenistic *Seated Boxer* in the Museo delle Terme.

Somewhere Stanislavski told the story of an actress trying to play some such typical part as a housewife. She tried to do it by imagining how "a housewife" would act. It didn't work, so she tried something else. She played the role eccentrically, giving the character strange quirks. Dozens of women then wrote in saying "It's me!" This has always been one of the primary issues of realism: the relation of the particular to the type, and the fact that no type is vivid without particularity (since the presence of unique particulars—or at least of a unique pattern of particulars—is itself a general feature). The particular divorced from the type is grotesque; the type denied particularity is lifeless. Against both idealism and nominalism, realism always keeps its head about the relation of the individual to type or class.

What leads me to these thoughts is the reclining nude girl resting on her elbows in John de Andrea's *Two Women Sitting* (1972). She looks so much like somebody one knows that one wants to identify her. Apparently many spectators have such a reaction to this particular figure, even though they do not to the other girl in the same piece. This must suggest that the girl resting on her elbows is in some sense more real. The fact that the other girl provokes no such response is a proof that the perfect realist balance of particular against type is more elusive—more a matter of artistic tact and accomplishment—than hard-line defenders or opponents of realism might suppose.

De Andrea's sculptures are similar to Hanson's, but they are nudes

and often appear in pairs. These pairs of figures are linked by implied narrative lines: a man seems to be attempting to intercept a running woman in *Two Figures (Woman in Flight)* (1971); in *Woman and Man Leaning against Wall* (1971) there is a soap-operatic interaction; in *Boys Playing Soccer* (1972) there is the natural context of the game. Unfortunately, this kind of significance can defy and disrupt plastic values. The poetic "content" in question could be likened to the poetic content in Roy Lichtenstein's comic-book balloons—only there it is spelled out and accommodated to an already artificial, graphic-informational convention. Here there is a too literal poeticism; the large size, the descriptive accuracy, and the illusionistic coloration of the pieces seem inelegantly heavy vehicles for the small, if poignant, poetic ideas. Painting and poetry are too different in their requirements for aesthetic economy to be entirely transposable, and with sculpture the substantial difference from poetry is even more acute. We should need another Lessing to disentangle the problem fully, but it is probably safe to say that the artistic means are at variance with the poetic overtones in these sculptures.

De Andrea's figures differ in two significant respects from Hanson's. First, they deal with the intrinsic beauty of the body. Second, they concentrate on pose, to an effect that is both more classical and more abstract than is the case with Hanson.

Art historically, de Andrea's mock-up nudes relate to Duchamp's last work, the Assemblage *Etant Donnés: 1° la chute d'eau, 2° le gaz d'éclairage*, put together in secret from 1946 to 1966. *Etant Donnés* consists of a picturesque but formidably closed door with a small hole in it. The hole gives furtive access to a landscape tableau whose main feature is a full-sized nude woman holding a gas lamp.[10] While his own piece was still unrevealed, Duchamp was aware of developments

[10] On Duchamp's piece, see Anne d'Harnoncourt and Walter Hopps, "*Etant Donnés: 1° la chute d'eau, 2° le gaz d'éclairage*: Reflections on a New Work by Marcel Duchamp," *Bulletin of the Philadelphia Museum of Art*, LXIV/299–300 (April–June, July–September 1969). It was Duchamp's wish that no view of the inside tableau ever be published. For calling Duchamp's tableau to mind, I am grateful to my student Mr. Peter Frank.

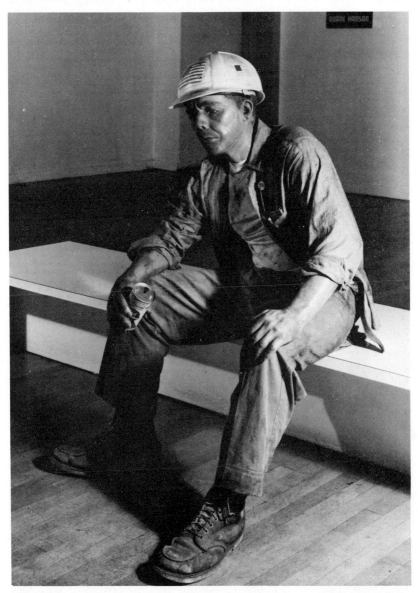

DUANE HANSON: *Hardhat*. 1971. Polyester and fiber glass, polychromed. Life-size. Photograph courtesy O. K. Harris Gallery, New York. Collection of Lewis Richman.

in contemporary figure sculpture. In 1965 he inscribed the catalogue of the Sidney Janis show of George Segal's plaster figures. Anne d'Harnoncourt and Walter Hopps have pointed out that such mannequin sculptures derive from Surrealist projects of the 1930s, and that the tableaux of Segal and Edward Kienholz are their progeny, born while *Etant Donnés* was still in gestation. Both Hanson and de Andrea, however, have more in common with the poetic clarity of Segal himself than with the vaguer, and often grimmer, human junk of Surrealist tableaux and those of Kienholz. Segal's rigorous, concise poeticism is their real starting point; the smooth, "buffed" skin of their figures is simply a stylistic variation on Segal's white but painterly surface.

The emphasis on intrinsic bodily beauty has a long history. It is one of Western sculpture's most venerable criteria of value and appreciation. Not only in antiquity, but from the Renaissance onward, the beauty of the portrayed figure has been a preeminent critical question. Winckelmann wrote a great deal on the subject; many pages of his *Geschichte der Kunst des Alterthums* (1764) concern the aesthetic qualities of the human body quite apart from their mimetic transformation in art. For instance, Winckelmann discussed the attractiveness of brown skin, claiming that it is best appreciated by those with tactile rather than wholly visual sensibilities, and noting that for the Greeks brown skin indicated courage in a boy.[11] This could be applied directly to the pair of lithe young blacks in de Andrea's *Boys Playing Soccer*, but of more general importance is the fact that for centuries such nonformal considerations have been recognized as supplying vital beauties that are simply not features of the overall artistic management of a work.

Yet such a critical attitude always carries with it a commitment to idealism of some kind, an attachment to some vision of bodily perfection that art—usually *only* art—can materialize. As soon as the loyalty to a bodily ideal of whatever kind breaks down, so does the

[11] Johann Joachim Winckelmann, *History of Ancient Art*, trans. G. Henry Lodge, Vols. I and II (New York: Frederick Ungar, 1969), Vol. II, bk. iv, ch. ii, par. 10, pp. 193 ff.

built-in advantage for art. In this light, the emphasis on artistic values has been necessary ever since romanticism: when subjects were no longer canonically beautiful, all subjects found themselves on an equal plane, and aesthetic and formal features became the only constant materials of beauty. Thus in his essay "Why Sculpture Is Tiresome" Baudelaire noted, almost with a yawn, that "there are few models who completely lack poetry." [12] Certain sculptures by de Andrea suffer from the same defects that Baudelaire found rampant in the sculpture of the mid-nineteenth century. Consider the leggy female in *Woman and Man Leaning against Wall,* or even her chunky male companion: too much is wrong with these figures from the classically physical point of view for us to value them as implicitly beautiful forms preserved by whatever means. Of course, there doesn't seem to be any redeeming artistic beauty either, which is why they are ultimately disappointing. But the point is that it could actually be maintained that this work would be better if the models themselves had been closer to perfection. Furthermore, there is an aesthetically underhanded and politically questionable use of social rank as bait for visual attractiveness, for in their coiffures even more than in their body types these figures are distinctly bourgeois.

The very nudity of such figures, which one would expect to detach them from social status, actually heightens the evidence of their hairdos, and, to some extent, the subtleties of their postures as well. Tom Wolfe once remarked that one of the clearest social distinctions in America is between men who comb their hair down and those who comb it back. Seen this way, *Reclining Woman* (1970), with neat chignon and creamy clear skin, is also an obviously upper-class figure, despite her absolute nudity.

If the figures lack the generality and ideality of the truly classic, that is perhaps because they are more Roman than Greek in feeling.

[12] Charles Baudelaire, *Art in Paris 1845–1862; Reviews of Salons and Other Exhibitions,* ed. and trans. Jonathan Mayne (London and New York: Phaidon Art Books, 1965), p. 113.

This is largely due to their intense, portraitlike uniqueness. Similarly, the presentation of lively, bouncy, realistic figures in racy but sporty undress is reminiscent of works like the early fourth-century mosaic floor with so-called bikini girls in the villa at Piazza Armerina.[13] Even the heightened residual significance of fashionable hairdos on nudes is Roman, and it is so widespread that it is a reliable clue for dating portrait sculptures.

I said that de Andrea's figures put a premium on the pose, and that this is both classicizing and quasi-abstract. It is classicizing because (after the features of the figure considered as parts of a real body, in turn judged by reference to a norm or idea) the arrangement of the body in a posture was an aesthetic consideration of great importance. From the modern point of view, the pose helped to mediate between the object as a mere illusion of life and the object as a pure construct. The pose had such importance because it was in just these terms partly an invention and partly an accommodation to the limits of the (real) body and to tradition. Interestingly, to the extent that it is an invention, working with the body as a mere instrument, the pose is a purely abstract idea.

The same thought, pushed further, may illuminate a main feature of de Andrea's sculpture. It is possible to consider the human body itself as so entirely familiar that it can take a place beside other animate and inanimate objects. Fernand Léger, in his *Fonctions de la Peinture,* maintained that his aim was to bring down the body's categorical superiority.[14] What Léger found engaging was the prospect that the body could be admitted to painting in such a way that it might have the same importance, potential, and even substance as any other

[13] George M. A. Hanfmann, *Roman Art: A Modern Survey of the Art of Imperial Rome* (Greenwich, Conn.: New York Graphic Society, 1964), pl. xxv.
[14] Fernand Léger, *Fonctions de la Peinture* (Paris, 1965). See the section entitled "A propos du corps humain considéré comme un objet" and the short piece "Comment je conçois la figure," which includes the statement ". . . for me human figures, bodies, have no more importance than keys or bicycles. It's true. For me they're plastically valid objects and they're for handling as I choose" (p. 76).

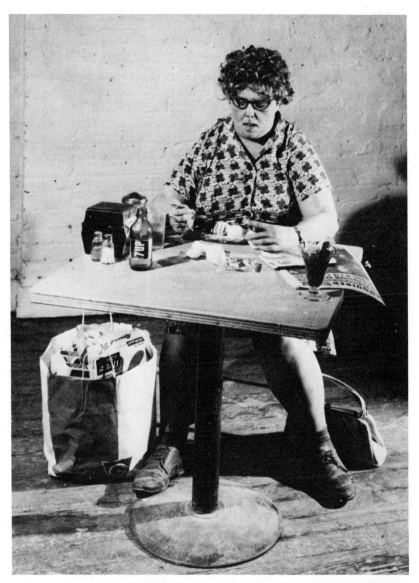

DUANE HANSON: *Woman Eating.* 1971. Fiber glass and polyester. Life-size. Photograph courtesy O. K. Harris Gallery, New York. Collection of Mrs. Robert Mayer.

object a painter selected as a motif. For Léger, of course, a lot of the fun was in the ideological deflation of the human form as the touchstone of bourgeois humanism. Nevertheless, his predispositions did enable him to approach the human body with a hearty readiness and a freedom from pseudoaesthetic protocol. The mode of presence of de Andrea's figures can seem similar.

Just as abstract art deals exclusively with values that are inclusively present in pre- and non-abstract art, so all true realisms share a common substance. The *form* of a particular realism can be revived, but then that is a revival of certain abstract qualities affecting or qualifying the realism of the previous time. As far as intrinsic realism is concerned, all realisms are simply phases or aspects of one realism. This is why all the same dilemmas arise when we approach the realism of any previous period with our baggage of abstract predispositions. Dutch realism of the seventeenth century, for instance, continuously trips us up on "poetic" qualities that our aesthetics cannot entirely account for and that, still insistently, seem to affect ultimate artistic worth. Like it or not, realist art can say more things than abstract art can. More challenging still, it can say them demonstrably well or poorly, which means that our own present-day views do not circumscribe as many of the possibilities of art as we normally assume.

There is really only one realism. To the extent that we can comprehend its values, it is partly an enemy—in its intolerance (toward nonreferential values, but also toward unfamiliar realisms)—and partly a more worthy handmaid to the humanistic classic, the ultimate source of form-in-itself, than we moderns are ourselves. The philosophical consistency of realism was observed in a hostile remark by Berenson:

> Realism is not disinterested. It has a dogma to proclaim, a theology to defend. It teaches that man is born a beast, that civilization does not make him less but more of a beast; that life is hell and that the only satisfaction to be got out of it is to recognize the fact and to dance over it a witch's sabbath of sneering glee.[15]

[15] Bernard Berenson, *Aesthetics and History* (Garden City, N.Y.: Doubleday & Company, Inc., 1953), p. 144.

Berenson plainly didn't like realism, although it is arguable that he is speaking rather indiscriminately here of naturalism (his next sentence identifies Zola as a modern "realist"). But he did unwittingly put his finger on one of its strengths. For the past hundred years radicalism in art has sustained respect as a kind of frustrated, exiled, or transferred form of political activism. This began when nobody gave the Impressionists a chance to speak; it ended when art, having agreed to talk of nothing but itself, had little left to say.

But realism always has open to it much more direct access to the world. In true realism, art is released from its limit as a mere analogue to reality and is permitted to regain continuity with the live concerns of mankind. (Thus even abstract art may be seen as a highly specialized and contingent form of realism that deals with the reality of art to artists.) True, even when the fear of involvement is left behind, artists still produce *forms,* and these forms vary in sophistication and significance.[16] But the content can't possibly go wrong, so long as it is real. In the words of Georg Lukács, oddly similar to Berenson's in their doctrinal sweep, "*any* accurate account of reality is a contribution—whatever the author's subjective intention—to the Marxist critique of capitalism, and is a blow in the cause of socialism."[17]

[16] For example, Burckhardt noted the inferiority of Dürer and other German landscape painters to the Italian landscape poets. The Germans were "brought up in a school of realism," whereas an Italian, "accustomed to an ideal or mythological framework, descends into realism through inward necessity." Jacob Burckhardt, *The Civilization of the Renaissance in Italy,* ed. Irene Gordon, trans. S. G. C. Middlemore (New York, Toronto, London: Phaidon Press, 1960), p. 225.

[17] Georg Lukács, "Critical Realism and Socialist Realism," in *Realism in Our Time: Literature and the Class Struggle* (New York: Harper Torchbooks, 1971), p. 101.

PAINT, FLESH, VESUVIUS*

Gene R. Swenson

One of the first of the new painters concentrating on a radical realist style was Joseph Raffael. Though his recent work involves a somewhat different approach to his subjects (note illustrations), his earlier paintings are the subject of this discussion with the late Gene Swenson. The conversation is mainly about the iconography of the works rather than about realist theory. This essay is, perhaps, the earliest published article pertaining to the Super Realist art style.

Why don't you paint facial expressions?

It's subjective to have a face. In theatre and painting, as opposed to dance, it's traditional to have communication coming out of the face. But I think I do paint facial expressions. What I try not to do is depend

* Reprinted from *Arts Magazine*, Vol. 41, No. 1 (November 1966).

on exaggerated ones for an easy definition of the mood or character of the painting, like sadness or joy. In life don't people wanting to cry often laugh instead?

Take those teeth in the little painting with the cigar . . .

It might look as if I'd given those teeth some kind of emotion, they're like claws, and that I am commenting. I'm not. It's a clinical illustration from a dental textbook of teeth formations. When you take X rays, you hold your mouth like that. If you had just been to the dentist's office before you came here, you might have thought of that. Everything has the quality you bring to it. In that sense it has a Rorschach quality—but the stated, objective thing is beautiful. Does a cigar held between someone's fingers become a sixth finger, a second penis, or does it remain a cigar?

Then they're with other images. It's like having three people in a room together. In Mailer's *American Dream,* when Rojack visits his rich father-in-law after he's murdered his wife, the father-in-law leaves him in a room with other people. He's brought to an action because of the addition of the other personalities and the taking away of the father-in-law. Somehow they expose certain things about themselves.

Is sex connected with art?

My paintings are about living things, which I find sexy—how hair comes out of an eyelid making it an eyelash, how lipstick shines on lips . . . I have my life set up in a chemical kind of way: I have my sleeping period, my working period, and my living period. I've got a steady flow. So when you say what does sex have to do with art—well, what does art have to do with life? In my life I don't want them to be separate. If there is a separation between sex and art in the mind of the painter, then I don't see how he can get any kind of exciting sexual or sensual statement.

Are your paintings a Surrealistic investigation of the subconscious?

Not really. My images are not iconographic, not symbols, not even Freudian, although I'm using a kind of sensibility that could not be

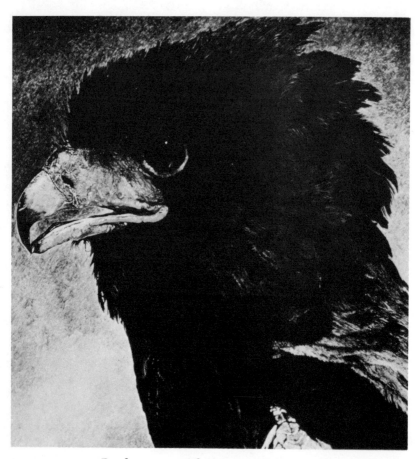

JOSEPH RAFFAEL: *Bataleur*. 1970. Oil on canvas. 84″ x 84″. Photograph courtesy Nancy Hoffman Gallery, New York. Collection of Mr. and Mrs. Harry W. Anderson.

JOSEPH RAFFAEL: *Barn Owl*. 1971. Oil on canvas. 82″ x 64″. Photograph courtesy Nancy Hoffman Gallery, New York.

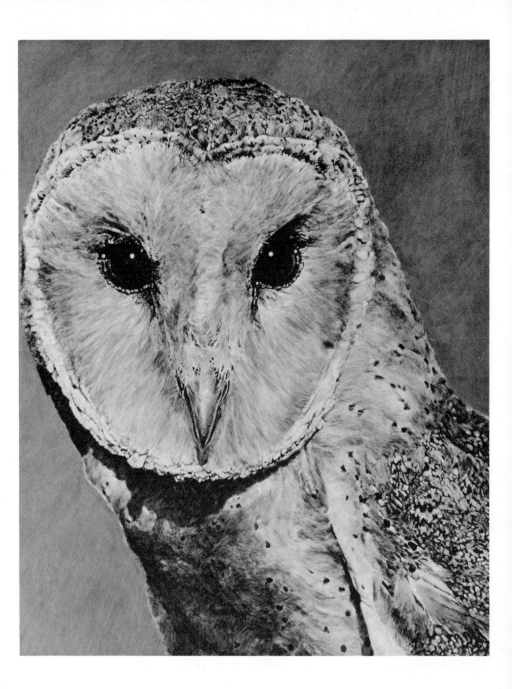

without Freud. It's being open to the possibility of all things, having pulled away the blinds. . . . In this painting with the breasts—they are first of all breasts, big and bulbous. It also has to do with lifting up, her arms are folded beneath them, and pressing in on oneself. And it has to do with undressing. The arm out of the sleeve is penislike.

But not the Rorschach way of seeing an objective thing?

That's right. After I'd done the green lipstick next to the breasts— I guess it's eye shadow—which is very phallic, I pointed in its direction and asked someone if it was too obvious; and he said, "Yes, you made the breasts too much like balls." Another friend, a girl, said, "Who is that married woman?" She saw the wedding ring, which I'd painted without thinking about it. The ambiguities lie in the viewer's frame of reference, I feel.

I'm painting facts, but they are—reality is—a fantastically complex thing. Now, if I know all about the sweater and breasts and arms "subjectively," why do I have to present them subjectively? I present them factually.

How do you recognize a sexual image?

Looking at someone across a dinner table, the way they hold their fingers, you can tell whether they're sensual or not. Or the way a person puts words together in a sentence—any number of things that are not in the categoried idea stream of the way we think about sex.

I know a girl who thinks my work is obscene, pornographic. I don't think of it that way. I won't say the pictures are done innocently but they're done . . . well, everybody knows that fingers can be penises, mouths and ears are vaginas, nostrils are assholes. And it's a question of coming upon something and having a sexual response to it. A cloud bursting in an otherwise clear sky and a dark rain pouring down from it can be more erotic than ordinary pornography.

Take the eye—feel your eye. It's like feeling in your scrotum. It has the sensitivity of the testicles. The eye's a sensitive, vital thing—and scary. It can be damaged very easily, like the testicles. To me the way images flow over, slide into one another, is fascinating.

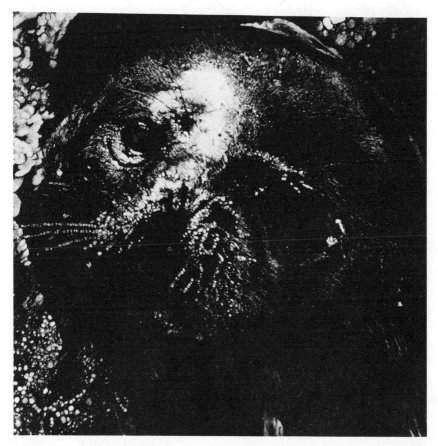

JOSEPH RAFFAEL: *Seal.* 1971–1972. Oil on canvas. 85½″ x 85½″. Photograph courtesy Nancy Hoffman Gallery, New York.

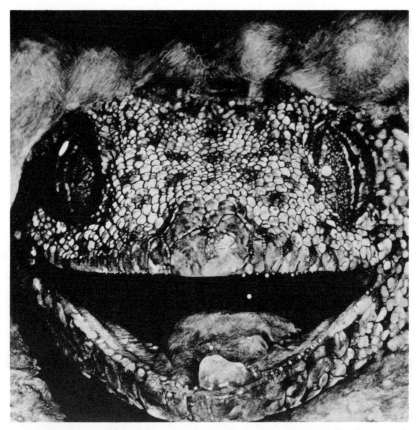

JOSEPH RAFFAEL: *Lizard's Head.* 1971. Oil on canvas. 84″ x 84″. Photograph courtesy Nancy Hoffman Gallery, New York.

Are your paintings psychoanalytical?

Certainly not. I'm just putting down things I like, innocently, to use that word again. I like sensual things. But I'm exploring the conscious, my consciousness. Our time is post-Freudian; there is an accumulation of everything we know about sex already. If you live in a family atmosphere, you see your family eat food, and you're taught to eat in a certain way. You accumulate ways of eating and talking; and you either eat that way or you react against it. Accumulated attitudes are like heredity. They become a part of you: hair and eyes, ways of talking. Today ideas about sex have been integrated into our life and feelings and what we see.

How did you come to your attitude toward painting?

A few years ago I was in the hospital. I almost died. When I got out, I could only work, do anything, three hours a day. Time became important to me, and life, in a very sensual way; I began observing things. Moving my fingers became an event. I was stunned by life and living things.

Walking down a street and seeing the sky above the skyline—earlier I would have looked at it as forms, a big white form fitting in, as in an Arp jigsaw-type relief. What now excited me, and extended the visual into an urban mid-sixties, was that it was this city and this sky. Not in a social realist way. Beyond the visual attributes which things have, they also have their identity.

Then Kennedy was killed. The fixation I had about life pounded itself home. After that I began to pull away, not the curtains, I had to break down the walls of things I'd been taught at Cooper Union and Yale by the abstract painters, and to begin presenting what I really cared about. The awareness of physicality dominated me and my work.

Abstraction was for them what reality was about; virility and vitality were all in the motor action of the arm. But they were describing a physical act, a slice of a slice of life; it wasn't a description of life but a description of motor action. Virility in painting is about observing fertile and fantastic things that have within them the power to erupt, like Vesuvius. The anticipation—going to Vesuvius for a holiday

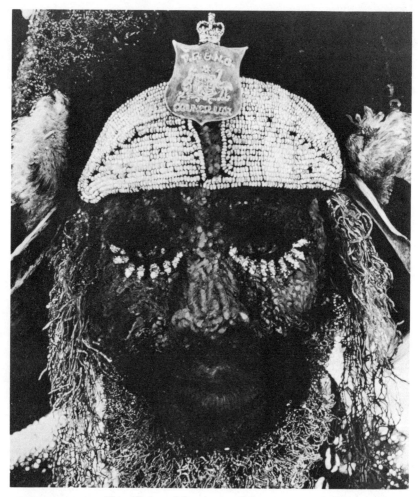

JOSEPH RAFFAEL: *New Guinea Man*. 1972. Oil on canvas. 84″ x 74″. Photograph courtesy Nancy Hoffman Gallery, New York.

JOSEPH RAFFAEL: *Water Painting IV*. 1973. Oil on canvas. 78″ x 114″. Photograph courtesy Nancy Hoffman Gallery, New York. Collection of Wally Goodman and Stanley Picher.

or staying on an island when a hurricane is coming—that's active vitality for me. In the zigzag brushstroke it's already stated.

Things are terrifically sensual. In certain portraits you can tell that the thing that really excited the painter was not the person but the creases in a dress or a pair of pants. Huxley has something on this in his book about mescalin, about folds and creases. He says he began to see them for what they were, always clearer and clearer. Then he related them to other things, as in certain sculptures, but he never lost what they really were. Abstraction can cloud the original excitement.

But take the figurative image of—there, now, you're wearing eyeglasses. I love things that can act as separators, but which you can still see through, obstacles which can be got through. Behind them you've got skin, with reflections of light in the room on the skin. Then your eyes, which have got dark and light parts, and different reflections. Before they're all those things, they're glasses, just to begin with as a basis.

Your paintings assume a kind of interpretation . . .

Do they? I find that people do that, but then people get very self-conscious with facts. You certainly have to cope with the images. They are very aggressive, but they are not in themselves emotional. They are what they are, like Vesuvius.

REALISM IN DRAG[*]

Honey Truewoman

The slick girlie and beefcake magazines modeled on the Playboy prototype have not only captured the popular imagination but they have caught the artistic eye as well. Recent parodies by Mel Ramos combine the art-historical past with the new graphic awareness to produce a type of hybrid realism.

The author disagrees with those who interpret Ramos' paintings as satire. Rather, she sees them as metaphors, parodies, and, most importantly, travesties. Yet the attitudes revealed are progressively deeper and broader. One of them, according to Truewoman, is "Man is basically conservative and unimaginative."

Honey Truewoman is a former model for Penthouse and Oui magazines. She has contributed articles to Art in America, Art News, and Arts Magazine, and has written a monograph on the etchings of Canaletto.

* Reprinted from *Arts Magazine*, Vol. 48, No. 5 (February 1974).

What kind of man reads *Playboy?* Apparently Mel Ramos does. For several years Ramos has been borrowing style and motifs from the glossy full-color pages of girlie magazines to develop a series of paintings that are usually humorous, sometimes vulgar, and often outrageously funny. His most recent paintings, *Playboy*-esque parodies of traditional artworks, develop Ramos' penchant for humorous commentary into a marvelously elaborated travesty of contemporary and conventional attitudes toward eroticism. In addition, they pose, once again, the aesthetic question of relationships of realism, Super Realism, and idealism.

Ramos' development over the last dozen years quite naturally led him to a more complex literary statement, for his work has evolved from Pop to pun to parody. He began his iconoclastic career in the Thiebaud tradition of Pop art. In the early sixties he concentrated on comic-book images of such luminaries as Wonder Woman and Phantom Lady. By the mid-sixties he was doing clever, visual puns in the style of the *Playboy* cartoonist Vargas. Such works by Ramos as *Val-Veeta* or *The Princess* were, in essence, cartoons for the hip *Playboy* reader: they did not condemn the overblown *Playboy* nude aesthetic, but rather intellectualized the humor of the visual semantic implication of the American male's association of materialism and sex. The Pop element, and Ramos' fondness for the literal and visual pun, are still present in the new work, but now are considerably embellished with a more complex literary motif implying metaphysical levels of interpretation.

Ramos has chosen several artists and paintings most dear to our art-historical hearts as the subjects of his recent parodies. *Ode to Ang* (1972) and *Plenti-grande Odalisque* (1973) parody *La Source* and *Grande Odalisque,* those classic examples of French idealism by the old master of marbleized eroticism, J. A. D. Ingres. *Touché Boucher* (1972–1973) is Ramos' interpretation of *Miss O'Murphy* by an older, but no wiser, dabbler in fanciful titillation. *Manet's Olympia* (1973) is a salute to the all-time favorite shocker of the century.

All the new paintings are done in the glossy, smooth, pseudovoluptuous style epitomized by girlie-magazine photography. They are

MEL RAMOS: *David's Duo*. 1974. Oil on canvas. 70″ x 96″. Photograph courtesy Louis K. Meisel Gallery, New York.

painted in a basically realist style; that is, an objective representation of the real, visual world based on meticulous observation. But it is a style that is a little too crisp, literary, and "commercial" to slip easily into place with current definitions of Super Realism or Photo Realism. Though he certainly makes more than a halfhearted attempt at trompe-l'oeil, Ramos' attention is clearly given to other formal considerations as well. In order to make a literary comment, such as a parody, Ramos must employ the style of one work while still maintaining the believability of the original work. Specifically, he is using a *Playboy* style to parody Ingres, Manet, and Boucher. In addition, his own stylistic tendencies struggle for recognition. The result is a curious combination of trompe-l'oeil and artifice, of realism and Pop art, of contemporary eroticism and traditional eroticism.

An investigation of the literary content and form of Ramos' paintings leads us to some interesting observations. Ramos' work has been interpreted as satire, but essentially it is not. Satire, in its pure form, blends a critical attitude with wit and humor in order to accomplish reform. Ramos' paintings are never strong enough condemnations of either the *Playboy* aesthetic or of traditional art to function properly as satire. They are, rather, metaphors, parodies, and travesties. As such, they are not too different from what *Playboy* itself does by placing a nude in the pose or setting of a familiar artwork. The difference is that, for *Playboy*, the travesty is merely a motif—a variation of presentation, maybe a joke, or perhaps even an attempt to reinforce its readers' sense of "cultural" accomplishment and awareness. Ramos, on the other hand, has taken the travesty out of the magazine and off the streets, hung it on the wall, and called it *art*. Therefore, we approach it differently, with all our critical faculties and scholarly trappings.

The literary forms become progressively more specific as they develop from metaphor to parody to travesty, but the ideas or attitudes revealed are progressively deeper and broader. Ramos' paintings, on the first level, are metaphors; that is, implied analogies that imaginatively associate one thing (Manet) with another (*Playboy*) and thus

MEL RAMOS: *Regard Gerard*. 1974. Oil on canvas. 80″ x 70¼″. Photograph courtesy Louis K. Meisel Gallery, New York.

give to the first one or more of the qualities of the second. The previously unsuspected similarity is enlightening. We see the implicit sexual, erotic, or vulgar content of Manet's *Olympia,* which we always knew was there but which was carefully veiled by the word *art.* Further, we may see that the male's sexual fantasy and his preoccupation with the female as a displayed object has changed little over the centuries. Man is basically conservative and unimaginative. We may even realize that the real similarity between Manet and *Playboy* is the preoccupation of both with the female nude; and that the real difference between Manet and *Playboy* is not whether one is art and one is pornography, but rather merely that one is elite and the other is mass-produced and sold on the street.

But it is in the investigation of Ramos' paintings as parodies, or more specifically as travesties, that his attitude is revealed, and a curious phenomenon of realism is uncovered. A parody is a composition that humorously imitates another, usually serious, piece of work. If it is directed against an artist or his style, it is likely to fall into barbed witticism or even invective, merely venting personal antagonism. If, however, the subject matter of the original piece is parodied, a more valuable, but indirect, criticism may be presented; or it may even suggest a flattering tribute to the original artist—a kind of left-handed compliment, so to speak. Clearly, insofar as Ramos' work is humorous and steadfastly maintains a very gentle criticism, we may assume that his intent, by directing the parody at subject matter, could embrace both aspects. He is not seriously criticizing Ingres, Boucher, or Manet, but rather, it seems, engaging in a little lighthearted tussle of basic good cheer and camaraderie.

So much for his attitudes and subject matter. Taking the literary investigation one step further brings us face to face with a question of visual and metaphysical realism. Ramos' paintings are not just parodies. They are specifically travesties. A travesty (from *trans* meaning over or across, and *vestire* meaning to clothe or to dress) presents a subject in a dress (style) intended for another subject. Thus Manet is dressed

up like *Playboy*, and Ursula Andress is undressed *a la Boucher*. The travesty itself is interesting for what it reveals about both dimensions: traditional art and *Playboy*. But even more interesting is Ramos' *choice* of vehicles for his travesty. By choosing a photographic style (*Playboy*) as the vehicle for his travesty, Ramos has uncovered an important element about the realism of *Playboy* and of his own style. He is not quite a Super Realist, and the reason may well lie in the vehicle for the travesty. Ramos' paintings are, and can only be, as real as the *Playboy* style allows. And *Playboy* photographs are not exactly real. In essence, what *Playboy* does is to take a real form, the nude female body, and manufacture an ideal. The body is posed, primped, plucked, painted, powdered, propped, and pumped-up into a form established as the contemporary aesthetic ideal for the female body. It is something real, dressed up to be an ideal; it is a lie. It is then photographed and distributed to the viewer. The next step, which occurs in the mind of the viewer, is predictable, and, perhaps, essential to the success and maintenance of the *Playboy* aesthetic. Because it is a photograph, the viewer accepts the presentation as truth. The ideal becomes, once again, realism. The lie is believed as truth, and men proceed, for the rest of their lives, to seek the ideal, nonexistent body that *Playboy* promises exists—the old quest for the pot at the end of the rainbow. It is a curious manipulation of an aesthetic—an inversion of realism masquerading as idealism and subsequently confused once again with realism, as the shift from artist to viewer is made. By adapting the *Playboy* style for developing a literary conceit, Ramos becomes involved in the visual semantics of the style he copies. His realist style is adapted from a photographic style, but, because of the nature of the particular photographic style (its artifice and deceit) and his peculiar use of it as a travesty on traditional art, his realism is altered into another form. Ramos is thus a kind of hybrid realist, a mutation, a sport.

THE GRAND STYLE*

Judith Van Baron

William Beckman, whose paintings are the subject of this article, came to realism with a viewpoint decidedly different from the mainstream realist. Beckman's work embraces a simple subject matter that seems to concern itself less with surface textures and more with traditional compositional schemes.

Judith Van Baron has written on the paintings of Whistler, and is Director, The Bronx Museum of the Arts.

William Beckman believes in a Grand Style of Painting. The very idea evokes dazzling memory flashes of Rubens or Ingres, of Titian and Courbet. We search our imaginations for proper contemporary glorious historical moments to immortalize—*The Coronation of Richard Nixon, The Arrival of Henry Kissinger at the Court of Mao, A Real Allegory: Seven Years in the Life of Andy Warhol.* But so far, Beckman has not

attempted such ambitious projects as those huge machines we associate with pre-twentieth-century giantism. His paintings are few in number and modest in scale. They are primarily full-length, frontal, life-size portraits of his wife, Diana, and bust-length portraits of himself. Nonetheless, a grand style is in the making in terms of Beckman's concentration on technique, insistence on meaningful subject matter, study and use of the old masters, aggrandizement of humanity, and belief in the necessity of the intuitive element in all great art. His very recognition of the idea of "great art," his flagrant lack of "false humility," his rejection of the mediocre, his horror at the ugly or grotesque demeaning the human form, and in a sense his reassertion of humanist interests as opposed to existential ones, disturb our contemporary ennui and confront our disenchanted sensibilities with a viable alternative to l'art pour l'art, which seems to have found its senile expression in the Pop art subject and mechanical method of Photo Realism.

For a grand style to exist, there must be a grand idea, a system of elevation, and, in fact, a hierarchy. It is a style of aspiration, not a vote for mediocrity on any level, and in this respect, Beckman is not alone in his desire for an alternative to the last decade's fascination with the mundane. Other pioneers in the reassertion of a grand style, for example, are the feminist artists of the seventies who have elevated the female subject from erotic plaything to her rightful position a little below the angels and found a whole new interpretation and presentation of the male nude.[1] Though not involved in political connotations such as those associated, legitimately or not, with feminist art, Beckman shares their interest in the emphasis on positive presentation of the subject, which is—humanity. There is a genuine thrill in confronting such a thing as Beckman's 1973 *Self-Portrait,* done after Albrecht Dürer. Its personalism and intimacy as well as its stunning tour de force of illusionism is mind-boggling and electrifying for anyone who does not get off on automobile engines, hamburger stands, airplanes, and other manufactured paraphernalia. It is a look, once again, with

[1] Observed by Linda Nochlin, "Some Women Realists: Part II," *Arts Magazine* (May 1974).

fascination at woman and man as they are in life, not chopped up by an aesthetic of fragmentation, not blown up by a slide projector, and not interpreted by the crassest, most foolish objects of a technological society. If subject matter is to be a dominant factor, then our response to that subject, its meaning for us, is significant. By comparison, an interest in humans makes an interest in men's toys—motorcycles, airplanes, cars—appear adolescent. And adolescence is too painful and too boring to stay in very long. Satiated with mediocrity, no longer amused by our toys, we may be ready, even hungering for a change, and the grand style may be exactly what our damaged egos most desire.

But how to get near it is more difficult than recognizing what it is. Beckman's modus operandi is a partial key to his attempt—his intellectual orientation complements his method to justify the style. "My interest in technique," he says, "is solely for the eternalization of my work." Not that most artists don't recognize this, but Beckman does it somewhat more deliberately with a real passionate ambition. Each of his works proves the sincerity of the assertion, for each is carefully crafted and constructed with an eye to eternity. Every one is handmade—the real thing—a little like growing your own tomatoes. Painted on kiln-dried, laminated hardwood, every stage, every bit of the material is carefully studied, selected—Beckman is not content to rely on learning from experience—trial and error is time-consuming and costly. He searches for the best, and is an assiduous scholar, a reader of books, old and new, a philosopher, aesthetician, and theorist. He does not carry his knowledge modestly and cannot conceive of experiencing meekness—no Nixonian double-talk from this artist, no apologies, no straw-man anguish. In fact, the rule he lives by, adapted he readily admits from Ayn Rand's *Romantic Manifesto*, reads, "The importance of an idea can be judged by the amount of labor it can with grace accept." Though verging on the much-scorned Protestant work ethic, it curiously enough accomplishes the more catholic concept of a grand style.

Beckman embraces the art of the past wholeheartedly, to the extent of doing paintings after the works of the great masters. For the

WILLIAM BECK-
MAN: *Diana II.*
1973. Oil on
board. 6'11" x
3'11". Photo-
graph courtesy
Allan Stone Gal-
leries, Inc., New
York.

last five years his models have included Vermeer, Fra Angelico, Dürer, and Rembrandt. He studies Ingres' work intensively, and spent the greater part of his first year in New York City in The Metropolitan Museum of Art, freaked-out by Pompeiian wall painting. He does not do his compositions after the masters as a trifling and amusing parody in the Pop art tradition as, for example, Mel Ramos' 1973–1974 paintings (i.e., *Manet's Olympia*) were done.[2] Rather, Beckman's paintings are contemporary recognition of the great discoveries of the past and, in a sense, are experimentation and self-challenge. If one wishes to find a new grand style, it is quite logical to turn to the great work of the past to see how it was done—or to try to understand what it was all about. Then the task of how to keep it in a contemporary context presents itself. Religious events or glorification of history were significant themes in the grand style painting of the past. Portraits and self-portraits would hardly have been grand style painting a few centuries ago. But then, a century or two ago, artists did not have to begin in the kind of ambiguous subject matter situation in which Beckman finds himself. The hierarchy of subject matter was established and it provided a structure for definition. Beckman is faced, first of all, with simply reasserting the primacy of *positive* subject matter.

Then the question arises, will a new hierarchy develop? To Beckman's way of thinking, it already has. For the moment he chooses woman/man as the most desirable subject—rejecting objects and things per se. He is not alone, for although many realists do concentrate on cars, motorcycles, traffic lights, and hamburger joints, others, notably Alice Neel, Chuck Close, Sylvia Sleigh, Philip Pearlstein, Jerry Ott, reveal a renewed interest in the human figure. Beckman differs from these realists in his severance from Pop art (Ott), rejection of the grotesque or abnormal (Pearlstein, Close), and absence of visionary cultural ideology (Sleigh). In terms of his desire to achieve a powerful human representation by way of the portrait we must make reference to the vast portrait oeuvre of Neel. Generally speaking, though, Beck-

[2] Honey Truewoman, "Realism in Drag," *Arts Magazine* (February 1974).

man's motivation may be closer to the sculpture of Duane Hanson, since each artist is involved in duplication, hence, the *aliveness* of the finished product. Beckman diverges considerably from Hanson, however, in the positive presentation of the subject, since many of Hanson's figures (junkies, derelicts, prostitutes) connote negative images— a quality Beckman abhors. The implication in Beckman's hierarchical approach is that, by virtue of the choice and approach to subject, much of the realism around today (object or figure) could, in comparison to his work, be viewed as the genre painting of the seventies. A good deal of current Photo Realism appears trendy, mannered, and dependent on a highly specialized sociological awareness—a knowledge that will gradually diminish as the technology and the aesthetics change. What Beckman's work seems to bring into play is "universality"—a conservatively lofty conception, sought thus far in the seventies mostly by pot heads and meditators, but generally ignored by artists in favor of the immediate rush of the machine or the pseudoglamour of camp.

Another aspect of the grand style Beckman envisions is the primacy of the intuitive approach—his art is made purely with the eye, mind, and hand. He is like an innocent in his fascination with the finished product—"How did I get all that stuff to fit together?" There is no room for the accidental or the mechanical in Beckman's method. It is in no way, however, related to the kind of intuitive method Abstract Expressionism used, for he is, after all, working directly from a model—copying visual reality. Similarly, it is in marked contrast to the method of the Photo Realists, who rely on the machine and mechanical transference. Since he paints from life, he avoids the distortion and mechanical nature of the photograph. Hence his figures breathe—they are real. It is the living nature of the subject that he tries to capture. In a Platonic sense it is one less step removed from reality than the realism of the Photo Realists—one step back in the direction of the "idea."

Whether or not a grand style will be established is anybody's guess. Attempts by Beckman and others may be merely obvious at the moment by virtue of their contrast to the current style. But a grand style

is not really suited for the flash in the pan either; once it gets moving, it is too heavy, too desirable, too self-satisfying, too ego-reinforcing to die with a whimper or a shrug. Maybe the seventies will see *The Burial at Arlington, The Entry of the Yanks into Dachau,* or *The Retreat of Hitler's Army from Russia.*

GALLERY OF ARTWORKS

Part IV

JANET ALLING: *Rubber Tree Plant 4.* 1971. Oil on canvas. 22″ x 22″. Photograph courtesy the artist.

RICHARD ARTSCHWAGER: *Diptych II.* 1968. Acrylic on celotex in shaped Formica box. 20⅛″ x 32¼″. Photograph courtesy Leo Castelli Galleries, New York.

RICHARD ARTSCHWAGER: *Polish Rider IV*. 1971. Acrylic on board. 76″ x 92″.
Photograph courtesy Leo Castelli Galleries, New York.

JOHN BAEDER: *10th Ave. Diner.* 1973. Oil on canvas. 30″ x 48″. Photograph courtesy Hundred Acres Gallery, New York. Collection of A. Haigh.

JACK BEAL: *Danae* (second version). 1972. Oil on canvas. 68″ x 68″. Photograph courtesy Allan Frumkin Gallery, New York.

ROBERT BECHTLE: *Xmas in Gilroy.* 1971. Oil on canvas. 48″ x 69″. Photograph courtesy O. K. Harris Gallery, New York. Collection of Dr. and Mrs. Gerald Gurman.

BLYTHE BOHNEN: *One Stroke—Simple Gesture.* 1972. Acrylic on paper. 28″ x 22″. Photograph courtesy A.I.R. Gallery, New York.

DOUGLAS BOND: *Den: Girl's Waffle Party.* 1973. Acrylic on canvas. 46″ x 64″. Photograph courtesy O. K. Harris Gallery, New York. Collection of Paul and Camille Hoffman.

JOHN CLEM CLARKE: *"Maids of Honor" Velazquez* (detail). 1972. Oil on canvas. 56″ x 52″. Photograph courtesy O. K. Harris Gallery, New York.

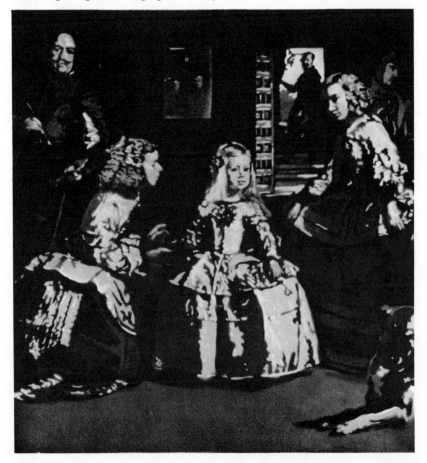

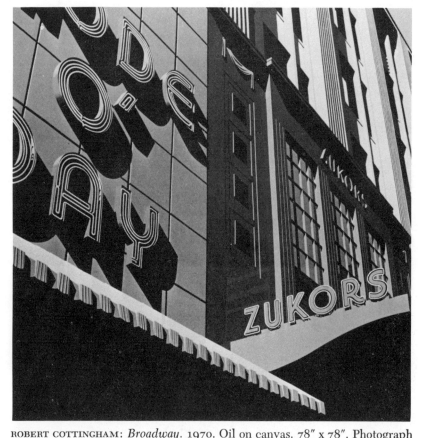

ROBERT COTTINGHAM: *Broadway.* 1970. Oil on canvas. 78″ x 78″. Photograph courtesy Jack Glenn Gallery, Los Angeles.

ROBERT COTTINGHAM: *Broadway.* 1970. Oil on canvas. 78″ x 78″. Photograph courtesy Jack Glenn Gallery, Los Angeles.

CHRIS CROSS: *Macrae.* 1973. Acrylic on canvas. 87" x 60". Photograph courtesy Warren Benedek Gallery, New York.

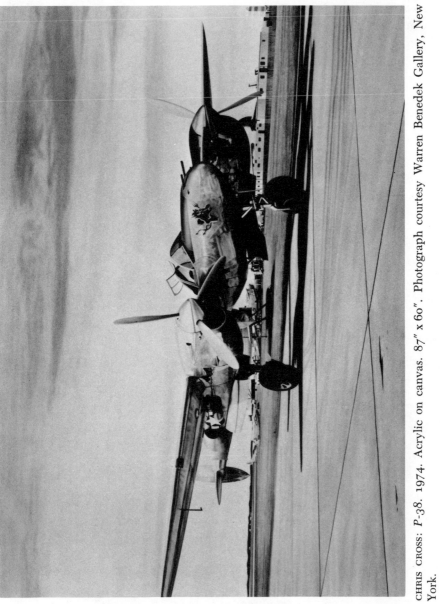

CHRIS CROSS: *P-38*. 1974. Acrylic on canvas. 87" x 60". Photograph courtesy Warren Benedek Gallery, New York.

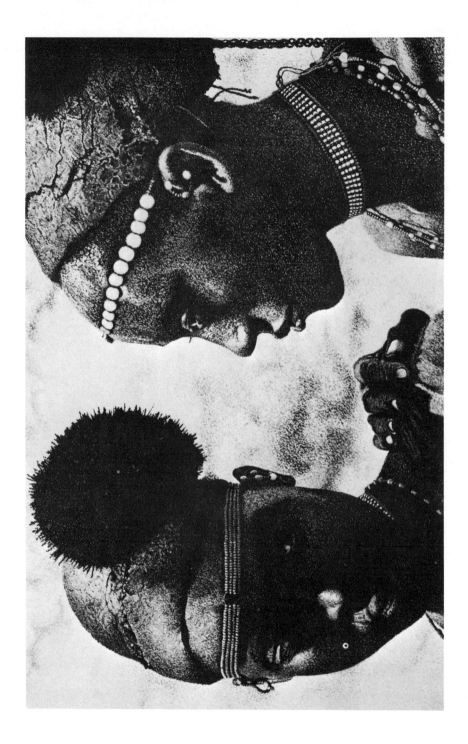

FRANK CYRSKY: *Masai Warriors.* 1972. Oil on canvas. 73″ x 108″. Photograph courtesy Warren Benedek Gallery, New York.

FRANK CYRSKY: *Pelekan.* 1973. Oil on canvas. 55″ x 55″. Photograph courtesy Warren Benedek Gallery, New York.

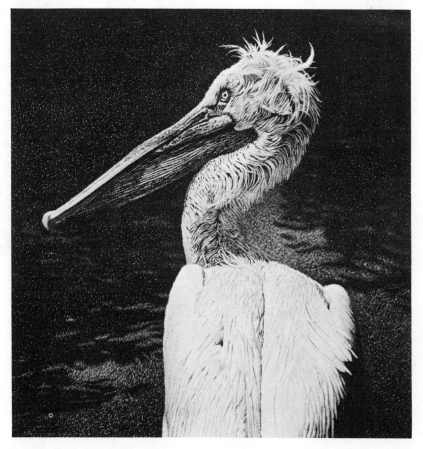

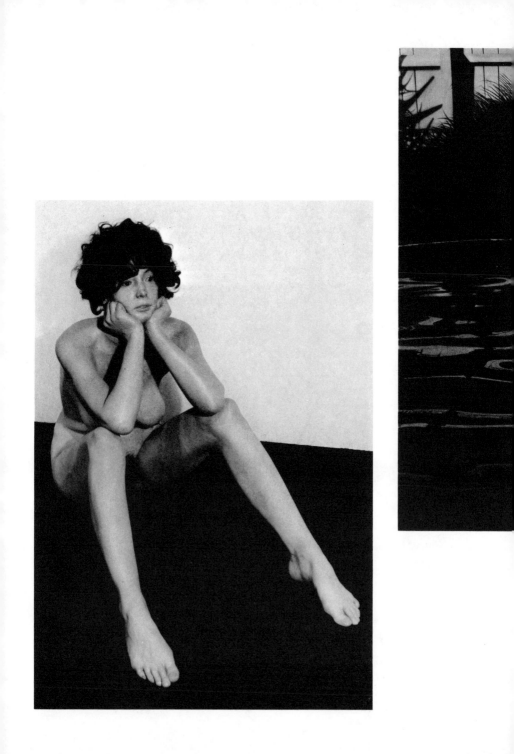

DAN DOUKE: Untitled (Reseda). 1973. Acrylic on canvas. 84" x 60". Photograph courtesy Warren Benedek Gallery, New York. Collection of Howard Kraushaar.

JOHN DE ANDREA: *Sitting Woman*. 1972. Polyester and fiber glass, polychromed. Life-size. Photograph courtesy O. K. Harris Gallery, New York. Collection of Warren and Bonnie Benedek.

MICHAEL ECONOMOS: Untitled. 1973. Oil on canvas. 72″ x 72″. Photograph courtesy Warren Benedek Gallery, New York. Collection of Goucher College, Baltimore, Maryland.

DON EDDY: *Tom Williams Used Cars.* 1972. Acrylic on canvas. 66″ x 80″. Photograph courtesy French & Company, New York.

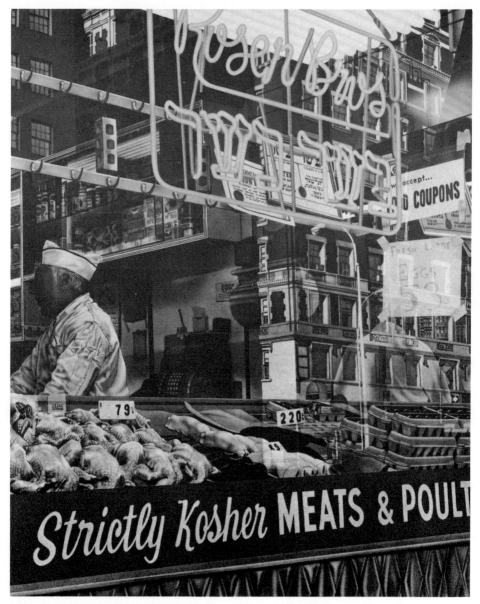

DON EDDY: *Rosen Bros. Strictly Kosher Meats & Poultry.* 1973. Acrylic on canvas. 59″ x 48″. Photograph courtesy Nancy Hoffman Gallery, New York.

BRUCE EVERETT: *Door Knob*. 1971. Oil on canvas. 74″ x 57″. Photograph
courtesy O. K. Harris Gallery, New York.

BRUCE EVERETT: *Gum Wrapper*. 1971. Oil on canvas. 60" x 108". Photograph courtesy O. K. Harris Gallery, New York. Collection of Yale University Art Gallery, New Haven, Connecticut.

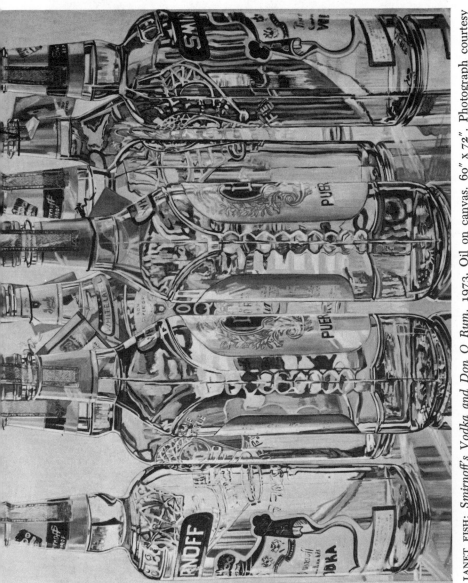

JANET FISH: *Smirnoff's Vodka and Don Q Rum.* 1973. Oil on canvas. 60″ x 72″. Photograph courtesy Kornblee Gallery, New York. Collection of Heublein, Inc., New York.

AUDREY FLACK: *Lady Madonna.* 1972. Oil on canvas. 68″ x 78″. Photograph courtesy French & Company, New York.

FRANZ GERTSCH: *Franz and Luciano.* 1973. Acrylic on canvas. 77″ x 117″. Photograph courtesy Nancy Hoffman Gallery, New York.

RALPH GOINGS: *Burger Chef Interior.* 1972. Oil on canvas. 49″ x 56½″. Photograph courtesy O. K. Harris Gallery, New York. Collection of Sidney and Frances Lewis.

HAROLD GREGOR: *Illinois Corn Crib #19 Route 9 Near Bloomington.* 1973. Acrylic on canvas. 60″ x 66″. Photograph courtesy Stefanotty Gallery, New York.

RICHARD HAAS: *Houston & B'way IND.* 1971. Mixed media. 28″ x 18″ x 22″.
Photograph courtesy Hundred Acres Gallery, New York.

H. N. HAN: *Mercer Street.* 1973. Acrylic on canvas. 114″ x 72″. Photograph courtesy O. K. Harris Gallery, New York.

H. N. HAN: *Newark Generator*. 1973. Acrylic on canvas. 72″ x 114″. Photograph courtesy O. K. Harris Gallery, New York.

DUANE HANSON: *Dishwasher*. 1973. Polyester and fiber glass, polychromed. Life-size. Photograph courtesy O. K. Harris Gallery, New York. Collection of Ed Cauduro.

DON HENDRICKS: *Shannon*. 1972. Pencil on paper. 24″ x 32″. Photograph courtesy O. K. Harris Gallery, New York.

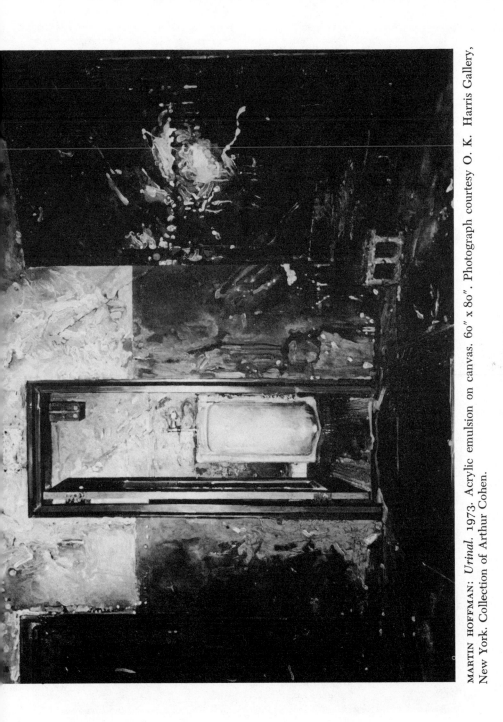

MARTIN HOFFMAN: *Urinal*. 1973. Acrylic emulsion on canvas. 60" x 80". Photograph courtesy O. K. Harris Gallery, New York. Collection of Arthur Cohen.

IAN HORNAK: *The Backyard—Variation III.* 1973. Acrylic on canvas. 54″ x 36″. Photograph courtesy Tibor de Nagy Gallery, New York.

YVONNE JACQUETTE: *Underspace.* 1967. Acrylic on masonite. 32″ x 22″. Photograph courtesy Fischbach Gallery, New York.

YVONNE JACQUETTE: *The Barn Window Sky*. 1970. Oil on canvas. 50″ x 67½″. Photograph courtesy Fischbach Gallery, New York.

LUIS JIMENEZ: *Barfly (Statue of Liberty)*. 1970. Fiber glass, resin, and epoxy. 7½′. Photograph courtesy O. K. Harris Gallery, New York.

GUY JOHNSON: *Men Smoking.* 1974. Oil on canvas. 22″ x 30″. Photograph courtesy Stefanotty Gallery, New York.

RICHARD JOSEPH: *Phone Call.* 1971–1972. Oil on canvas. 68″ x 74″. Photograph courtesy Warren Benedek Gallery, New York. Collection of Edmund Pillsbury.

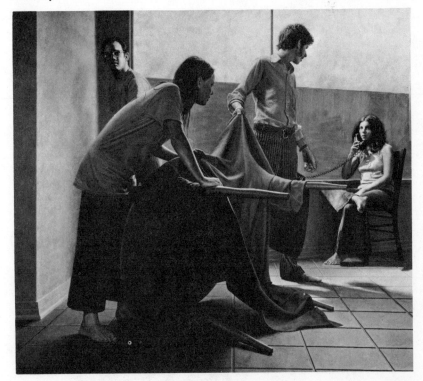

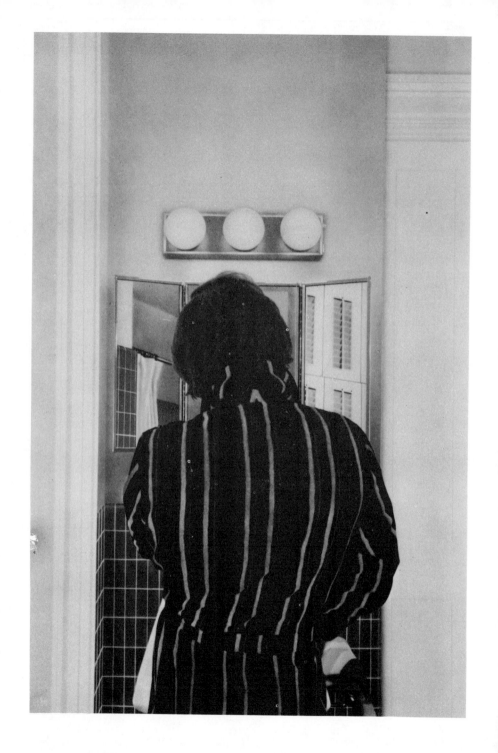

HOWARD KANOVITZ: *In the German Bathrobe.* 1973–1974. Liquitex polymer acrylic, Liquitex mat varnish. 60″ x 40″. Photograph courtesy Stefanotty Gallery, New York.

ALAN KESSLER: *Dog.* 1972. Oil on canvas. 49½″ x 49½″. Photograph courtesy Bernard Dannenberg Galleries Inc., New York.

RON KLEEMANN: *Leo's Revenge.* 1971. Acrylic on canvas. 48″ x 48″. Photograph courtesy Louis K. Meisel Gallery, New York.

RON KLEEMANN: *23 Skidoo.* 1973. Acrylic on canvas. 36″ x 46″. Photograph courtesy Louis K. Meisel Gallery, New York. Private collection.

ALFRED LESLIE: *Robert Scull.* 1966–1970. Oil on canvas. 9′ x 6′. Photograph courtesy Whitney Museum of American Art, New York.

MARILYN LEVINE: *Brown Boots, Leather Laces.* 1973. Stoneware and leather. 7″ x 12″ x 5″ each. Photograph courtesy O. K. Harris Gallery, New York.

DAVID LIGARE: *Sand Drawing #18.* 1973. Pencil drawing on paper. 11″ x 9″.
Photograph courtesy Andrew Crispo Gallery, New York.

MICHAEL MAU: *Railway.* 1973. Oil on canvas. 48″ x 72″. Photograph courtesy Hundred Acres Gallery, New York. Collection of William Jaeger.

JOHN MANDEL: Untitled. 1971. Oil and acrylic on canvas. Two panels, each
78″ x 78″. Photograph courtesy Max Hutchinson Gallery, New York. Collec-
tion of Australian National Gallery, Canberra.

RICHARD MC LEAN: *Installation Shot.* 1971. Oil on canvas. Photograph courtesy O. K. Harris Gallery, New York.

RICHARD MC LEAN: *Rustler Charger.* 1971. Oil on canvas. 66″ x 66″. Photograph courtesy O. K. Harris Gallery, New York. Collection of Dr. Peter Ludwig.

RICHARD MC LEAN: *Albuquerque.* 1972. Oil on canvas. 50″ x 60″. Photograph courtesy O. K. Harris Gallery, New York. Collection of the Kraushaar family.

JACK MENDENHALL: *2 Figures in Setting*. 1972. Acrylic on canvas. Dimensions unavailable. Photograph courtesy O. K. Harris Gallery, New York. Collection of Morgan Gallery, Kansas City, Missouri.

JACK MENDENHALL: *Yellow Sofa and Swan Vase*. 1972. Oil on canvas. 6'8" x 6'2". Photograph courtesy O. K. Harris Gallery, New York. Collection of Robert Mayer.

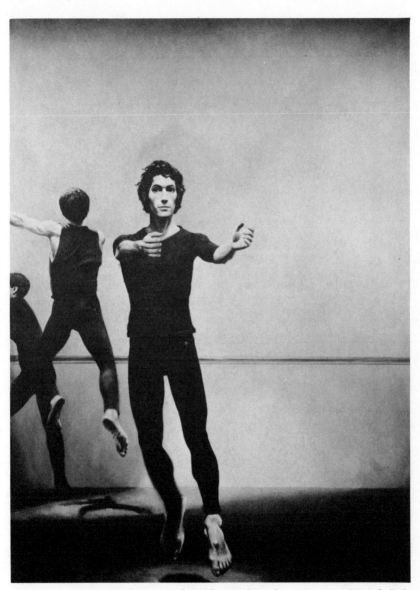

WILLARD MIDGETTE: *Choreography: The Paul Taylor Company* (Panel #4).
1972. Oil on canvas. 9′ x 6′. Photograph courtesy Allan Frumkin Gallery,
New York.

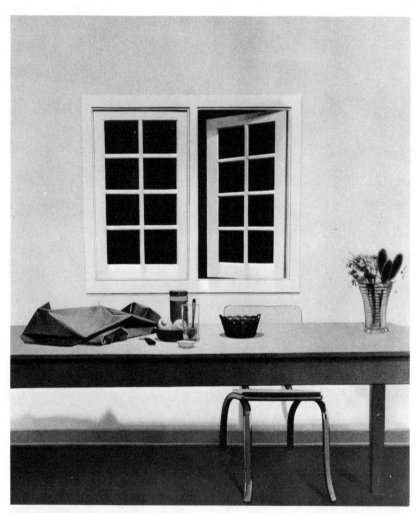

JOHN MOORE: *Summer.* 1972. Oil on canvas. 75″ x 84″. Photograph courtesy Fischbach Gallery, New York.

MALCOLM MORLEY: *On Deck*. 1966. Magna color. 84″ x 72″. Photograph courtesy Stefanotty Gallery, New York.

MALCOLM MORLEY: *Rotterdam*. 1974. Acrylic on canvas. 84″ x 72″.
Photograph courtesy Stefanotty Gallery, New York.

NAKAGAWA: *White Angel*. 1973. Acrylic on canvas. 70″ x 58″. Photograph courtesy O. K. Harris Gallery, New York.

LOWELL NESBITT: *Athens in Ruins—Acropolis.* 1970. Oil on canvas. 70" x 90". Photograph courtesy Gimpel & Weitzenhoffer Ltd., New York.

PHILIP PEARLSTEIN: *Two Female Models with Cast Iron Bench and Indian Rug.* 1971. Oil on canvas. 72″ x 60″. Photograph courtesy Allan Frumkin Gallery, New York.

SHIRLEY PETTIBONE: *Shoreline—Brighton Beach.* 1974. Oil on canvas. 35½″ x 26½″. Photograph courtesy Hundred Acres Gallery, New York. Collection of Mr. and Mrs. Monroe Myerson.

JOSEPH RAFFAEL: *Mountain Lion.* 1972. Oil on canvas. 80″ x 60″. Photograph courtesy Nancy Hoffman Gallery, New York.

CELESTE REHM: *Disappearing Ink.* 1972. Acrylic on canvas. 40″ x 65″. Photograph courtesy James Yu Gallery, New York.

JOHN RUMMELHOFF: Untitled. 1970. Oil on canvas. 46″ x 70″. Photograph courtesy Louis K. Meisel Gallery, New York. Collection of Stuart M. Speiser.

JOHN SALT: *Purple Impala*. 1973. Oil on canvas. 43½" x 64". Photograph courtesy O. K. Harris Gallery, New York. Collection of Ivan and Marilyn Karp.

BARBARA SANDLER: *Tumbling Tumbleweeds*. 1972. Oil on canvas. 70½" x 95". Photograph courtesy Gimpel & Weitzenhoffer Ltd., New York.

WILLIAM SCHENCK: Untitled. 1974. Acrylic on canvas. 60″ x 52″. Photograph courtesy Warren Benedek Gallery, New York.

CAROLYN SCHOCK: *Window Interior.* 1970. Acrylic on canvas. 63″ x 45″. Photograph courtesy Allan Frumkin Gallery, New York.

BEN SCHONZEIT: *Cabbage.* 1973. Acrylic on canvas. 80″ x 108″.
Photograph courtesy Nancy Hoffman Gallery, New York.

BEN SCHONZEIT: *Ice Water Glass*. 1973. Acrylic on canvas. 72" x 48". Photograph courtesy Nancy Hoffman Gallery, New York.

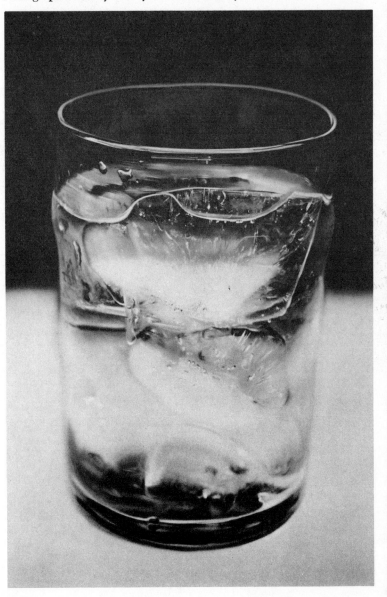

ALEX SIBURNEY: *Welcome to Maryland.* 1974. Acrylic on paper. 36″ x 36″.
Photograph courtesy Hundred Acres Gallery, New York. Collection of Neil
Rosenstein.

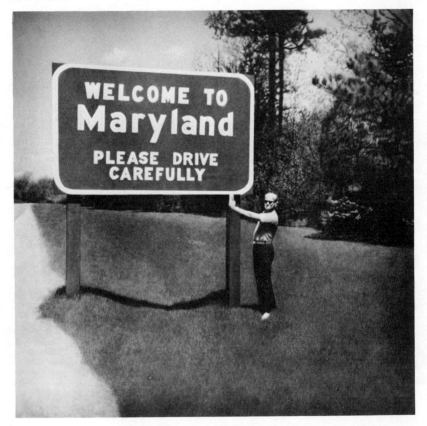

JEAN SOBIESKI: *Child in the Bank.* 1973. Acrylic on canvas. 45″ x 57½″. Photograph courtesy Marie-Louise Jeanneret Art Moderne, Geneva.

HAROLD STEVENSON: *An American in the Museum of Naples.* 1971. Oil on canvas. 78″ x 32″. Photograph courtesy Alexander Iolas Gallery, New York.

HAROLD STEVENSON: *Black Fates I*. 1973. Oil on canvas. 8′ x 10′. Photograph courtesy Alexander Iolas Gallery, New York. Collection of Mr. and Mrs. Brooks Jackson.

MARJORIE STRIDER: *Soda Box*. 1973. Mixed media. 47″ x 46″ x 9″. Photograph courtesy Nancy Hoffman Gallery, New York.

IDELLE WEBER: *Bluebird.* 1972. Oil on canvas. 38" x 50". Photograph courtesy Hundred Acres Gallery, New York. Collection of Robert Kelly.

IDELLE WEBER: *Pushcart—86th & 3rd Ave. 1973*. Oil on linen. 50" x 40". Photograph courtesy Hundred Acres Gallery, New York. Collection of Charles and Doris Saatchi.

STEPHEN WOODBURN: *Yarrowmere.* 1973. Acrylic on canvas. 66½″ x 83½″. Photograph courtesy O. K. Harris Gallery, New York. Collection of Galerie Petit, Paris.

ANTONIO XIMENEZ: *Noli Me Tangere.* 1974. Acrylic on canvas. 84″ x 67½″. Photograph courtesy Tibor de Nagy Gallery, New York.

Page numbers set in **boldface** indicate illustrations.